A HUMUMENT

TOM PHILLIPS

A HUMUMENT
A TREATED VICTORIAN NOVEL

Fifth Edition

First published in the United Kingdom in 1980 by
Thames & Hudson Ltd, 181A High Holborn, London WC1V 7QX

Fifth edition 2012
Reprinted 2015

A Humument © 1980, 1987, 1997, 2005, 2012
Thames & Hudson Ltd, London / Tom Phillips

Introduction © 1980 and 2012 Tom Phillips
Artwork © 1980 and 2012 Tom Phillips
Designed by Alice Wood

British Library Cataloguing-in-Publication Data
A catalogue record for this book is available from the British Library
ISBN 978-0-500-29043-9

Printed and bound in Slovenia by DZS-Grafik d.o.o.

To find out about all our publications, please visit
www.thamesandhudson.com. There you can subscribe
to our e-newsletter, browse or download our current
catalogue, and buy any titles that are in print.

AUTHOR'S PREFACE

Hoping that the reader would want to meet the book
head on I have put the introduction at the end.

for ruth and marvin sackner, patrons, friends
who guard my work between them, like book-ends.

A HUMUMENT

A HUMAN DOCUMENT.
New Edition

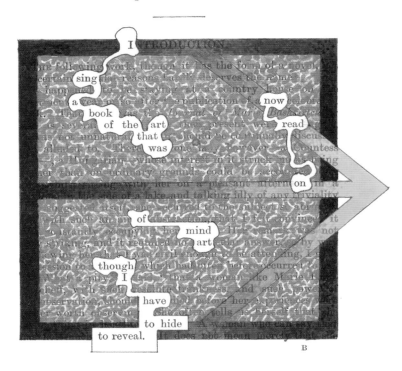

INTRODUCTION.

I sing now book of the art read was on of mind though I have to hide to reveal.

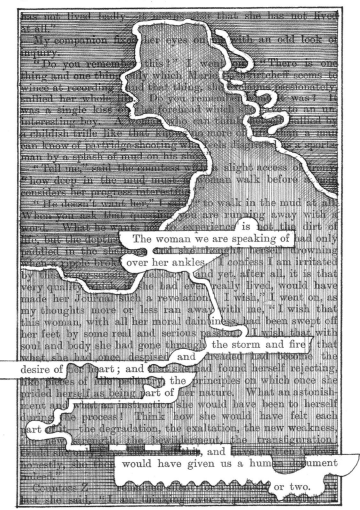

has not lived badly, it means also that she has not lived at all."

My companion fixed her eyes on me with an odd look of inquiry.

"Do you remember this?" I went on. "There is one thing and one thing only which Marie Bashkirtcheff seems to wince at recording—and that thing, she, so brave passionately sullied her whole life. Do you remember what it was? It was a single kiss on the forehead which she gave to an uninteresting boy. A woman who can think herself sullied by a childish trifle like that knows no more of life than a man can know of partridge-shooting who feels that he is a sportsman by a splash of mud on his shoes.

"Tell me," said the countess with a slight access of irony, "how deep in the mud must a woman walk before she considers her progress interesting?"

"He doesn't want her," I said, "to walk in the mud at all. When you ask that question, you are running away with a word. What he wants, and what experience is not the dirt of life, but the depths. **The woman we are speaking of** had only paddled in the shallows, and she thought herself drowning when a ripple broke **over her ankles.** I confess I am irritated by this oversensitive delicacy; and yet, after all, it is that very quality which, if she had ever really lived, would have made her Journal such a revelation. I wish," I went on, as my thoughts more or less ran away with me, "I wish that this woman, with all her moral daintiness, had been swept off her feet by some real and serious passion. I wish that, with soul and body she had gone through **the storm and fire;** that what she had once despised and dreaded had become the **desire of her heart;** and that she had found herself rejecting, like pieces of idle pedantry, the principles on which once she prided herself as being part of her nature. What an astonishment and what an instruction she would have been to herself during the process! Think how she would have felt each part of it—the degradation, the exaltation, the new weakness, the new strength, the bewilderment, the transfiguration—and if, all this while, she had written truly and honestly, she then **would have given us a human document** indeed."

Countess Z—— remained looking thoughtfully for a minute **or two.** At last she said, "I am thinking over what you have said.

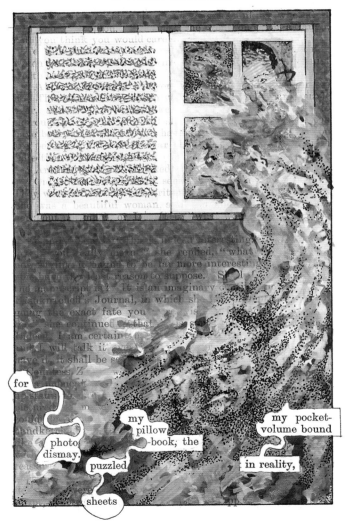

for

my
pillow
-book; the

my pocket-
volume bound

photo
dismay.

in reality,

puzzled

sheets

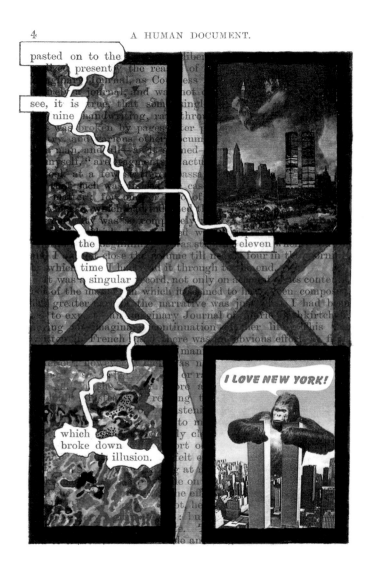

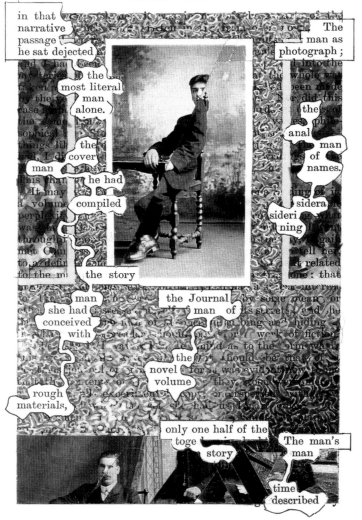

in that
narrative
passage
he sat dejected

The
man as
photograph ;

most literal
man
alone.

the
anal
man
of
names.

the
man
he had
compiled

the story

sidera
sideri
ning

man
she had
conceived
with

the Journal

rough
materials,

novel
volume

only one half of the
toge
story

The man's
man

time
described

scribe

scribe the
once or twice
story
the story
reveal
a sister

story.

a veil thrown over

veil,

see
now
the
arts
connect

changes made
the
book
continue

ask your opinion about this. I have several times wondered
during the last few weeks whether some one might not be
found who would take the volumes in hand and do for my
poor friend what she had herself intended to do with the work
up its contents into some presentable form, and publish it.
Do you think that a book like that would be found generally
interesting?"

"That would depend largely," I said, "on how it happened
to be written. The whole of the materials would have to be
recast; for as they stand they are not a story in any literary
sense; though they contain the matter for one before us, to do that —

ask only one very simple thing: I mean in suchred
dumpress the reader with the truth of it—no novel be
found for years would for me personally have half my
poog or interest." ork

up ave thought," said Countess Z——," of writing it,
Dorian novelist I—— and asking him to look ally
interipts, and see if he could make anything out of
"I have now got a new project, and you must ned
toty what you think of it, for it is to make that be
ree him. But to you. There are several reasonary
sened, why, if you care to undertake it, you wuct
oncy rinked to the task. The characters, as ycory
Engave a certain connection with England; this
Human, would understand the better way
knenn. There is one reason here is another I
haplungory, or at least certain parts of it, much
very that some of the places where you stayed
haplaces in which some of the incidents of thour
Dord. But now I am coming to a better reasthe
S—remember that, when you were staying at m
N—you made an expedition to Count D——'s now
cas a house on the slope of a hill, just under xing
 But
wasw" I exclaim d, "could you possibly know that way
a—I am certain—one of the things I told you also
ofte" she said "but Countess D—— is my si what
knew there; and a little white boudoir, into ain,
You needn't opening out of the hall, is my own thought

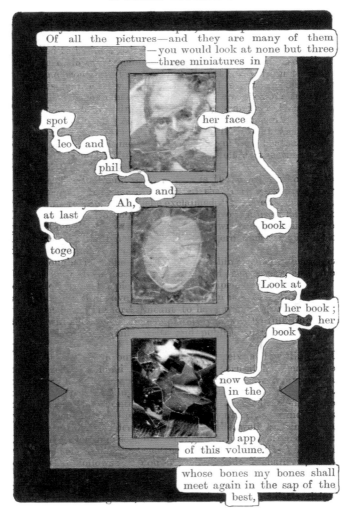

Of all the pictures—and they are many of them
—you would look at none but three
—three miniatures in

spot

leo and

phil

and

Ah,

at last

toge

her face

book

Look at

her book ;
her

book

now
in the

app
of this volume.

whose bones my bones shall
meet again in the sap of the
best,

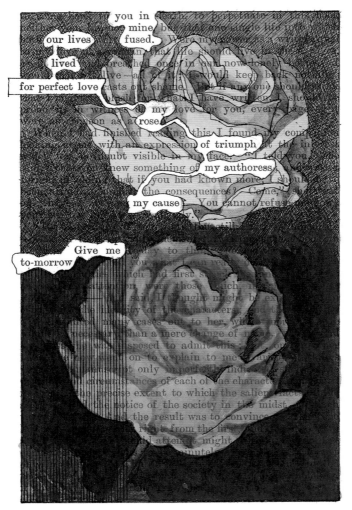

you in ... to perpetuate in ...
mine b... single life in ...
our lives fused. Were my ... as I wr...
... that life should liv...
lived ... breathed once in you now lonely...
live—and if it ... would keep back ...
for perfect love casts out shame. But if any one should
... what I have written, she...
... witness to my love for you, every page
... upon as a rose.

When I had finished reading this I found my comp...
with an expression of **triumph** ... the in...
... doubt visible in my face. "I told you
... knew something of **my authoress,**
... that if you had known more, should...
... the consequences? Come," sh...
my cause. You cannot refus...
... but still...

Give me to th...
to-morrow ... you what I can rea...
... ich had first s...
... ... those ... ich ...
... said, I thought might be ex...
... ity of the characters, and th...
... many cases out to her, wh... ...
... rest in than a mere change of ...
... was ... sposed to admit this ... or...
... went on to explain to me
... ...t only imperfectly indic...
... circumstances of each of the charact...
... precise extent to which the salient facts...
... notice of the society in the midst...
... the result was to convince ...
... right from the first
... attempt might
... minutel...

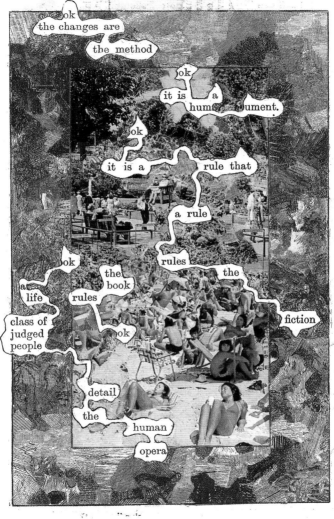

ok
the changes are

the method

ok
it is a
human document.

ok

it is a rule that

a rule

rules

ok
the
book the

a
life rules

class of
judged ok
people

fiction

detail

the

human

opera

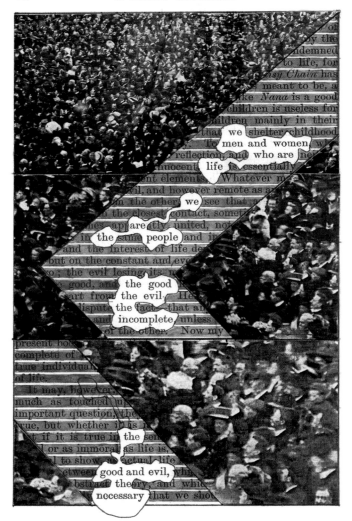

of
y the
ndemned
to life, for
asy Chain has
s meant to be, a
ke *Nana* is a good
children is useless for
ildren mainly in their
that we shelter childhood
To men and women wh
reflection, and who are ne
nnocent life is essentially
nt element. Whatever m
il, and however remote as a
m the other we see that a
n the closest contact, somet
nes apparently united, no
s in the same people and i
and the interest of life de
but on the constant and eve
o; the evil losing its n
e good, and the good
art from the evil. He
dispute the fact that a
and incomplete unless
of the other. Now my
present bo
complete of
true individua
of life.

It may, however,
much as touched up
important question, the
rue, but whether it is
t if it is true in the sen
l or as immoral as life is,
l to show, as actual life
tween good and evil, whi
bstract theory, and whi
necessary that we shou

and farth
for
moralists

with

moral
motives.

moral
minds

manipulate

teach

doubtful.

contradict the

general

scandalized

sharp
people

CHAPTER I.

enter toge

wheeled slowly
in
by

French and

German ladies of vague conditions in life,

...spotted to be sea-sick, and seemed dirty and pale already with the mere anticipations of their journey; and amongst them all were an Austrian count and countess, he examining his fellow-travellers with a smile of curious *superiority*, she with a look of quiet, refined distress, tempered by aristocratic resignation.

There was also another *curious* spectator, who, *evidently* completed all his preliminary *arrangements*, *standing* on one of the balconies was placidly contemplating the scene. He was a dark man, with dark, almond-shaped eyes, which, assisted by his moustache and teeth, kept a chronic smile *shining*; whilst the curled brim of his hat, the startling ... the *lavender gloves*, and *large gold* ... the *world* to recognise and respect him ... a *viveur*. He ... indeed at the moment another ... still harder ... the ... or he was engaged in what was apparently a farewell *conversation* with a *lady, beautiful* but somewhat extravagantly dressed, who was one of the best known ... the *freshest* of the flowers, the Parisian *demi-monde*. ... the two seemed saddened by the thought *of separation*, ... to be *rejoicing* in the consciousness of a bright ... past; and their happy *laughter*, ... they commented on the people round them, was ... by a glance or type of ostentatious tenderness. Only ... was the man's good-humour ruffled, and this was by a *porter*, who, charging the carriage with a bag, slightly jostled him, and trod accidentally on his toes. ... became a vindictive ... a mingling of exclamations, half French, some in English, some from his mother Scotch ... extraordinary ...

... *doucement* ... the ... undertone of remonstrance ... know *mon* ... the devil of ... and I ... can ... *chérie*, ... de *man* ... recovered himself ... leg ... he continued, ... *swell* ... *mistake*. ... you see what a bow ... *chef de* ... *ma* ... with him, carrying a despatch-box, belong ... and ... *British* Embassy ... I've seen him *sometimes* getting luggage passed through the *douane* ...

The lady, having studied the new-comer, flashed a glance on ...

fancy to him darling?

getting jealous

coming to his hand

went on, to a val... to enter first, with luding the despatch-box, which

with his tongue, comes again.

Don't tell me," replied the lady, "what a man means by his looks. This man means one of two things, or very probably both—that he thinks, *chéri*, very little of you; or that he is thinking a great deal about something or somebody else.

Dieu!—but see, something has roused him now," the person who was the subject of all these observations, who partly justified the tenor of them by a look of distinction and breeding, together with an obvious inattention to the whole public about him, at this moment suddenly fixed his attention on a fresh arrival visible at some little distance. This was a man, round-faced and fair-bearded, not distinguished looking in the social sense of the word, indeed dressed in a way impossible in the world of fashion; but still bearing something

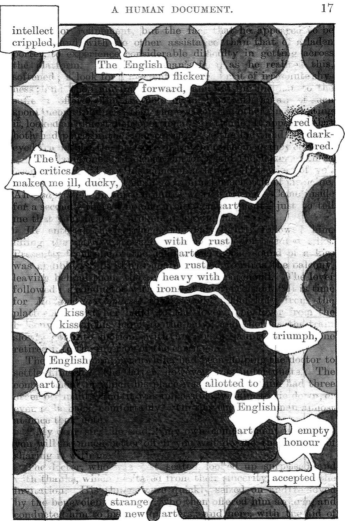

intellect
crippled,

The English flicker forward,

red dark red.

The critics make me ill, ducky,

with rust art rust heavy with iron

kiss kiss

triumph,

English art

allotted to

English

empty honour

accepted

strange

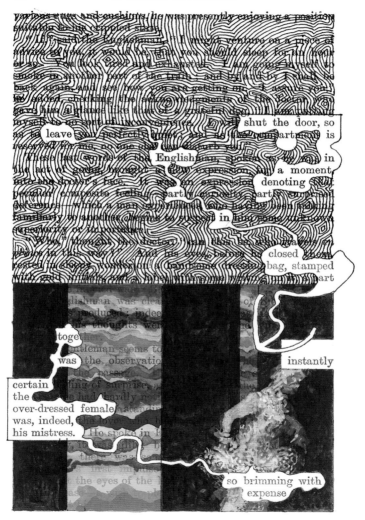

leave

shut the door, so

artment is

English

a moment
denoting

in

closed

bag, stamped

part

together

was

instantly

certain
the
over-dressed female
was, indeed,
his mistress.

so brimming with
expense

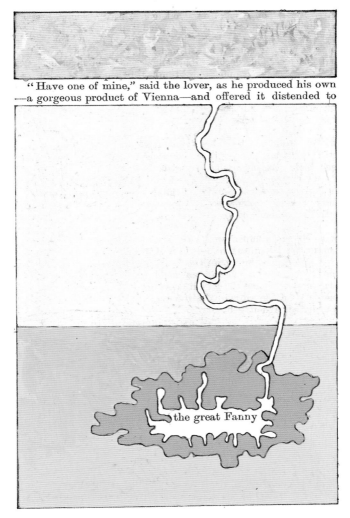

"Have one of mine," said the lover, as he produced his own
—a gorgeous product of Vienna—and offered it distended to

the great Fanny

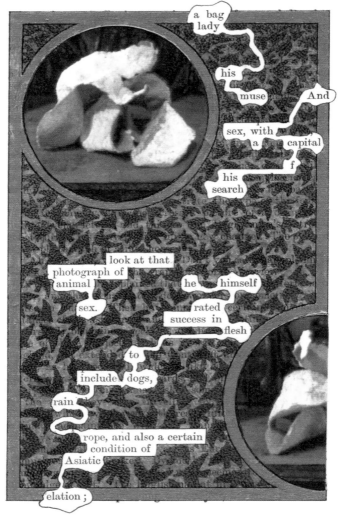

a bag
lady

his

muse And

sex, with
a capital
f

his
search

look at that
photograph of
animal he himself

sex. rated
success in
flesh

to

include dogs,

rain

rope, and also a certain
condition of
Asiatic

elation ;

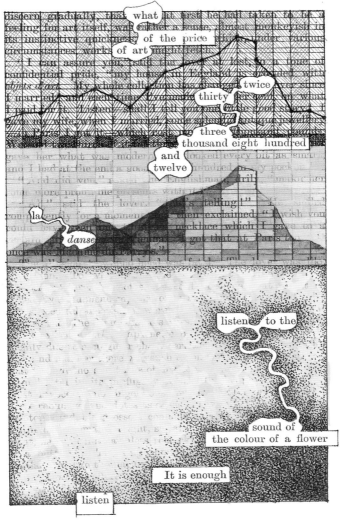

what
of the price
of art

twice
thirty
three
thousand eight hundred
and
twelve

danse

listen to the

sound of
the colour of a flower

It is enough

listen

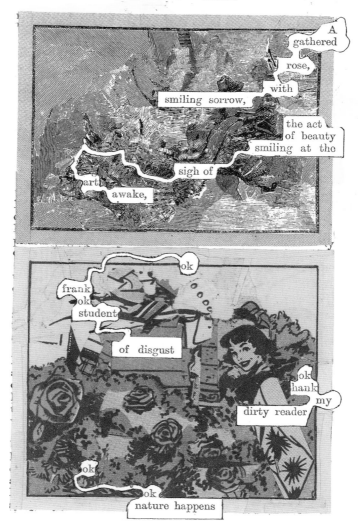

A gathered rose, with smiling sorrow, the act of beauty smiling at the sigh of art awake,

frank student of disgust

ok thank my dirty reader

ok nature happens

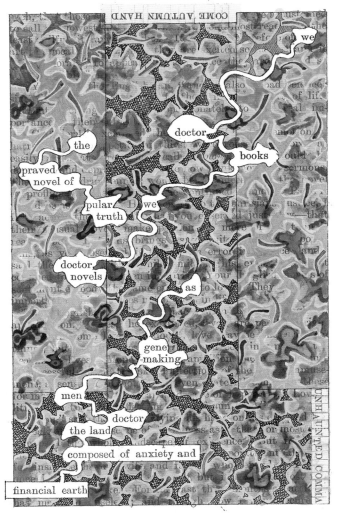

COME AUTUMN HAND

oh we

doctor

the books

praved
novel of
pular
truth

doctor
novels

as

gene
-making

men
doctor
the land
composed of anxiety and

financial earth

UNHAUNTED COMMA

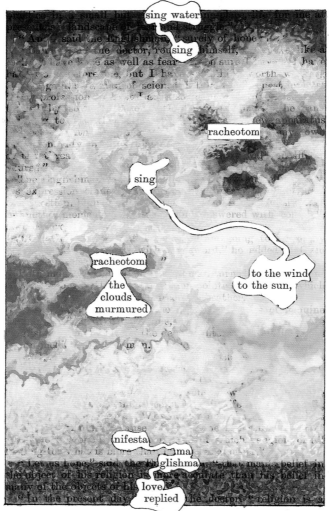

sing water

"A... said the Englishman,...surely of hope

...the doctor, rousing himself,

...have...e as well as fear...

racheotom

sing

racheotom
the
clouds
murmured

to the wind
to the sun,

nifesta

ma

"Let us hope," said the Englishman, "that man's belief in
the object of his religion is more accurate than his belief in
many of the objects of his love.

"In the present day," replied the doctor, "religion is

belief no longer. It is only the raw material out of which some new belief will be fashioned. I hope I do not offend you. Perhaps I am speaking to a Catholic?"

"You are not," said the Englishman, "though Catholicism is the only religion that is logical."

"Yes," said the doctor, "and my reading of life as a materialist is that our higher life can be lived only in defiance of logic. All forms of Christianity affect to explain too much. A belief which pretends to have no difficulties is a belief that solves none."

"And do you," said the Englishman, "as a materialist, consider a belief necessary? And what belief in the future do you think the world will accept?"

"That," the doctor answered, "the future alone can show. In the present state of knowledge, religion cannot express itself in any definite form which knowledge will allow us to tolerate. How will knowledge allow us to define God? Hardly as the echo of man's soul from the universe—a whisper which we impute to the stars. All the same I still maintain this—that man is only human because of his longing for what is more than human. There, sir, you have my creed."

"Yes," said the Englishman, "and I think you have mine, only we are apt under its influence sometimes to do this—that life has lost all its hopes, and death none of its terrors. However, we are not peculiar. I have talked with the leaders of science in my own country"—and he here mentioned names of European celebrity—"and though many of them were shy of making distinct admissions, at the back of their minds I believe that they felt as I did. You look surprised at my having any scientific acquaintances."

The doctor hesitated.

"The plain fact is," he replied, "if I may be excused for saying so, that you seem like a man of affairs, and like a man of fashion; and such men as a rule care little for men of science."

The Englishman's face for a moment betrayed a feeling shared by many others, and somewhat difficult to explain. It showed that this speech pleased him, as though it were a kind of compliment. But the feeling vanished, and his look was again thoughtful.

"Well," the doctor continued, "and if our religion be such

love, and the art of man's development,

growing love,

is, the expression of

does

modern marriage

change in change

English

convinced conservative"

" replied the doctor, live in a new way

require

the martyr's

art

loving, that hard

art

an invitation it was not possible to refuse.

martyr
art

The
champagne

art
which had
the Muses

of
show
feeling,
follow-
things
financial

the way

the
gravy

train

sorry to be a woman, said eve

CHAPTER II.

numb winter lust unable to come to candles. drew aside from white age, utter love So late in her lips

a generation
in love with

chancy
art

"Just look at

Julian

rise to fame."

said

the Muses at

the opening

Constant

self

morphosis.

turning

seventy, with
benevolence, and
wrinkles.

making

this
world is the
world ;

turning

age

face

age

seventy, with
benevolence, and
wrinkles.

turning

an

experience

ago

and

a

feeling

of vanity,

no
vain
rose
had more to say than
the

ago

little
party
graces
in the halls of
foreboding

the table,

everybody

correct,

accurate, persons put

together

correct

conversation ;

Grenville

soon relieved of

his

Lady Ashford

awful partner

deliver me from

you

to-night

Grenville looked at her with the shy air of a man who honestly hates being the hero of his own conversation, but Lady Ashford was at once so firm and so fascinating that she had soon extracted from him the information she asked for.

"Well," she said, when he had finished. "and so it all came to this. The world, when first you entered it, was enchanted for you by two necromancers, love and religion, who coloured it with colours, and filled it with objects of ambition, which gradually as years went on, dissolved or faded from your sight, till at last you woke up to what you now consider realities. Like most gentlemen nowadays, you happened not to be rich, and the first reality that came home to you was the want of some more money. Accordingly you began to dabble in what you describe as business, and you found your wits were far sharper than you expected. You did not, however, make your fortune in the first six weeks, and you were beginning to think that real life was a failure, when you suddenly stumbled into a high-road to success—a sort of success better than what you were looking for in the city, for it gives you a promise not of fortune only, but of fame. Now to a man ambitious like you—for you always were ambitious—this luck ought to be intoxicating. Still, it is success not as you used to dream of it. You dreamed of it with the feelings of a poet. You have found it as a practical man. I want you to

"When you you with great pleasure you succeeded in anything

Lady Ashford laughed. Grenville," she answered, "do you know that? Stuff! You have the opportunity other people know you have. You are though you have not yet satisfied them in your position, is success in its most heard our host saying, as he went in to dinner that he never had known so rapid a rise as were always figure of some interest in society of a sudden you are beginning to make a stir before you entered the drawing pretend you were unconscious of the Well," she said, sighing, "listen to this. I was told long ago by somebody who ought to have known, how nothing is so sweet to a man

found so little in it, but that you looked

so much
waiting for.

love

first love
the Golden

First love
The magic
love

giver of joy, but
the
love
you are waiting for
waiting for
comes
equal
comes
old

and remembers

young, so
young

Unfortunate

angel;

Sarah behind the tent-door. Do you remember
?

CHAPTER III.

The sound.

art

the

ear

praises,

holy eyes

sing

beautiful hands, glance up and wonder-

that
girl's eyes met his
and
her scarlet lips

had
his name
on

the only thing to be done
with a muse is love
our poem
of the pulses—
you like it, that
wild and soaring pulse
poke of love—surely
you,
night
, and the time will come

marry me

lovely young eyes in my life.

said Grenville

"I hope not," said Lady Ashton

toge

In another moment rapidly surrounded by men with stars,

But

only toge her may

circle

her sofa

The Princess with effusion held out a wrinkled hand to him. She expressed a vivacious pleasure at thus unexpectedly seeing him; she recalled the old times when he had stayed at her house in England; and complimented him on his prospects in a way that would have sounded fulsome in the strong foreign accent, which she had acquired in living abroad, had not sufficed to confer a peculiar privilege on her English. All the time, however, though he listened and responded cordially, he could not prevent a certain part of his consciousness being occupied with Miss Markham, and the fate of her two admirers. These last he had taken in at a glance. They were indeed attached to the Embassy, and he more or less knew both of them. They were well-bred young men, with the quietest manners imaginable; and if ordinary expensive dissipation means knowledge of life, they were probably right in flattering themselves that they were complete men of the world: but the girl's manner to them—a manner even quieter than their own—reduced each of them—Grenville could plainly see this—one after the other, in his own estimation, to a boy. Their first observation had been made with a smiling confidence. She had smiled also, and replied with complete civility; but joined to that civility was a yet more complete indifference, which seemed to produce, as it were, some chemical change in their characters. They blushed; they repeated their words; their laughs became doubtful and apologetic; and they presently found that nothing was left for them but to retreat, with an air that betrayed discomfiture, even if it aimed heroically at indifference.

"Listen," the Princess was by this time saying to Grenville, "the thing is quite simple; I will tell you all the particulars."

Whatever the particulars were, they threatened to be long in telling; and Grenville, who had been standing hitherto, unconsciously scanned the sofa, to see whether there was room for him to seat himself. Miss Markham, with extraordinary quickness, caught the meaning of his look, and, raising her eyes to his with a half unflinching softness, moved so as to make a place for him between the Princess and herself.

"Thank you," he said as he sat down. "I hope I am not crushing your dress."

"No," she replied, with a smile on her lips, which were half parted, "but I think you have done one thing. Do you know what it is? You have hurt a feather of my fan." ... the injury thus complained of, with

she folded her
attention to the carpet

impossible
music

the piano

velvety, like
love
Her voice

Her
voice

listened

with admiration.

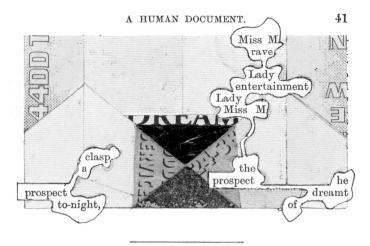

Miss M
rave
Lady
entertainment
Lady
Miss M

DREAM

clasp
a

the
prospect

he
dreamt

prospect
to-night,

of

CHAPTER IV.

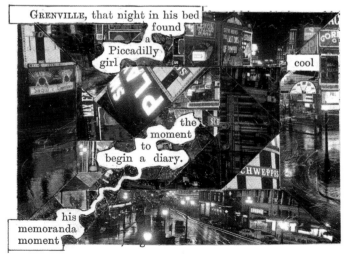

GRENVILLE, that night in his bed
found
a
Piccadilly
girl

cool

the
moment
to
begin a diary.

his
memoranda
moment

"The day after to-morrow, I am going to do something interesting,

for the first time

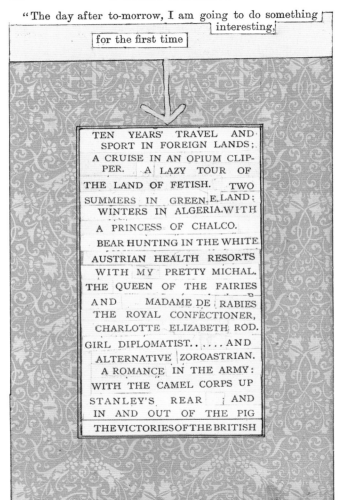

TEN YEARS' TRAVEL AND
SPORT IN FOREIGN LANDS;
A CRUISE IN AN OPIUM CLIP-
PER. A LAZY TOUR OF
THE LAND OF FETISH. TWO
SUMMERS IN GREEN.E.LAND;
WINTERS IN ALGERIA.WITH
A PRINCESS OF CHALCO.
BEAR HUNTING IN THE WHITE
AUSTRIAN HEALTH RESORTS
WITH MY PRETTY MICHAL.
THE QUEEN OF THE FAIRIES
AND MADAME DE RABIES
THE ROYAL CONFECTIONER,
CHARLOTTE ELIZABETH ROD.
GIRL DIPLOMATIST......AND
ALTERNATIVE ZOROASTRIAN.
A ROMANCE IN THE ARMY:
WITH THE CAMEL CORPS UP
STANLEY'S REAR ; AND
IN AND OUT OF THE PIG
THE VICTORIES OF THE BRITISH

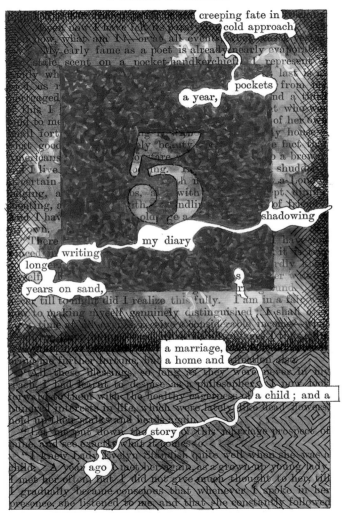

creeping fate in cold approach

pockets

a year,

shadowing

my diary

writing

longer

years on sand,

a marriage, a home and

a child ; and a

story

ago

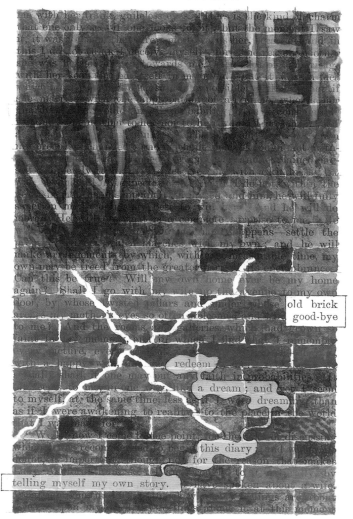

old brick
good-bye

redeem

telling myself my own story.

this diary

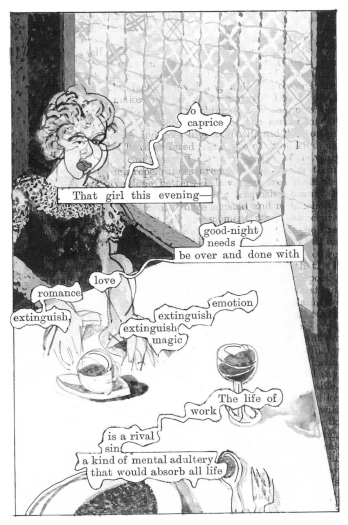

caprice

That girl this evening—

good-night
needs
be over and done with

love
romance
extinguish,
emotion
extinguish
extinguish
magic

The life of
work

is a rival
sin
a kind of mental adultery
that would absorb all life

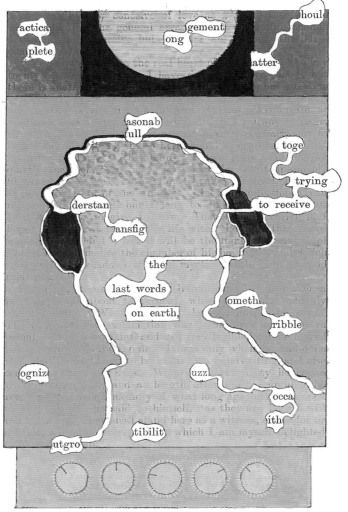

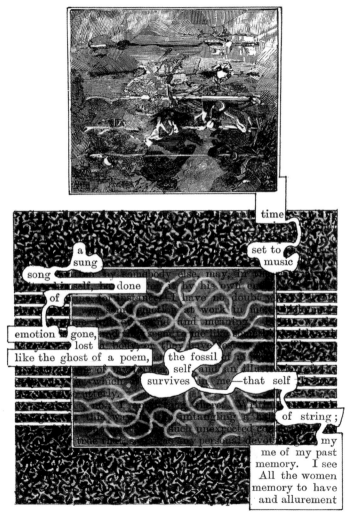

time

set to
music

a
sung
song

done

of

emotion gone,
lost

like the ghost of a poem,

the fossil
self, and an illusory
survives in me—that self

of string;

my
me of my past
memory. I see
All the women
memory to have
and allurement

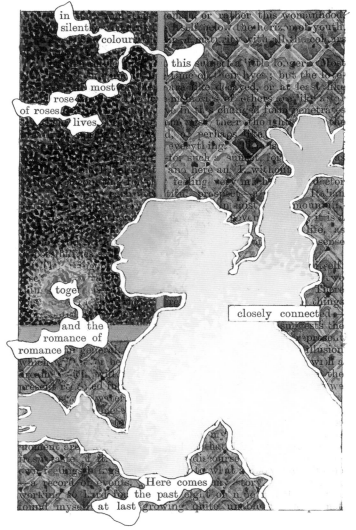

in
silent
colour

this

most
rose
of roses
lives,

toge
and the
romance of
romance in general

closely connected,

Here comes
a record of events.

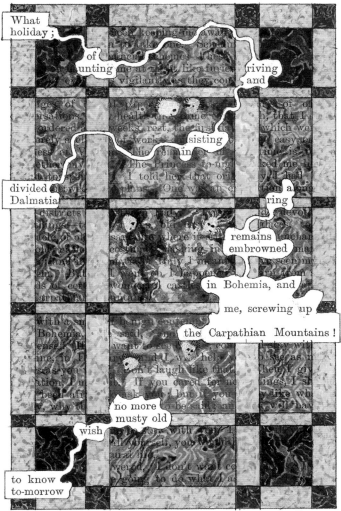

What holiday;

of

unting me at night, like furies riving

vigilant as they could and

divided
Dalmatia

ring

remains embrowned

in Bohemia, and

me, screwing up

the Carpathian Mountains!

no more musty old

wish

to know to-morrow

E

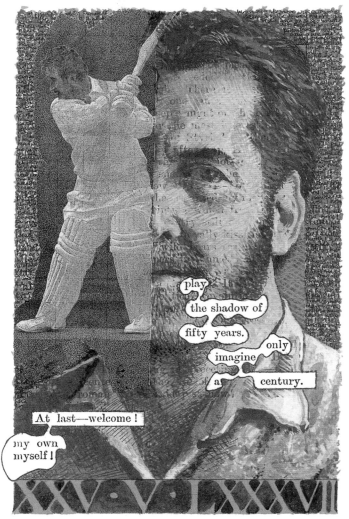

CHAPTER V.

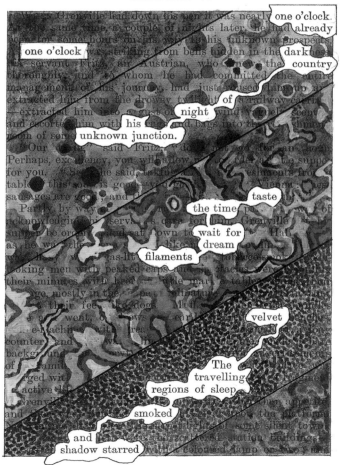

all around were hills covered with pine-forests, which showed
in the dim moonlight their serrated outlines against the sky.
Grenville was ignorant of the name, and even of the locality,
of the station. All the country round was steeped in the
charm of mystery. By and by some figures issued from the
refreshment-room, crossing the rails to another platform
beyond, and before long, with a rumbling moan out of the
silence, came a lighted passenger train, sliding, and hissing,
and arresting itself. A few moments more, and it had
passed away like a somnambulist. Grenville looked at his
watch, and his servant at the same ear said—

"Our train starts in four and a half-five minutes. Here,
excellency, is the station-master. He will see to your compartment,
if he can forward, and show him. He thrusts it toward to
the last frame of Room."

Grenville turned round, and acknowledged the profound
bow of the station-master, with keen eyes, and white
whiskers, covered with a broad gold-laced cap. The master passed the
night which was, and pointed toward a lean and reserved
close to the ground of the lighted window
shining of damage and the word "Trieste" on
the panel, and began to talk rapidly. The station-master
bowed his way with much ceremony after a little
talk with the guard, he bowed Grenville into a reserved
compartment, saying, as he did so, "His
excellency caught it—Your excellency will arrive
there at half-past four in the morning."

"Certainly," said Grenville, smiling to himself, as he
stretched himself out on the cushions. "I am an exception
to the rule that no man is a hero to his valet. Fritz imagines
me a minister of state already; and, what is even more to the
purpose, he communicates his own conception of me to
others."

The truth of this reflection was experienced even at G——,
when, in the hot, ill-ventilated, chill obscurity of the station a commissionaire
from the Kochstrasse had been joined by the guard the moment
these persons appeared at the door of the compartment,
and assisted his excellency to descend. In these days every-
one pays for some value; the bow of the departing guard
had to be also in burden paid sufficiently; and Grenville
before long, in a heavy rattling omnibus, was being shaken
to pieces over the paving-stones of a dim angular street.

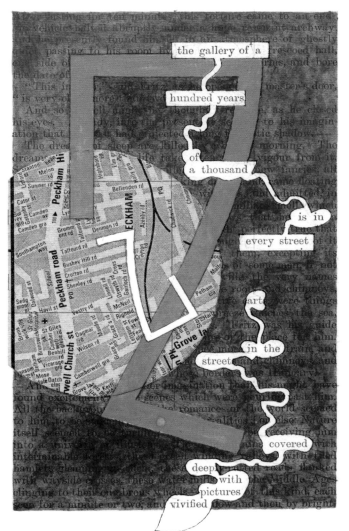

the gallery of a

hundred years

a thousand

is in

every street

in the
streets

covered

deeply
with

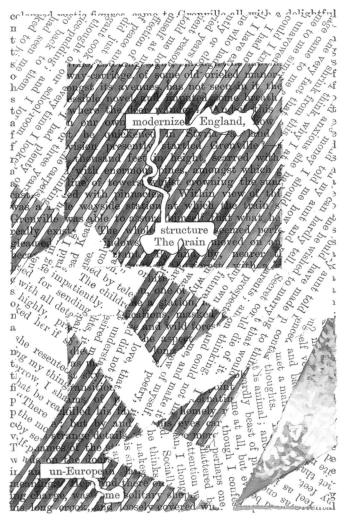

modernized England, how

structure

The train

un-European

fashion... above... the... of villages islanded in sprouting orchards... the towers of the churches showed themselves with bulging Oriental domes... Grenville now knew where he was. Everything spoke of Hungary.

So the hours wore on, the prospect hardly changing itself, till at last the traveller, thrusting his head out of the window, descried... a new distinguishing feature—an enormous poplar avenue straight ahead, joining the whole landscape and disappearing on each horizon. Watching this with a vague feeling of curiosity, he saw the trees grow more

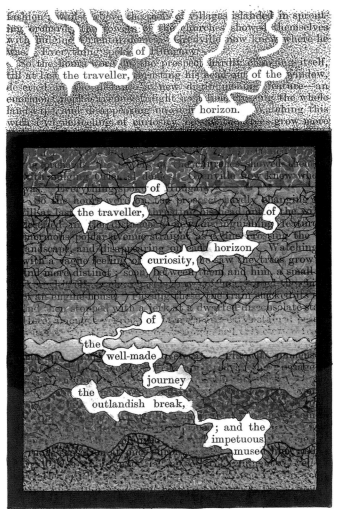

of
the traveller, of
horizon
curiosity,
of
the
well-made
journey
the
outlandish break,
; and the
impetuous
muse

archway; they crossed a well-like court surrounded by walls
and windows, and drew up under a second archway beyond.
Here on a step was standing a majestic porter, with gold lace
on his coat and a gold-headed sceptre in his hand. Through
the door behind him was visible a great ascending stair use
on which were stationed several liveried servants, a wizened
little dwarf, who might have been either sixteen or sixty, a
steward who would have done honour to any German melo-
drama, as he smiled and blinked a respectful benediction on
the scene. Grenville feared for a moment that they would
all of them be kissing his hand—an act which, though he
approved of it in theory, would, he felt, be embarrassing in
practice. As a matter of fact, however, they merely muttered
something and bowed, and somehow or other between them
conducted him up the staircase. This was not unlike the
staircase of a palace at Genoa. There was the same spacious-
ness, the same fine proportions, though the stair and balus-
trades were of coarse stone, not marble, and the walls were
rudely whitewashed. But a life-size portrait of Maria Theresa
was on one side, a cardinal simpered superb benevolence on
the landing

massacre in the Egmont, Grenville found at this point
that the dwarf alone was conducting him. He was ushered
through two bare ante-rooms whose walls were foggy with
pictures. A further door was opened. In he had a voice and
he recognized and the princess, in of smiling way greeting
him in good sized drawing-room. Here everything had an
oddly familiar look—tables, carpets, and sofas. It all
gazed on glass only an England most robbed of its comfort.
There was English comfort, however, in the night, the eat-
table really for him; and in and the Princess were so
happily seated with nothing between them but service of ble
Vienna china.

"You must be frightened," she said, at finding me
alone. Some time next week there will be a few people
coming about you, perhaps, who was once ambassador in
London, and a little niece of mine with two finger o old
child o. To-night, too, at dinner, I have company for you in
the shape of the priest. He talks thin but Imperial so
I must be the interpreter. I door than this will make me
conversation further than usual. I have taught you at one

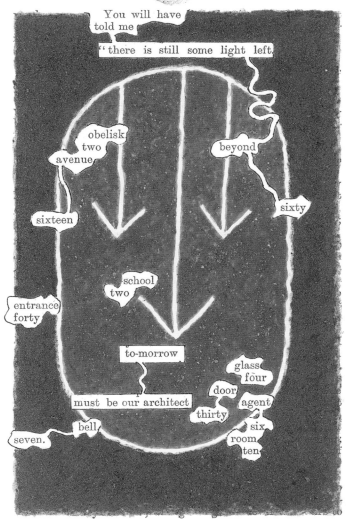

You will have
told me

"there is still some light left.

obelisk
two
avenue

beyond

sixteen

sixty

school
two

entrance
forty

to-morrow

glass
four

door

agent

must be our architect

thirty

seven.

bell

six

room
ten

at last in a bed
the curves of the
congruous
joined
Princess and
priest
bilingual
let us come
across
large
ruinous
sprouting

Compared with

red
luxuries

London, all
shadowland ; and the numb
who shuffled round

work
ville
helpless

between the

cheeks he emitted

unciation

unciation the

gradually

eased

delighted.

the most magnificent object in the universe; and he evidently
felt a kind of personal pride in accounting to a stranger a

expectations

the next

expectations.
under the vaulted roof

giant
fashion
in the centre
of
the

huge

forcing-house
newest art

each morning

a bright world unfolded its secrets

pictures

museum hidden in the story

of

a whisper

in the papers

of silence,

in the branch a mist of milky lamp-light and out of the thickets beyond would thrill the first notes of the nightingale.

But at last came a day of rain, and then Grenville betook himself to a region which as yet he had quite neglected the library. The bulk of the books were French—books of the last century, and many of them were extremely curious. There were quaint guides to old-world water; treatises on old-world household economy, and others, without number, on building, containing plans and pictures of mansions in the Faubourg St. Germain, and of chateaux in the days of their glory. In addition to these he found a collection of tall folios, which were full of superb engravings, illustrating in the most minute way, the life of Paris and Vienna from the street to the royal bedroom.

These the Princess had never seen before, and her pleasure knew no bounds. She and Grenville, before they went to bed, would spend an hour in turning the pages over like children. By...

...before the...

...pages...

...fronting...

...of the last discovered volume tattered and dirty...

chance opened...

...ravings...

...up...

...ceased...

his imagination

to the work of a life hidden behind

walls

ketry, and

cullis

were

The

sent for

agent
carefully

and

knew nothing;

a
dozen
identified,

he knew to be

engaged

of which

four

sped away into the level limitless land

and

camped in clearings,
on the borders of the shadow

Western Europe

had changed

walls looked down on it,
towers and guard-rooms,

the shadow; and Grenville had found, in its wilderness of half-roofless masonry, not only the bric-à-brac of which the Princess had spoken, but a great banqueting-hall high over a lofty chapel; and in it its old oak table, surrounded by carved chairs, sideboards adorned with trays of dim oriental lacquer and breast-plates and rusty helmets looking down on it all.

"I should hardly have been surprised," he said that evening to the Princess, "if Frederick Barbarossa or King Arthur had been sitting at that table with their followers."

"Well," said the Princess, "I am glad you have enjoyed yourself; and now I have got a piece of good news with which to welcome you. The agent has been with me to-day, and has arranged two more expeditions for you—to castles as large as this one, and, he says, not ruined at all. To see them, however, you must sleep for a couple of nights at a little town about thirty miles away. So as one or two people are coming here almost directly, you had better, perhaps, calm your impatience, and wait until they are gone. Remember," she added, "there are my little grand-nieces and their mother. For my sake you must stay and admire these. And then, as I told you before, there will also be Count C——. He knows Hungary thoroughly, and he was for some years at Constantinople: so for every reason you ought to be here to meet him."

"Nothing," said Grenville, "could please me or suit me better. A parcel of letters, I find, has come to me from Vienna. They will want a good deal of answering, and I shall be glad of a few days' quiet."

CHAPTER VII.

Grenville's letters were indeed a formidable budget; and when, during the next few days, he set himself to consider and answer them, he found himself troubled by misgivings which he certainly had not anticipated. Most of the letters dealt with official business, or political matters connected with it; and, regard being had to the character of the minister who wrote them, the tone of them all, even more than the

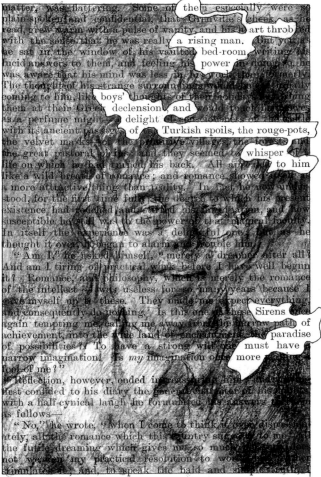

matter, was flattering. Some of them especially were so
plain-spoken and confidential, that Granville's cheek, as he
read, grew warm with a pulse of vanity and his heart throbbed
with the sense that he was really a rising man. But yet, as
he sat in the window of his vaulted bed-room, writing his
lucid answers to them, and feeling his power in doing so, he
was aware that his mind was less in his work than formerly.
The thoughts of his strange surroundings would keep continually
coming to him, like boys' thoughts of their holidays, distracting
them at their Greek declensions, and would teach his senses,
as a perfume might, delight themselves with the spoils
with its ancient passion of the Turkish spoils, the rouge-pots,
the velvet masks, of the primitive villages, the forests, and
the great pastoral plains, and they seemed to whisper of the
life on which he had turned his back. All appealed to him
like a wild breath of romance; and romance showed itself as
a more attractive thing than reality. In fact, he now under-
stood, for the first time fully, the degree to which his present
existence had troubled and altered his imagination, and how
susceptible he still was to the power of that magical faculty.
In itself, the experience was a delightful one, and, as he
thought it over, it began to alarm and trouble him.

"Am I," he asked himself, "merely a dreamer after all?
And am I tiring of practical work before I have well begun
it? Romance, and philosophy, which is merely the romance
of the intellect—was useless for so many years because I
gave myself up to these. They made me expect everything,
and consequently do nothing. Is this one of these Sirens once
again tempting me, calling me away from the narrow path of
achievement, into the wide land of enchantment, of paradise
of possibilities? To have a strong will one must have a
narrow imagination. Is *my* imagination often more than a
fool of me?"

Reflection, however, ended in coss, and having
first confided to his diary the general character of his letters,
with a half-cynical laugh he formulated his answers to himself
as follows—

"No," he wrote, "when I come to think it over dispassion-
ately, all the romance which this country suggests to me, all
the futile dreaming which gives me so much pleasure, does
not weaken my practical resolution to work, it actually
stimulates it; and, to speak the bald and simple truth, I

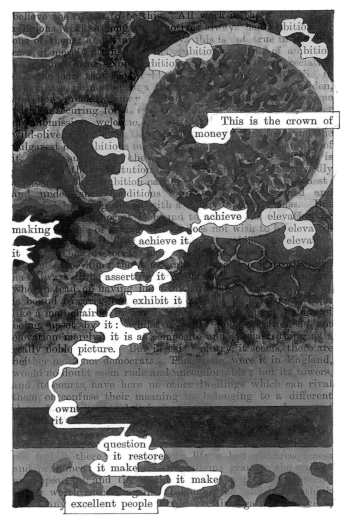

This is the crown of money

achieve

achieve it

assert it

exhibit it

picture.

own it

question it restore it make it make

excellent people

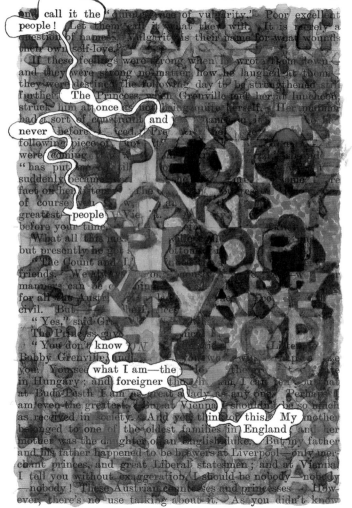

one call it the "quintessence of vulgarity." Poor excellent people! Let them call it what they will. It is merely a question of names. Vulgarity is their name for what wounds their own self-love.

If these feelings were strong when he wrote them down—and they were strong, no matter how he laughed at them—they were destined the following day to be strengthened still further. The Princess, when Grenville met her at luncheon, struck him at once as not being quite herself. Her manner had a sort of constraint and ... manner, which he had never before noticed. Presently she made the following piece of ... "... were coming ... "has put as ... of ... suddenly became ... face on her story. The ... of course ... greatest people in Vienna ... before your time.

What all this means ... but presently he got ... bottom of it.

"The Count and I ... friends. We ... manners can be ... for all his Austrian ... civil. But ... their ...

"Yes," said Grenville ...

The Princess gave ...

"You don't know ... Bobby Grenville ... you. You see ... what I am—the ... in Hungary; and foreigner though I am, I can tell you that at Buda-Pesth I am as great a lady as any one. Perhaps I am even the greatest. But at Vienna I shouldn't be so much as received in society. And yet think of this! My mother belonged to one of the oldest families in England, and her mother was the daughter of an English duke. But my father and his father happened to be brewers at Liverpool—only mer-chant princes, and great Liberal statesmen; and at Vienna I tell you without exaggeration, I should be nobody—nobody—nobody! These Austrian countesses and princesses—. How-ever, there's no use talking about it. As you didn't know

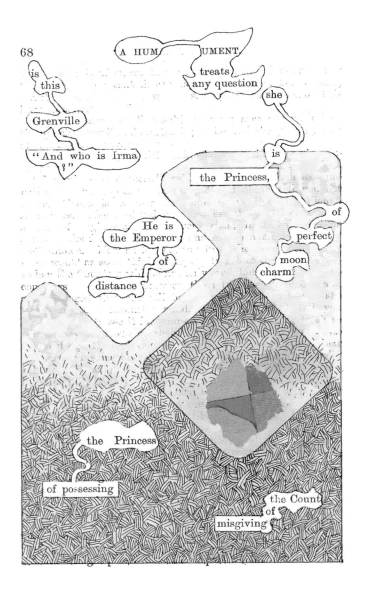

This remarkable lady and her husband arrived about five o'clock. Entering the drawing-room Grenville found them at tea; and after all he had heard, he watched them with some interest. The Count, a handsome man, who looked about sixty-five, with his frank expression and carefully-trimmed beard, had all the air and manner of a high-bred fashionable Englishman. The Countess was a slim woman, who had many remains of beauty, and evidently a Parisian maid; and she was prattling to the Princess with all the lightness of a girl, in a quick alternation of German, French, and English. The Count, when Grenville was introduced, greeted him with the greatest cordiality. For that indeed he was prepared; but the greeting of the Countess was a surprise to him. She turned towards him with a bright twinkle of welcome, which seemed to gleam on him from her eyes, her lips, and her bracelets.

"Mr. Grenville," she said, in the prettiest foreign accent, "I didn't know we were going to find you here. We were so sorry, the Count and I, not to have met you at Vienna. Dear Princess, let Mr. Grenville sit by me. Perhaps you'll allow him just to move the tea-table."

Grenville experienced two conflicting emotions. He would hardly have been human if he had not felt somewhat flattered at being distinguished thus by a lady whom he had been told was proud and so *difficile*. But another emotion, which he was far more keenly conscious of, was annoyance for the sake of the Princess, who he felt, in spite of her kindness, would be mortified for several reasons at this falsification of her prophecies. He honestly wished that the Countess would been rude to him ... her friendly advances ... towards the Princess, for ... asking her to remark his conquest ... Countess suddenly said to him ... they are, those ... I think ... in modesty, wandered away ... by accident full on those of the Princess. He was puzzled by seeing in these no signs of annoyance, but a knowing smile which said to him, "Isn't it as I told you?" What she could mean by this he was quite unable to conjecture; but the moment the Count and Countess were taken to see their

We have been there; we have seen

bourgeois
pictures.

We saw
rooms—galleries—full
we know all about you;

So

quettish

laughing
gnomis

qually

and

and
noy

rudged

"My dear Prince

Pooh!" retorted the Princess, laughing, as fine ladies

nuine

uffer

ympa

noy
rievan

rievan

remote princely castle, and the stately and old-world life
which he liked to think survived in it, he was glad his
pleasant illusions, as a noise might disturb a dream.

In this mood of mind the society of the Count and
Countess gave him a pleasure, for a pleasure which he could not
help feeling, but for which he reproached himself, as if it
savoured of treachery. They, in every way, suited the castle
absolutely. What the castle was to the country, they were
to life. The position which they instinctively assigned to
themselves suggested no invidious comparison with mere
ordinary mortals; it seemed based on the assumption that
there could be no comparison at all. And the result was, to
Grenville, charming. There was a soothing calm about them,
especially about their social judgments, which said that for
them a social grievance could be impossible; and further,
they showed not only grace, taste, but the kindness that
comes to people for whom acrimony could never be a necessity.
In the Count, too, he noted something, a certain discrimination,
even with regard to the Prince's niece—a mere bourgeoise—
the wife of a financier.

"Well, she has been well said," he said; "a pretty refined
woman."

"Yes," said the Countess, "very. Her mother, I think,
was noble."

"You would quite get the impression," the Count continued
to Grenville, "that she has made a mésalliance in marrying this
Schilizzi—a Levantine, and very rich. In Vienna, where he
must have made a great deal of money, the Princess told me he
had a grand villa; and he is to be perhaps by this time in
London, he's a millionaire or something further."

In these last words there was a softness that spoke volumes.
Shortly afterwards the Countess, with a pleasant smile,
happened to say of the Princess, "She is always so nice, so good
she is."

These words spoke their volumes also. Grenville now
detected the state of instinctive feeling, and was certainly
glad that he was not himself its victim. The sense that he
was not, the sense that these two humorous aristocrats,
which patronizing others, saw in himself an equal, had not
only saved him from any painful mortification, but was now
giving him, in his own eyes, a certain increased importance,
the very nature of which he would hardly have understood at

home, thought
ridiculous. ridiculous

here was a woman

a

vision

beyond the pale of
shy
ideas

sonry
blic adula
derstan
ked

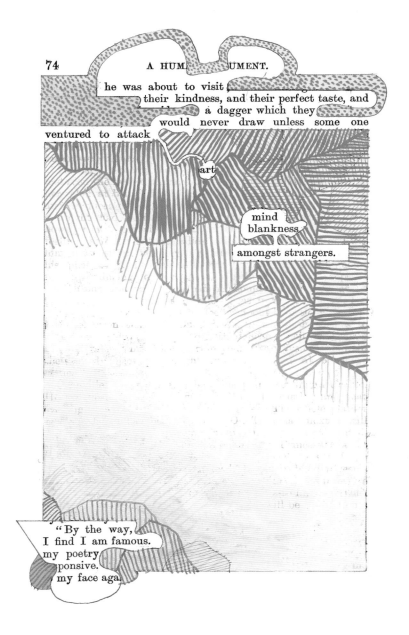

he was about to visit

their kindness, and their perfect taste, and

a dagger which they

would never draw unless some one

ventured to attack

art

mind
blankness

amongst strangers.

"By the way,
I find I am famous.

my poetry

ponsive.

my face aga

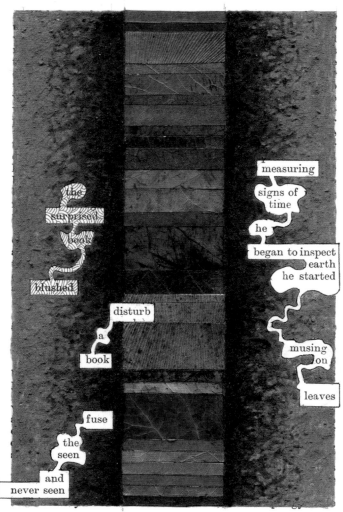

measuring

signs of
time

he

began to inspect
earth
he started

the
surprised
book

blushed

musing
on

disturb

a

book

leaves

fuse

the
seen

and
never seen

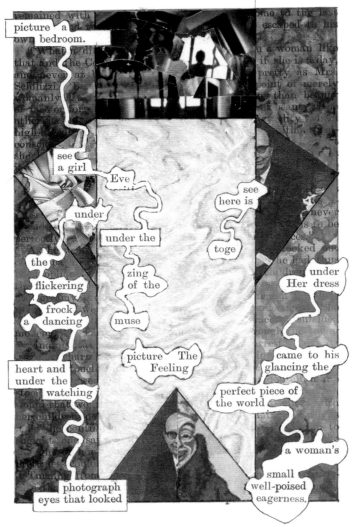

picture a
own bedroom.

see
a girl

Eve

see
here is

under

toge

under the

zing
of the

under
Her dress

the

flickering

frock

muse

dancing

a

heart and
under the

watching

picture The
Feeling

came to his
glancing the

perfect piece of
the world

a woman's

photograph
eyes that looked

small
well-poised
eagerness.

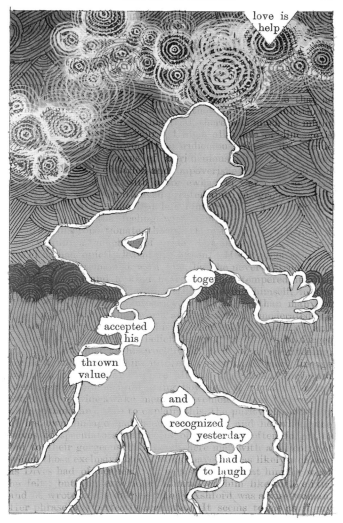

love is
help

toge

accepted
his

thrown
value,

and

recognized
yesterday

had
to laugh

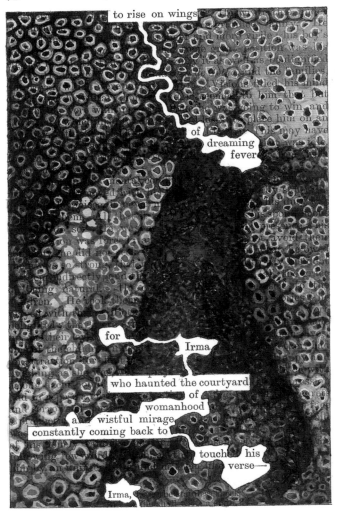

to rise on wings

of dreaming
fever

for

Irma

who haunted the courtyard
of
womanhood
a wistful mirage,
constantly coming back to

touch his
verse—

Irma,

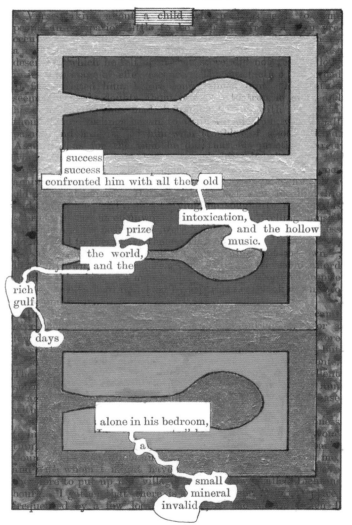

a child

success
success
confronted him with all the old

intoxication,
and the hollow
music.

prize

the world,
and the

rich
gulf

days

alone in his bedroom,

a

small
mineral
invalid

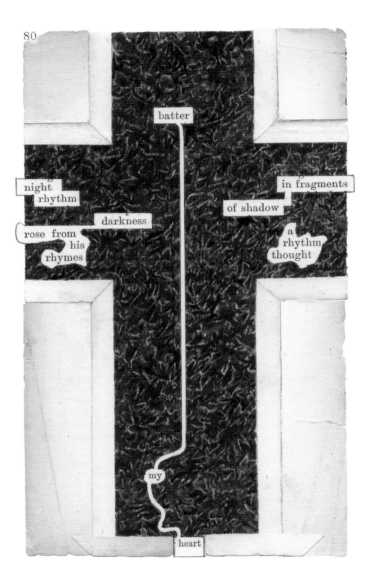

CHAPTER VIII.

Though Grenville's imaginative mood had by no means next day deserted him, it had lost for the time, at all events, all of sadness. So far as the railway was concerned, is not formidable. The station at which he was ut forty miles away; and the train being an ss, took but three hours in reaching it. The as hot as an English midsummer. Flowers s like sparks dropped from a rocket, and there

G

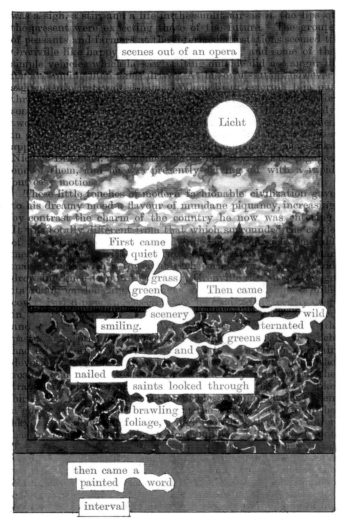

scenes out of an opera

Licht

First came quiet grass green scenery smiling. Then came wild alternated greens and nailed saints looked through brawling foliage,

then came a painted word interval

future
began

the night,

of
long white
words

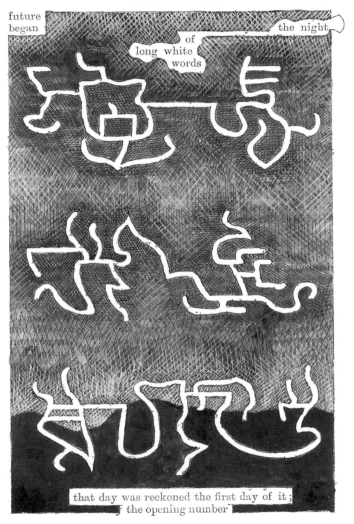

that day was reckoned the first day of it ;
the opening number

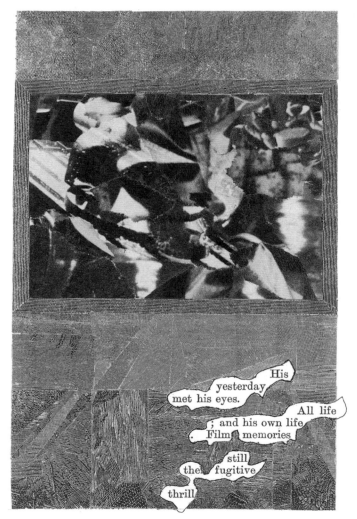

His
yesterday
met his eyes.
All life
; and his own life
Film memories
still
the fugitive
thrill

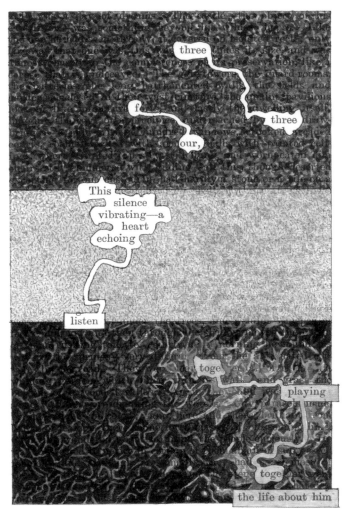

three

three

f

our,

This
silence
vibrating—a
heart
echoing

listen

toge

playing

toge

the life about him

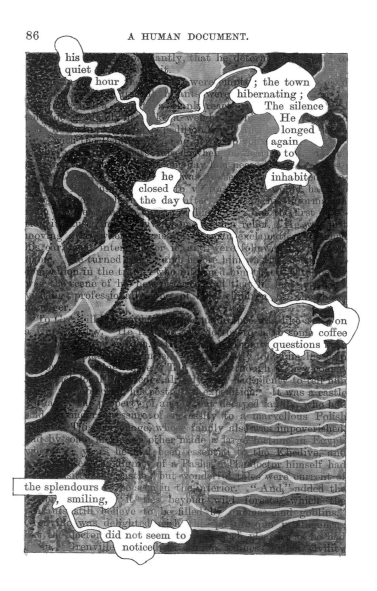

his
quiet
hour

were empty ; the town
hibernating ;
The silence
He
longed
again
to

he
closed
the day

inhabit

on
coffee
questions

the splendours
smiling,

did not seem to
notice

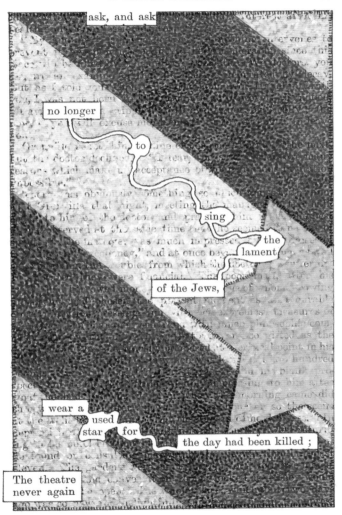

ask, and ask

no longer

to

sing

the lament

of the Jews,

wear a

used star for

the day had been killed ;

The theatre never again

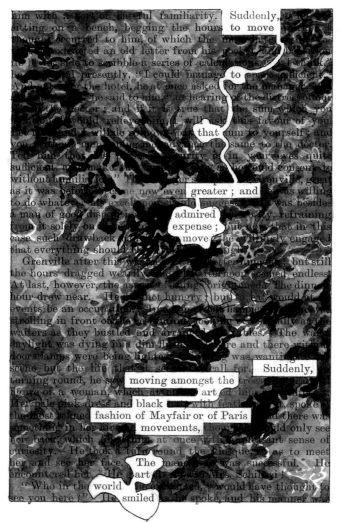

him with a sort of lateral familiarity. Suddenly,
sitting on a bench, begging the hours to move
thought occurred to him, of which the
extracted an old letter from his pocket
side to scribble a series of calculations
presently, "I could manage to spare sufficient
the hotel, he at once asked for the manager
he said to him, at hearing of the distress of
doctor; and if it is true that the sum which you
would relieve him, I will ask this favour of you
and I will do so now, that sum to yourself; and
such thing in advance the same to the doctor.
Tell him the security is in your eyes quite
sufficient, and make he could consent to
without humiliation." The greater Grenville, great
as it was before, became now even greater; and was willing
to do whatever he excellent suggested. He was besides
a man of good disposition body, refraining
from it solely on but now that in this
case such drawback move he willingly engaged
that everything should

Grenville after this but still
the hours dragged wearily the afternoon seemed endless
At last, however, the aspect things brightened. The dinner
hour drew near. He not hungry; but would at
events be an occupation. He
strolling in front of the occasionally at the
waiters as they bustled and arranged the tables. The
daylight was dying in a dim flush here and there
doors lamps were being lighted was wanting
scene but the life that to call for. Suddenly,
turning round, he saw moving amongst the trees
figure of a woman, which art
Her pale pink dress and black with feathers spoke
the most refined fashion of Mayfair or of Paris there was
something in her air and movements, could only see
her back, which at once with pleasant sense of
curiosity. He took a turn round the kiosque, as to meet
her and see her face. The manoeuvre was successful. He
encountered her. He start was Mrs. Schilizi
"Who in the world would have thought to
see you here?" He smiled as he spoke, and his manner was

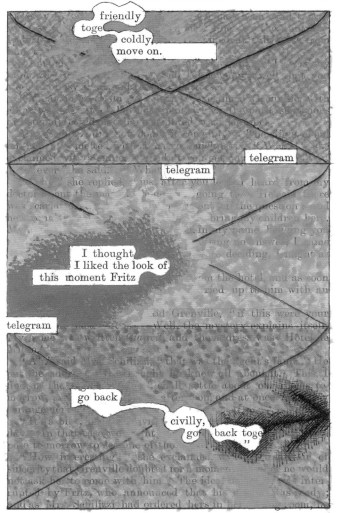

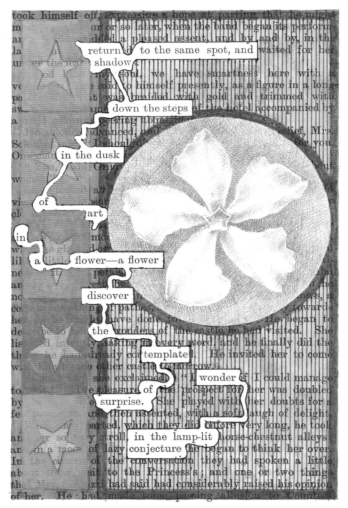

return to the same spot, and waited for her

shadow

down the steps

in the dusk

of

a flower—a flower

discover

template

I wonder if I could manage

surprise.

in the lamp-lit

conjecture

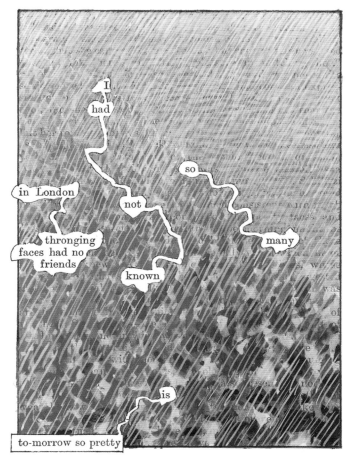

CHAPTER IX.

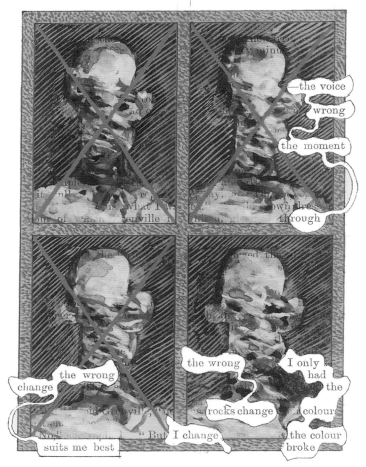

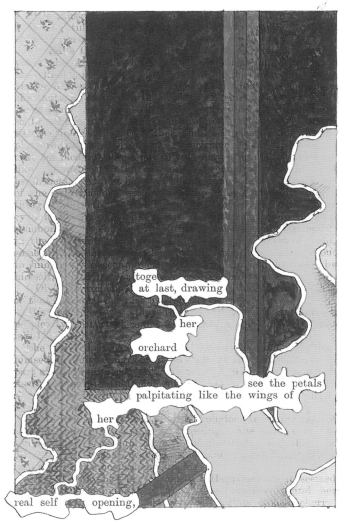

toge
at last, drawing

her

orchard

see the petals
palpitating like the wings of

her

real self opening,

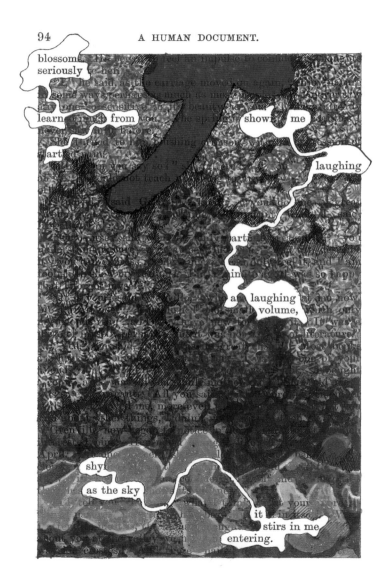

blossoms

seriously

learn much from you

show me

laughing

art

laughing
volume,

shy

as the sky

it
stirs in me
entering.

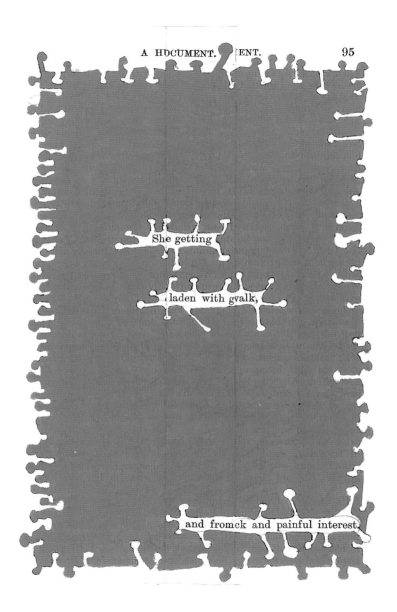

She getting

laden with gvalk,

and fromck and painful interest.

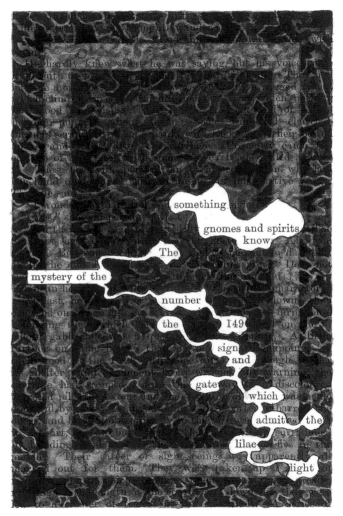

something

gnomes and spirits know

The

mystery of the

number

the 149

sign and

gate which

admitted the

lilac

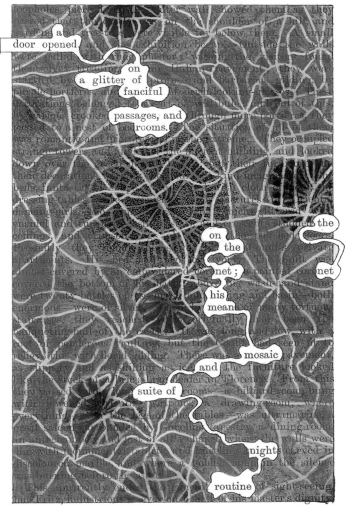

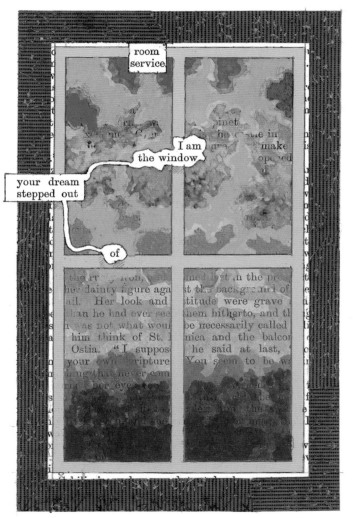

taste its present owner

time,

mind

century

open a new door in

my old four walls

M

M

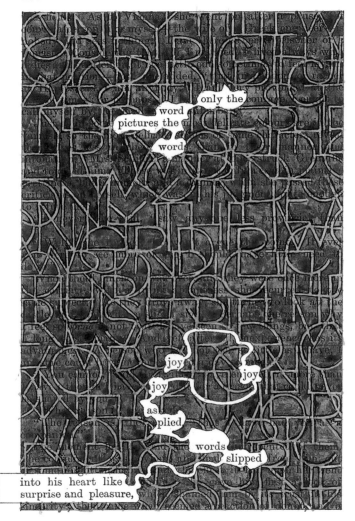

only the
word
pictures the
word

joy
joy
joy

ask
plied

words
slipped

into his heart like
surprise and pleasure,

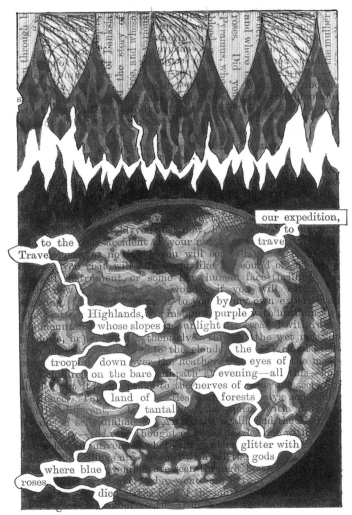

our expedition, to

to the trave
Travel

Highlands, for instance purple with autumn
whose slopes in sunlight

troop down over the heather eyes of the
and children on the bare path at evening—all
nerves of secret
land of forests
tantalizes

glitter with
all the gods
where blue
roses
die

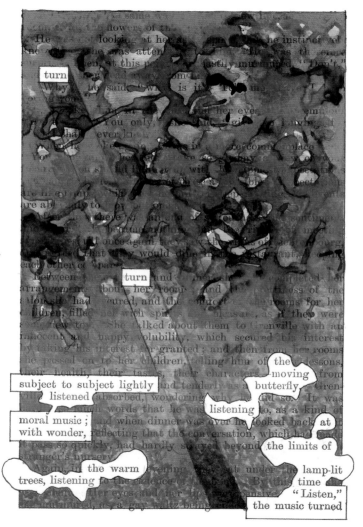

turn

Why he said "w... is it... for me

turn

subject to subject lightly ... and tenderly as a butterfly. Gren-

listened absorbed, wondering why he did so. It was

moral music; ... and when dinner was over he looked back at

with wonder, reflecting that the conversation, which had

the limits of

listening to

the warm ... under the lamp-lit

trees, listening ... the ... time

"Listen,"
the music turned

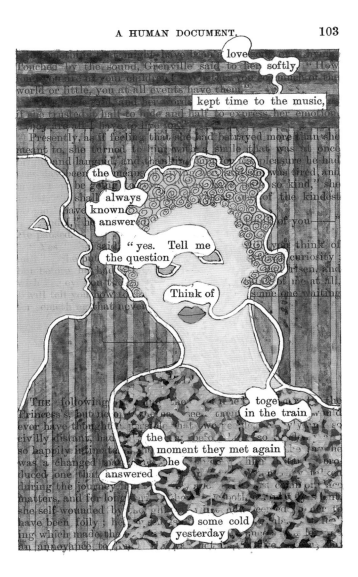

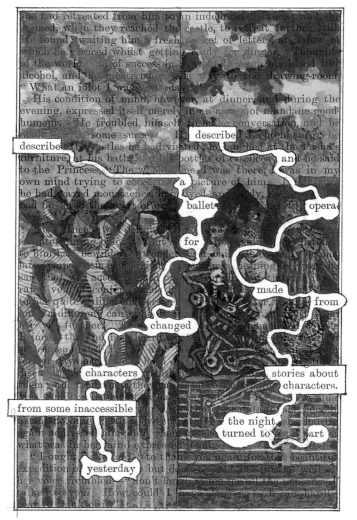

he had retreated from him to an indefinite distance; and she
seemed, when they reached the castle, to retreat further still.
He found waiting him a fresh packet of letters, at a few of
which he glanced whilst getting ready for dinner. Thoughts
of the world and of success in a word, through his blood like
alcohol, and he muttered to himself on his way to the drawing-room.
"What an idiot I was yesterday!"

His condition of mind, however, at dinner, and during the
evening, expressed itself merely in an access of mundane good-
humour. He troubled himself to make conversation, and he
described Lichtenbourg; he
described the castles he had visited; he laughed at the Pasha's
furniture, at his bath, and his bottles of essences; and he said
to the Princess, "The whole time I was there, I was in my
own mind trying to construct a picture of him. I gave him
waxed moustaches, and dyed and curly
had fancied the rest of every ballet and opera

for made from

changed

characters stories about
 characters.

from some inaccessible

the night
turned to part

yesterday

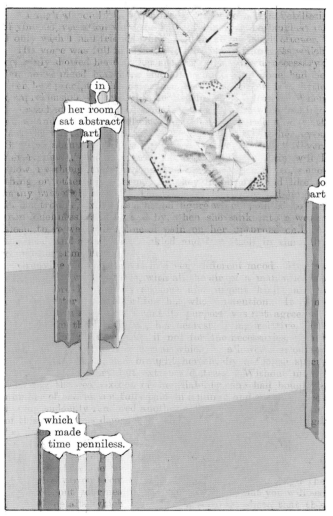

in
her room
sat abstract
art

o
art

which
made
time penniless.

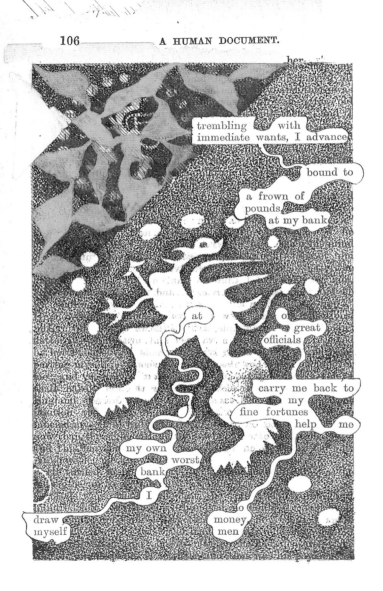

trembling with
immediate wants, I advance

bound to

a frown of
pounds
at my bank

at

o
great
officials

carry me back to
my
fine fortunes
help me

my own
worst
bank
I

draw
myself

o
money
men

The economies that would be
art he now proceeded to calculate ; and
with extreme reluctance, that he
travels and at once return to

the Prime Minister himself,

for his opinion on certain

in Parliament. The other was from the Chancellor of

extremely troublesome

Lord Solway

of considerable

the signature Solway.

...stand, there is hardly a mother in England ... to daughters in any way suitable ... would not object to you in the character of a son-in-law ... as ... as she would value you in the character of a ... and a ... You are indeed a ... whole of this ... way, so much admired by the ... visits to the children ... Another ... As you are not, however, ... must not be shocked ... own ... victim, that half our duty to Providence consists in ... and, if we cannot get rid of errors, at least ... their consequences. I propose, therefore, ... me, to assist in dishing Providence, as far as regards ... know by this time quite enough of what there is ... whether you have before you a ... and serviceable ... and I will assure your success to you before you have ... believed it. Why should you waste any longer time ... waiting ... you can manage to do so, you might propose to ... you once to marry ... I don't advise you to say that exactly ... it would have been done by ... but at all events ... use whatever expedition you can ... I will tell you don't ... without ... you will be quite as expeditious as ... necessary. My sister and her two daughters are just going to ... or Italy. They ... going to Milan, Padua, ... last to Venice. I will send you to-morrow ... of their movements; and then, my advice ... now, my way of saying something specially ... may as well tell you this. Evelyn's ... is a ... looking boy, but to my mind a monster ... excited her admiration by the degree he has ... people think I'm blind, but I see as much as the ... has been lending her books, which she takes ... reads ... gratitude. There's nothing in this thus far ... It's all very silly and natural; but none the less you must ... remember, as Byron said from experience, 'There is a tide in ... the affairs of women.' And ... you don't know that by this ... time, I needn't attempt to teach it to you."

As Grenville read this, something that was not trouble exactly, but excitement mixed with anxiety, not only took possession of his face, but also expressed itself in his movements. He rose from his seat, paced the room restlessly, smoked some

cigarettes in order to calm his nerves, and finally, with an impatient rapidity, undressed himself and went to bed.

Early next morning he sent a note to the Princess, to tell her he was wanted in England, and must start that afternoon for Vienna. She was sincerely annoyed at this, and when she met him at luncheon, she was armed with a piece of news which made her regret stronger. She put into his hand a picture she had just received from the agent—a picture of a castle on the summit of a wooded rock. "Could you only have stayed," she said, "you might easily have seen that. It is said to be by far the most curious place in the country." The moment he looked at it, it struck him as being familiar; and he presently recognized it as the castle which he had seen, with such wonder, from the railway. He eyed the picture wistfully, and a strong wish came over him not to quit these regions of yet unexhausted dreams. He passed it to Mrs. Schilizzi, who took it with a distant smile. When she examined it, she softly exclaimed, "How curious!" That was her only comment, but she kept it beside her plate, and throughout the meal her eyes were continually turning to it.

As for Grenville, whatever his regrets were, they did not interfere with the decision and promptness of his movements. There was a train for Vienna at five in the afternoon, going by the direct route, and arriving early in the morning; and by it he had arranged to take his departure. The station for this was seven or eight miles distant; so his hours with his friends were already almost numbered. "I suppose," he said to the Princess, "if my business is done quickly, you will let me come back and finish my explorations?"

"Do," she said, brightening up at the idea. "You must remember I feel you are treating me very badly. However, I'll come to the door with you, and give you a parting kick."

Mrs. Schilizzi came too, with her pair of fair-eyed children, and watched with a quiet face the carriage disappear from the archway.

CHAPTER XI.

... he viewed w ...
... total wo ...
... content to sh ...
... thought wha ...
... startling ...
... thought ... to ...

... he wa ... fur ...
... of ... res would ...
redu ... their te ... Nothing ...
... self ... starvation ...
... people, he ... al light,
... to him ... taper ... which the
slightest breathi ... inguish.

He allowed his ... and ... even exaggera ...
facts, like these, i ... value of the release upon ...
them that was being ... easy for him, and without ...
intentionally construc ... picture of his future, details o ...
forbidden ... themselves in upon his consciousness. He
saw his ... in half the ... ers of Europe. In various capitals,
and at Vienna especially, he saw himself the object of peculiar
... consi ... tion. In London his lodgings, and his one man-
servant, gave place to state, and decorous house and house-
hold. He saw a star in his coat, and a ... blue ... ribbon across
his breast. From ... time also he saw at his side a wife.
Now her happy eyes were making a light in his solitude; now
he ... and she ... at some ... undergo ... some brilliant party.
And yet all ... how, to his own surprise, pleasing
as they were ... him moderately ...
I wonde ... as he foun ... himself alone ... the

good things find the mind

look at

the lover, on the journey from

a broken photo

the same story. Certain sinkings

Memory after memory

turned to one another.

with a centre and two wings, all whitewash and windows,

pictures in the case

surprised observation

after the
Unauthor

end
ship
into friendship. The virtual

language-

in

characters

of

time

fusal

peraments of
the character

ossib

dang

anquil

tomary

anquil

bling

Morning ... was ... on the ... paper ... of ... at ...
above ... could he have done so,
... 'd have gone ... to the Embassy, to see if ...
always ... arrived. Exhaustion, however
... his ... philosophy ... submit to the contents of ...
... a spare mattress ... before he was up ... expected
letter was ... It was short and much to ...
... "My ... dear daughters," said Lord S...
... to-night, and will arrive at ... — it will
be good enough ... to a ... three days from
now. They will remain there for the ... of a ... week,
... now to get for me some chimney-pieces ...
doors in a certain ... palace ... saw him two ...
... and ... I had no time to ...
... My sister is going to attempt ... so for me ...
I told her ... I knew you were
coming this way to join her ... possibly, and help her in her
negotiations ... in time ... give you ...
his grace ... you are to date their ...
... the morning after ... I enclose you a ...
... with his spectacles in one
... and Aristotle's Ethics ... If you like the look ...
... him at Venice. He will not be ...
... I think that I have made ...
... pretty ... for you.
No news ... was the last item ... could in itself have
been more welcome ... Grenville ... He had however by no
means calculated on being driven to such instant action. His
settled intention had been to go first to London, and do what
he could in assisting his poor old helpless relation, pictures of
whose distress had been constantly presenting themselves to
his mind. And now it perversely happened that if he should go
to this, his own golden opportunity would be lost. Suddenly
he saw a way — a simple way — out of the difficulty. Springing
out of bed he wrote a note to his bankers, to tell them that he
might have presumed to overdraw his account, which as on a ...
... occasions they doubtless would let him do. He then
drew a cheque for a hundred pounds, and enclosed it to his
man of business for his aunt's immediate relief, promising if
possible to be with them the following week, and in any case
allowing such further funds as might be necessary.

written by the

forrounded

ladies

full of London

gossip

My dear,
there's no holding

mystery
Lady

Lucy, the
art
dandy

cameo
Lady

Grenville,
amused by

the latest

girl—the new
audacity

began

talk about

scenes

devoting himself to
Vice

on the day specified,

hail

bright

Vice

after

indulged himself in the pleasure district

Palladio

still

smelt of fields and damp

thoughts

He had just been stuccoed

a moment

no fresco reflected

Paul Veronese.

he suddenly ejaculated,

You know Veronese—

above the sideboard.

up in the cupboard

on the wall;

On the contrary,

placence, "That then settles everything. A dealer as twice offered five hundred pounds for it. Before a week is over settled my without going London now another my them

my banker's

CHAPTER XII.

THE white house had the

fag

warm, peach-coloured

plying flower

crowd,

a number

quare prinkling

were gay

most of them

officers in uniform, the prettiest

pretty; and

mounted by the prettiest

officer making the most of his

enviable, eyes; delicate colour excited

cheeks

the middle man

si diplomatiquement.

the lady's change.

This man's trouble

the cute

cute art of the lady

toge

and

his

of

fled friend,

coldness.

the lady ghost.

since I last saw you,

a photograph ago

so much has happened

so much has happened to

king toge

that Austrian

of the
handsome
mouth.

the pleasure he's given me

so

I shall
tell you my adventures

in the

arms of your friend,

I can tell you

he

turned it into a

trance of

an

evening

lonely

boy sing

the heart,

to a

school-girl, sighing and

believe

all

the

facts

the only facts which

feelings are

meaning. The

genius, the slave of

feeling or works for

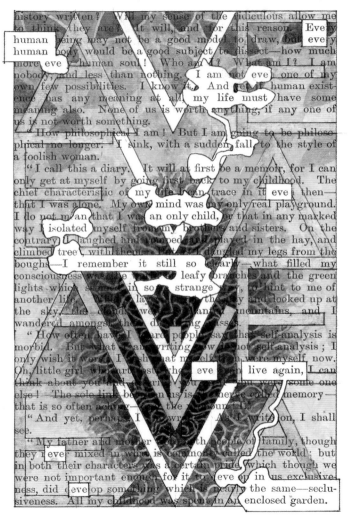

history written? Will my sense of the ridiculous allow me
to think they are? It will, and for this reason. Every
human being may not be a good model to draw, but every
human body would be a good subject to dissect—how much
more eve human soul! Who am I? What am I? I am
nobody, and less than nothing. I am not eve one of my
own few possibilities. I know it. And yet if human exist-
ence has any meaning at all, my life must have some
meaning also. None of us is worth anything, if any one of
us is not worth something.

"How philosophical I am! But I am going to be philoso-
phical no longer. I sink, with a sudden fall, to the style of
a foolish woman.

"I call this a diary. It will at first be a memoir, for I can
only get at myself by going first back to my childhood. The
chief characteristic of my life I can trace in it eve then—
that I was alone. My own mind was my only real playground.
I do not mean that I was an only child, or that in any marked
way I isolated myself from my brothers and sisters. On the
contrary, I laughed and romped and played in the hay, and
climbed trees with them. Yet if I dangled my legs from the
boughs—I remember it still so clearly—what filled my
consciousness was the wind in leafy branches and the green
lights which seemed in some strange way a hint to me of
another life, while I lay on the dry and looked up at
the sky, the clouds were distant mountains, and I
wandered amongst the dim long grasses.

"How often have I heard people say that self-analysis is
morbid. But what I am writing now is not self-analysis; I
only wish it were. I wish that my self then were myself now.
Oh, little girl whom I almost forget, if I might live again, I can
think about you and criticise you; but if you were some one
else! The sole link between us is a thing called memory—
that is so often aching—the account, I—

"And yet, perhaps I somewrite. And I write on, I shall
see.

"My father and mother were both people of family, though
they never mixed in what is commonly called the world: but
in both their characters was a certain pride, which though we
were not important enough for it to eve op in us exclusive-
ness, did develop something which is nearly the same—seclu-
siveness. All my childhood was spent in an enclosed garden.

"And what sort of childhood was it?
. to say.
. of diffidence. It is . . . enough to say . . .
. loneliness, b to say—
. that that loneliness
. . . religion. But so it was. Nobody would have
. . . clergymen would not admit that I am using the word
. For I do not mean that I was always going to
church . . or always or indeed often saying my prayers, but
. of the longing that moves people to pray and to do
and feel many other things besides. It was a longing for
something beyond and above me, and at the same time about
me, but always eluding me. I saw it in the sky and in the
woods, and I heard it in church when the organ sounded.
As for what people commonly call religion, I had to make up
my knowledge of that pretty much for myself, for mother was
born a Catholic, though she went to the English church, and
my father, though a very good man, had, I believe, only one
religious belief, and this was that the Church of Rome was
wrong. Still I was confirmed; and when I went to my first
communion, I felt—I can't express it now; but it was some-
thing the same feeling I had when first I saw the sea, or
when the sky, or a flower, or anything struck me suddenly
with its depth of beauty. I remember so well how on such
occasion as these I used sometimes to whisper to myself
'How beautiful!' and sometimes 'God, be good to me!' It
was a chance which of the two I whispered; I meant the
same by both.

"I remember also another thing, which makes me laugh as
I think of it. I used often—as most girls do—to stand
looking at myself in the glass, and the beauty of my own
reflection, such as it was, moved me and troubled me, much
as other beauty did. I never thought—never, so far as I can
remember, 'There's beautiful me.' I only thought, 'There's
a beautiful something.' I seemed to myself, as I looked at
my cheeks, to be merely like a flower given into my own
keeping, and I wondered about the meaning of the petals,
and was half frightened at their delicacy.

"I not that I care to write these down. And yet
. They are such distinguished facts of a
that at all events from affectation. And
why should . . . the movements of a young girl's thoughts not

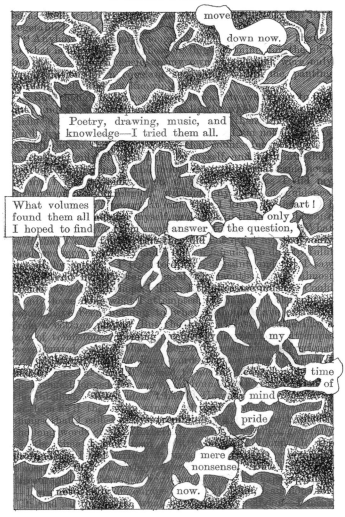

move

down now.

Poetry, drawing, music, and
knowledge—I tried them all.

What volumes
found them all
I hoped to find

art !

answer the question, only,

my

time
of

mind

pride

mere
nonsense

now.

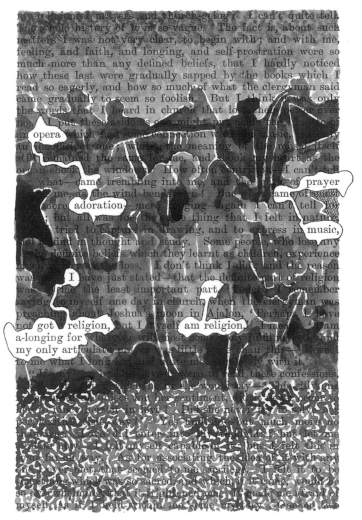

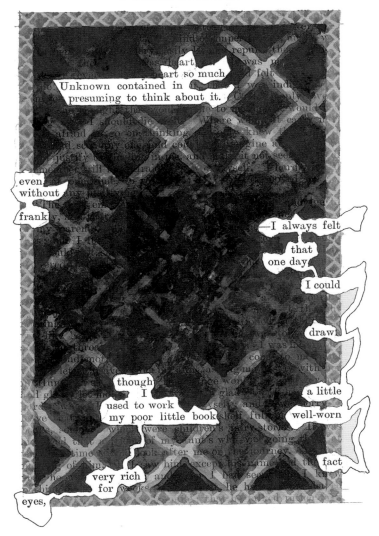

Unknown contained in presuming to think about it.

even without frank

—I always felt that one day I could draw

though I used to work my poor little book

a little well-worn

very rich for

eyes,

fact

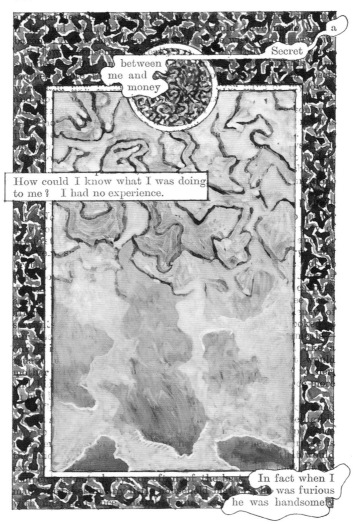

a Secret

between me and money

How could I know what I was doing to me? I had no experience.

In fact when I he was furious he was handsome

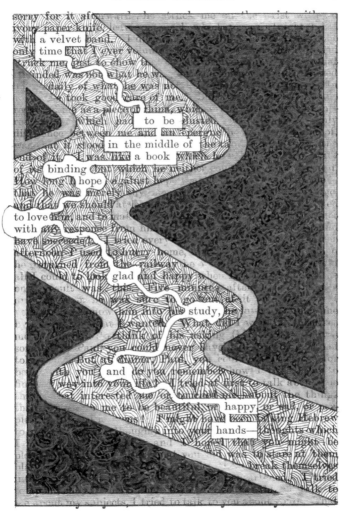

a velvet band
time that ever

to be
in the middle of a book
binding
hope

to love
with

glad and happy

into his study,

and do you remember

happy
into your hands—

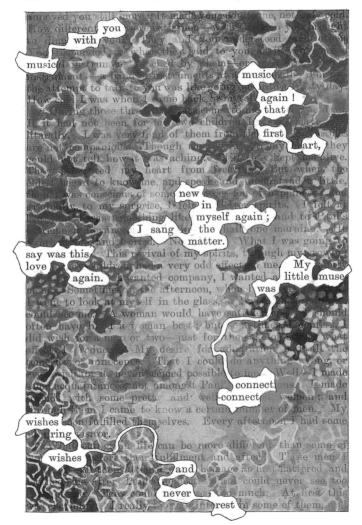

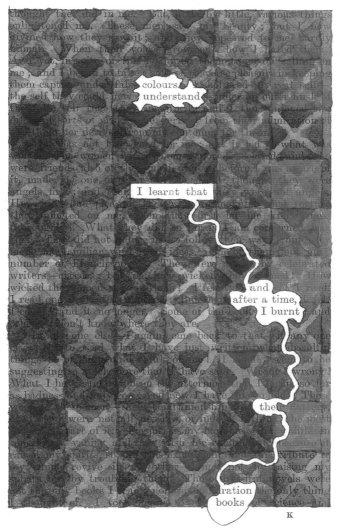

colours understand

I learnt that

and after a time, I burnt

the

ration books

K

art

took
ornament

as

water
found
desert

and

love
night

erne
erne

You have

treated

soul

and sunset

in the glass

Great

good
thoughts

dying
God

let me pour

you

! Let me

some

forgive your

selfish

solitude

art

morning.
eleven?—IRMA

"Yes"

charm
freedom
breath
and
sunlight
At eleven

Sunshine

bells magnolias
princes
and lions and
happiness

happiness was such, indeed, that he had gone on walking beside her, without any thought of what direction they were taking, but realizing presently that they had left the town behind them, he said to her, "Where are we going? have you any idea? I've not.

river

Birds sang with united garden

Ah! "how peaceful this place

ten miles away in your face.

on the philosophy of life and poetry, and the types of

surprise and pleasure.

beings, poets are to men as human beings. The highest use of the practical man is to improve the environment of life; the use of the poet is to develop the spiritual organism, or to be an example of its development. Do you see my meaning?"

"Yes," she said eagerly; "of course I do."

"I talk of poets," he continued; "but you understand, of course that I don't mean merely people who write verses. I mean people generally, whose chief desire and necessity is to live the life, of which poetry is the literary expression; for poetry is merely the body, of which those who appreciate it are the soul. I don't want to be sentimental; but I think I may say this: few people can write good love-poems; but whoever loves deeply lives one."

"Go on," she murmured; "your words are like carrier-pigeons. My feelings have wings, but my words can hardly flutter."

He hesitated, and then said,

"I am urging all this, as you will see presently, in order to shield myself from my own self-criticism. I want to show to you, and to myself too, that the emotional or poetic life has, on practical grounds, as good a claim to be cultivated and respected as the practical life. I am not thinking specially of love, though I took that as an example, but of every kind of feeling that fills the heart with music, or lifts it with aspiration. Just take a type or two of the two kinds of life. Take Shelley, or Goethe, or Horace, or Sir Walter Scott—and then take Napoleon, or the Duke of Wellington, or James Watt. Compared with a campaign, or a revolution, or the introduction of steam-power, what a trifling thing a poem seems—a butterfly as compared to a locomotive. And yet all that gives meaning to such things as these—to the hurrying train or steamer, or miles of military pageant—to courage, or triumph, or to industry—is, the jewels that the poets brighten. Poetry—let me go on; let me tell you how I define poetry—it is the emotional expression of a sense of life's value. I don't mean that a poem need be all sentiment. Poems like 'Faust' and 'Hamlet' may be full of the profoundest thought; but thought in poetry is always thought which is in direct connection with emotion; and that emotion, whatever it may be, depends upon some belief in the value and the beauty of life. Well, such being the case, I put the matter in this way. Poetry is adoration secularized, and the poetic life, or, if you

the romantic life,

aims at complete

striking

a
love-match

hi
poetic
people—

always
they are right—
the lovers
jerking
of-f
f

following
Stephen

dream

the
social
dream

public

muse

amongst the secular

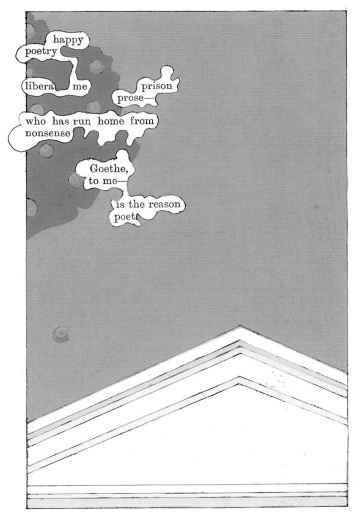

happy
poetry

libera me prison
prose—

who has run home from
nonsense

Goethe,
to me—

is the reason
poet

call on
sounds of the present, echoes of
vibrating music,

flowers,

pick flowers

T——.
has just arrived ;

off to the mill with the
heard and seen.

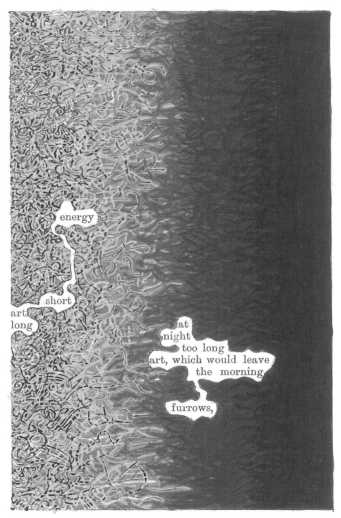

energy

short

art
long

at
night
 too long
art, which would leave
 the morning

furrows,

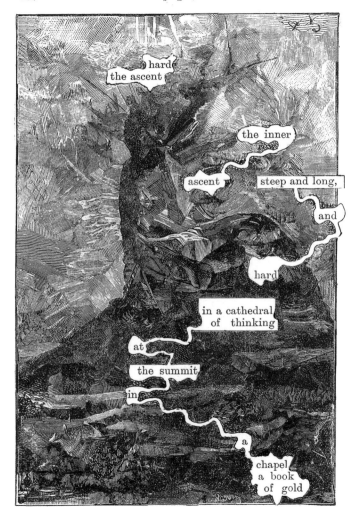

hard
the ascent

the inner

ascent steep and long,

and

hard

in a cathedral
of thinking

at

the summit

in

a

chapel
a book
of gold

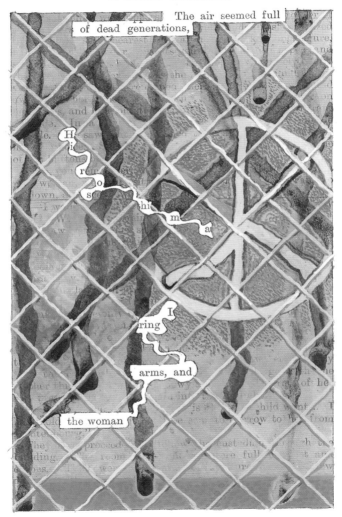

The air seemed full
of dead generations,

H
r
o
se
hi
m
a

I
ring
arms, and
the woman

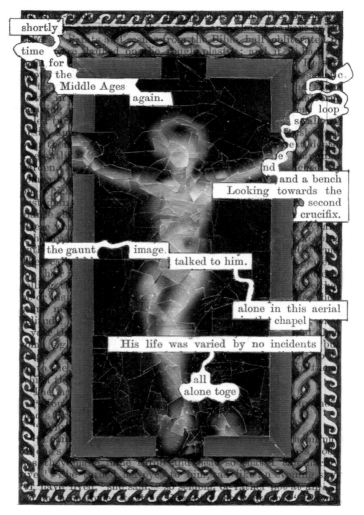

shortly

time

for
the
Middle Ages

again.

loop

and a bench
Looking towards the
second
crucifix.

the gaunt image.

talked to him.

alone in this aerial
chapel

His life was varied by no incidents

all
alone toge

, I thin
erally
eel it all
nto drea

the second part of

this high silence

past
too s

I called poetry.

instead of a movement towards, we ought to begin one
downwards."

As they went **toge**ther descending the winding road, un-
noticed by him she often **turned** and looked at him with the
curious intentness of a child.

Suddenly she said, laughing, "Had you curls when you
were a little boy?"

He laughed too, and again asserted that he had.

"When you were a little boy," she asked, "what name
did they call you?"

He told her it was "Bobby."

She **repeated the** word softly. "That," she said, "was my
brother's name." She looked him in the face for a moment,
and once more repeated, "Bobby."

"And you," he said, "when you were a little girl, I know
what **they called you**, for your name to one else was silver. It
was Irma. Miss Irma, little Irma. Did not they call you
that? I wrote **a poem once** to a person of that name—to you
indeed—and not very long **ago.**"

She stopped short, and looked at him, reddening with a
painful flush. He went on rapidly. "It was to a very small
person. It was to Irma, your little daughter."

She caught her breath sharply, as if with sudden relief;
then he saw the shadows of her throat trembling. She gasped,
"You must tell me the verses—not now, but some day."
And her eyes before she could avert them had filled suddenly
with tears.

CHAPTER XIV.

That evening, before she went to bed, **inspired by** the
events of the day, she produced the sheets of her diary, and
having given her children's eyelids **the gentle** benediction of
her kiss, she leaned her head on her **hand** and began writing
as follows—

"Am I sad or happy? I don't know. I never felt as I
do now before. I am quite bewildered. I wish I was a
child again, and had mother to guide me. And yet, why

What is there to make a fuss about? Only a very pleasant thing has happened to me; which, though to me it is surprising, is surely in itself very commonplace; but I find it quite new. How baldly and badly I put things: what has happened is this. I have met a man who cares to talk to me because he understands my thoughts. He likes me for what is human in me, not for what is animal; and he does not look at me with the eyes of a cowardly beast of prey. At first, indeed, he did not care to look at me at all, but even that is better than the ways of other men: though I confess that there have been times—months, I think—perhaps one whole year, when I allowed my vanity to be flattered by those men's admiration. I thought any sort of attention was better than none, then. Again—as to this man, I thought at first that he laughed at me. Perhaps he did. Socially I knew he thought nothing of me; and I'm sure he thinks nothing now. But of that I am glad, for somehow it makes the change in him seem deeper and more sincere. He is sincere, I am sure; for only once—and then it seemed forced and unnatural—has he paid me a single compliment, except that one compliment of understanding me.

"To be understood! The sensation is so strange to me that it makes me a new creature. My mind, my tastes, my feelings have all become new things. Bobby—dear deaf Bobby, my sailor brother—once described to me his joy when in some strange place in the East he heard the sound of his own language. For the first time in my life I have heard some one else talk mine. But this does even more. He not only talks my language, he enlarges it for me. In addition to saying what I have felt myself before, he says other things I have only tried to say, and with others which I have never even thought of, but which become mine the moment he has said them. He has liberated in me a host of thoughts that were in prison. He is the fairy prince who has entered the sleeping palace.

"What have I written? Perhaps I shouldn't have written that: and yet I am reassured, so far as regards him, by seeing that I have written it so naturally. It is a witness to the fact that he has never tried to make love to me. He might easily have tried to do so, and so have destroyed everything. But I noticed this, that whenever matters of sentiment were talked about, everything personal or even impersonal was

politics

understood

from the hard benches

barren become green

fields

floating –as if

take off

under

the wind.

thoughts rise like

the forest
hope

books

I ravelled

and treated

Words

all of a

heap

derlin

Words

changed and grew

certainly catholic

we
we
are
are
the
the
are
people
ourselves,
people
in novels
treated
as
the human
pages
who
man
the mind
nature
reader

148

unfatwawards
to brownness

. And yet,

truth

Mr. Gren
made everything easy
mospher . her white
chivalronite word, for
religion

On the tabrite stand a small looking-glass
accident
to
Mr.
Most

And yet, And yet,
—we are going into the
heart of brownness

such

art of
balls to
unfathom

going into the looking-glass

unaccountably,

up in her bed, in her bed,

heart of

Samuel. not disappointed.

brownness

moved
through
wild
needles
for
two hours
chair
bound
to
the
high-pitched
room
and his wife,
who

was

her,

wrong and
requisite,

with
colour on
her utmost,
bare
toge
writing

examine

walls ;

for

microscopic incidents

toge

inspect the landscape

for
fittings

had their collcd; their tray rested on the beech-husks, and
they themselves lay on some rugs beside it. During luncheon
everything reminded her of incidents in her childhood, of
picnics with her brothers and sisters, and of absurd shifts
they were put to. She told him how Dick stuck his kni
handkerchief for a napkin, and how Ol
look a rman thing." And Grenville had brought, wishi
he had come to tell her so, that now that sober childhood
during still mischievous in her Nnn
mood had become in amusements of her

She talked of
of charms and dreams.
in a lake that was

home

recalled her father's garden, its tall

Each memory as it floated
into artless words, and occasionally she would
ville's attention to something
—some ripple of sunlight on the lake or the ruddy or shiny
bark of some gleaming tree which appealed to her for its own
sake only.

This extraordinary quality in her of sensitiveness to
beauty struck Grenville afresh as
back he at last gave his thoughts

I have never, he said, since the mere colour-
ing of see these appeals so strongly to your sense of
you imagination, how you would be affected by

Italy

All sorts of
chance memories,
violet
shadow
lily I have walked by in
the dark

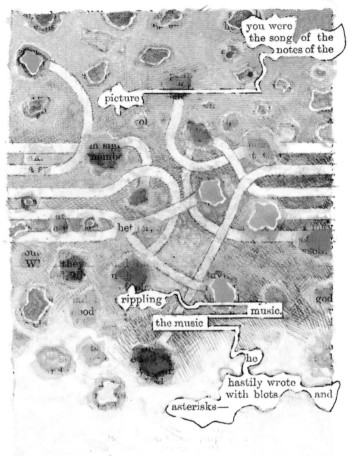

you were
the song of the
notes of the

picture

rippling music.

the music

he

hastily wrote
with blots and
asterisks—

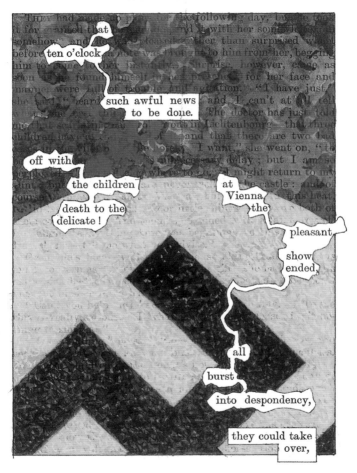

ten o'clock

such awful news
to be done.

off with

the children

death to the
delicate !

at
Vienna
the

pleasant

show
ended,

all

burst

into despondency,

they could take
over,

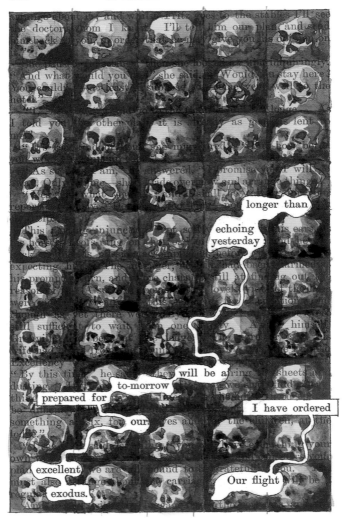

longer than

echoing yesterday

will be airing

to-morrow

prepared for

I have ordered

our

excellent

exodus.

Our flight will be

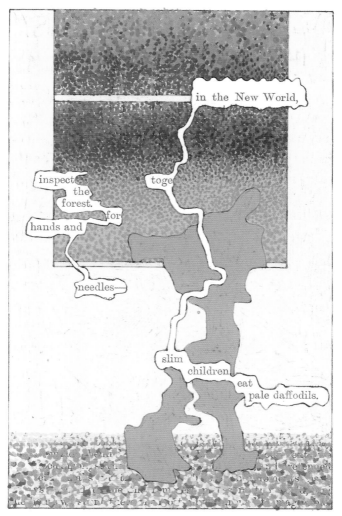

in the New World,

inspect the forest.

toge

for

hands and

needles—

slim children eat pale daffodils.

somehow

children,

the

beautiful

children opened their
imagination.

come back
dusk,

come shy and change

back to the
silence.
said a
about the fading view; and
rose, fold their cloak
round her.
smoke," she said presently. "I'm sure you

the silence,
counting the clouds,
pink
again.
I think.

like

no

rose

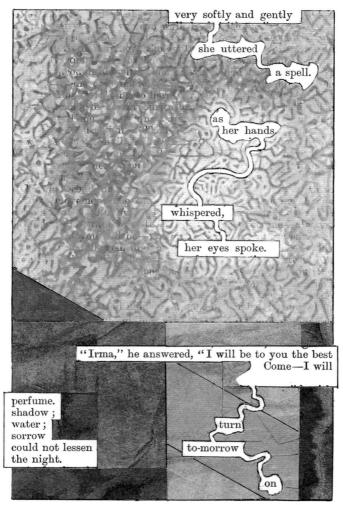

very softly and gently

she uttered

a spell.

as her hands

whispered,

her eyes spoke.

"Irma," he answered, "I will be to you the best
Come—I will

perfume.
shadow ;
water ;
sorrow
could not lessen
the night.

turn

to-morrow

on

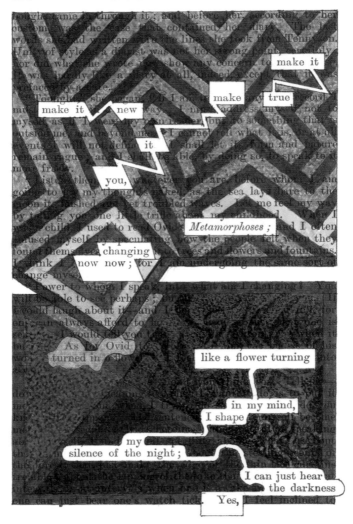

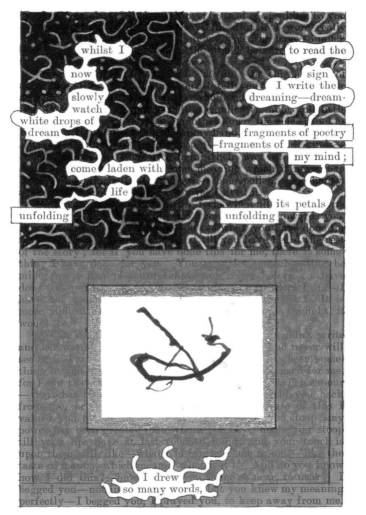

whilst I
now
slowly
watch
white drops of
dream

to read the
sign
I write the
dreaming—dream-

fragments of poetry
—fragments of
my mind;

come laden with
life

its petals
unfolding

unfolding

I drew
so many words,

CHAPTER XVI.

alcon
akfa

akfa

letters

he found,

poems he collected

closed

C LOOPSEEND

open

akfa

alcon

araso

araso

M

Oh, sunlit "let us drive!"

they drove off the lake, and the following the road The wheels playing and the white wonder.

magical music. passing

driver amongst pines,

toge

turn to serious, syllables soft as your body the blue film of the hush and whisper of your mind

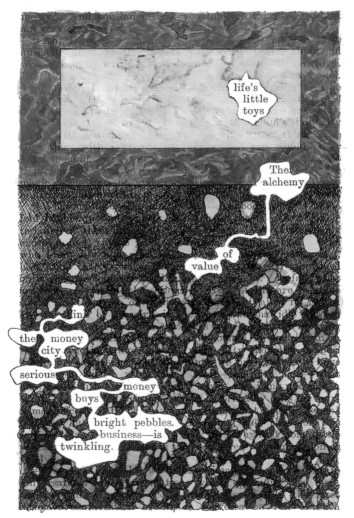

life's
little
toys

The
alchemy

of

value

in

the money
city

serious

money
buys

bright pebbles.
business—is
twinkling.

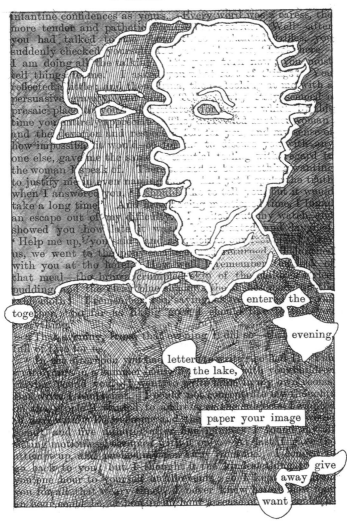

developed in one, springing up like the tree that grows under the napkin of an Indian juggler. At the end of that hour I went to you, and found you still in the summer-house. 'Have you written your letters?' I asked. You pointed to two sheets of note-paper, on each of which were scribbled a few lines, and which you began listlessly to put into their envelopes. 'I couldn't write,' you said. 'That is all I have done.' Irma, that pleased me. We had been going through the same experience.

"But then suddenly, to my intense surprise, I was annoyed with you. You said you were tired, and wanted to lie down in your own room. What was more natural? And yet how to explain it, I don't know, one of those wayward caprice of temper, which sometimes take the lost of reason in their mouths, and carry off the imagination on their backs, made me say to myself, you were tired because you were tired of me. 'Must you go?' I murmured, as if this petty parting were a tragedy. I felt I would have done anything to keep you. I had brought those verses with me which I had written about your child. I pulled them out, and asked you to let me read them; but instead of doing that, you bade me give them up to you. 'How pretty they look!' you said; 'I will take them and read them by myself.' That annoyed me still more. Perhaps my poet's vanity was wounded, though I don't think so. When you went, and for an hour I was left alone. Fool that I was—what folly could have possessed me? I actually felt deserted, despised, miserable. Could you believe it? I went roaming about, longing as if I could tread time under foot, and still longing with you, and yet longing, longing, longing for you as if we had been separated for weeks.

"The hour went by, and still you did not come. You had told me that, when you were rested, you would come out on the balcony. 'Come, come, come,' I said, 'and I will tell you everything. About Italy—and what kept me there—come out and tell you all. Every thought in my mind is longing to pour itself into yours.'

"Suddenly it occurred to me that the old man at the lodge had shown me a boat-house with some boats belonging to the Count in it. An idea came to me. We would dine at the lodge at six, and I would row you on the lake afterwards. This gave me at once an excuse for sending in a note to you.

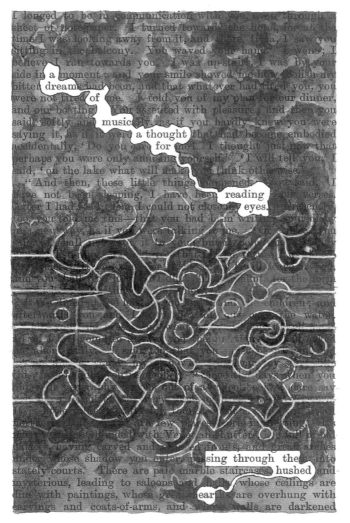

I longed to be in communication with you, even through
sheet of notepaper. I turned towards the hotel, for at the
time I was looking away from it, and suddenly, I saw you
sitting in the balcony. You waved your hand. I went, I
believe I ran towards you. I was up-stairs, I was by your
side in a moment; and your smile showed me how foolish my
bitter dreams had been, and that whatever had tired you, you
were not tired of me. I told you of my plan for our dinner,
and our boating. You assented with pleasure; and then you
said, softly and musically, as if you hardly knew you were
saying it, as if it were a thought that had become embodied
accidentally, 'Do you care for me?' I thought just now that
perhaps you were only amusing yourself.' 'I will tell you, I
said, 'on the lake what will make you think otherwise.'

"And then, these little things happened. You said, 'I
have not been sleeping, I have been reading your verses.
After I had read them, I could not close my eyes. Presently
you you told me this—that you had been writing something in
a new way, as if you were talking to me

. .
. .
. .

. children; and
afterwards you . the water

. .
. .
. .

. a few .
. blinds, with Venetian shutters, and tall
. having carved and floors, and great arches
under whose shadow you enter, passing through them into
stately courts. There are pale marble staircases, hushed and
mysterious, leading to saloons and halls whose ceilings are
dim with paintings, whose great hearths are overhung with
carvings and coats-of-arms, and whose walls are darkened

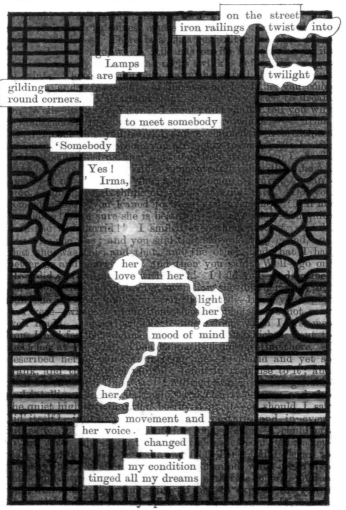

on the street
iron railings twist into

twilight

Lamps
are

gilding
round corners.

to meet somebody

'Somebody

Yes!

her
love with her

mood of mind

her

movement and
her voice.

changed

my condition
tinged all my dreams

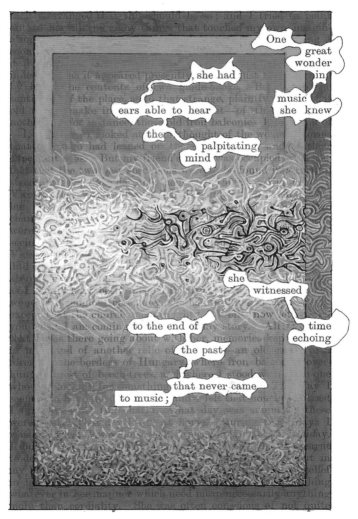

One great wonder in music she knew

she had ears able to hear

the palpitating mind

she witnessed

to the end of time echoing

the past

that never came to music;

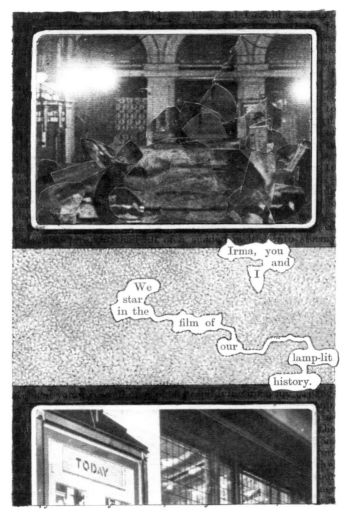

Irma, you and I

We star in the film of our lamp-lit history.

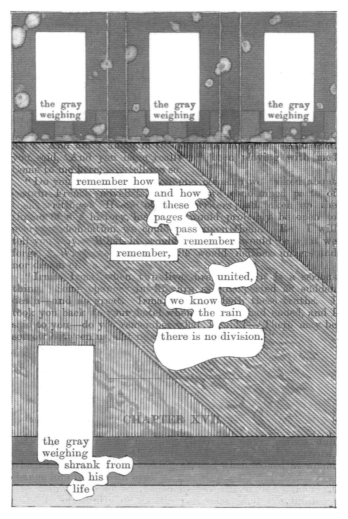

the gray
weighing

the gray
weighing

the gray
weighing

remember how
and how
these
pages
pass
remember
remember,

united,

we know
the rain
there is no division.

CHAPTER XVI.

the gray
weighing
shrank from
his
life

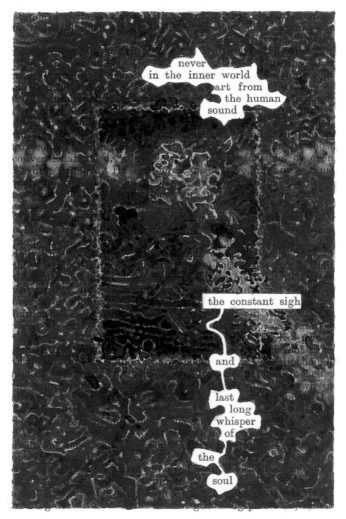

never
in the inner world
part from
the human
sound

the constant sigh

and

last
long
whisper
of

the

soul

he lay drowsy, filled him with horror of himself; and then his
thoughts in a moment turned to the situation of another, and
he wondered whether she was overtaken by the same humilia-
tion and torture. This poignant consideration stung him into
complete wakefulness. He roused himself; he sat up; he
stared round him, with heavy-lidded eyes. He felt as if he
had done her a wrong. He wondered if she were reproaching
and scorning him. He wondered, with even more anxiety,
how she would bear her own scorn of herself. The doors of
his conscience opened, and her phantom came forth to meet
him.

He moved to get up, but felt like a man on a steamer, who
is so sea-sick that he dares not quit his berth. To get up
would be to face realities; he had not the heart to do so.
He did so at last however; his will rallied its strength. He
hastily put some clothes on, muffling himself in his great-coat.
He softly unlocked the door, and he went out. The sky was
a field of dim moving fleeces, damp as Gideon's, and so was the
lake as well. All the ground was spongy and gray with dew.
Nothing about him stirred but a slow and silent breeze, which
just laid on his cheeks the touch of the weeping air. He
looked blankly round him. In spite of its strange aspect
everything spoke of her. He thought of their drive of
yesterday, and the meeting of their sympathies in the sun-
shine; and then he started as his eyes rested on the hotel.
Had it not been for that, yesterday might have been years
ago; but that was a witness of her actual neighbourhood, as
it slept with its closed white curtains, and its wet tiles glimmer-
ing. His eyes were heavy still; his head ached. How,
he asked himself, would she meet him? Or would she meet
him at all? Perhaps, he thought, she would merely send him
a letter, telling him coldly never again to see her; or perhaps,
so some fancy whispered, she would be dead. He looked at
his watch. It was only five o'clock. Hours must pass before
He could have any news of her. He longed to throw himself
at her feet, crying, "Forgive, forgive me!" Then again
another thought tormented him. "Perhaps she will be saying
to herself that I despise her."

Close to the lodge was a little patch of garden. There were
some white roses in it, and some red tulips. He picked a
bunch of these, and arranging them very carefully, went
about and filled them in a tumbler of water. The cold air

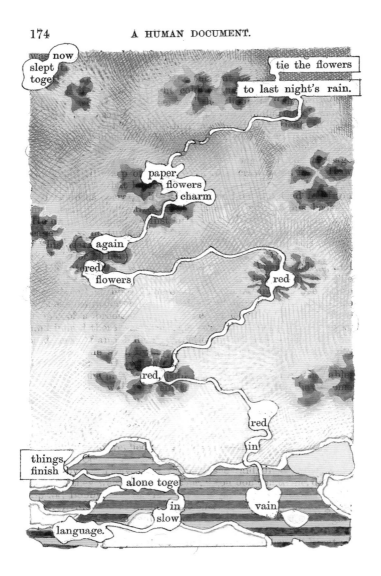

now
slept
toge[...]

tie the flowers
to last night's rain.

paper
flowers
charm

again

red
flowers

red

red,

red
in

things
finish

alone toge[...]

in
slow

vain

language.

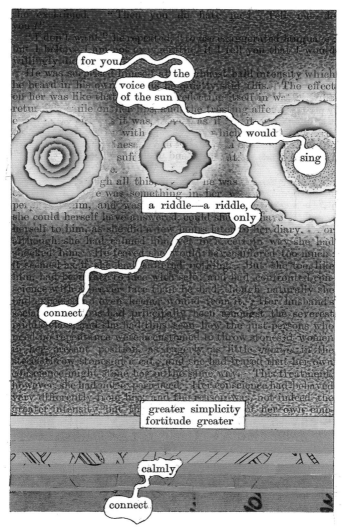

for you.

the
voice
of the sun

would

sing

a riddle—a riddle,

connect

greater simplicity
fortitude greater

calmly

connect

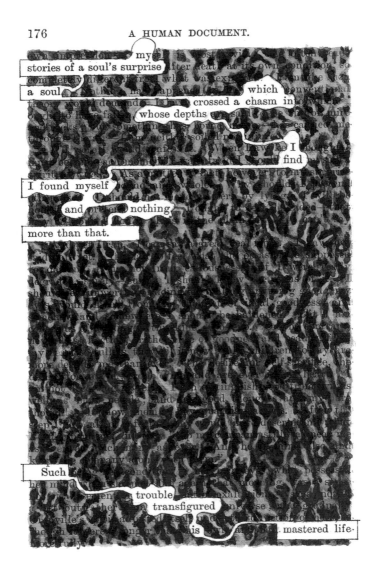

my
stories of a soul's surprise

a soul which
 crossed a chasm in
whose depths

 I
 find

I found myself

 and nothing

more than that.

Such

 trouble
 transfigured

 mastered life.

"I want you," she said presently, " to be with me all to-day.
The children have their lessons to do. Let them come with
us into the summer-house, and whilst they work you shall
read to me."

He was himself not in a mood for reading; but he felt, for
a reason which by and by became more clear to him, that this
did but make him happier and more zealous in obeying her.
As they returned to the hotel for luncheon, he picked up a
broken flint. "Do you think that pretty?" he said. "Don't
you? I wish you did."

She asked why.

"Because," he said, "if it would only give you pleasure,
I would willingly sit all day long and break stones for you."

Few things are so constantly misinterpreted, as the changes
of women's moods, by the perverse vanities of men. After
luncheon, contrary to what she said in the morning, Mrs.
Schilizzi surprised Grenville by begging him to leave her to
herself for a little, explaining her words by adding, "till four
o'clock." He felt that to do this was a tax on his self-denial
not quite so agreeable as that she had lately made on it. But
he hid his reluctance, and left her when she wished. Her
first step was to write—and she was some time in doing so—
the passage in her diary which was just now quoted; and
then, not being strong, she lay down to rest, repeating it with
closed eyes, and reaffirming its meaning.

He, meanwhile, was undergoing a very different experience.
He walked restlessly along the borders of the lake, and, re-
moved from her presence, the charm of which seemed to pro-
tect him, the first bitterness of his waking mood revived in
him, and he partly and wholly aggravated by the sense that she
did not share it. He hardly dared to scrutinize what was
going on within him. He tried to believe it was mere im-
patience to be with her again. But when the time came to go
back to her, something had begun to stir in him which, though
he would not recognize as like anger against her; and
shrinking from this, and indignant at it, he tried to get
behind him; but it did not vanish; it dogged him like some
cowled figure, and kept him a prey to self-reproach and
dejection. He did his utmost to master the change
that had overtaken him, and his manner conquered its tender-
ness, but he could not recover his spirits. They had arranged
to take the children for a walk among the shadows of the

forest ; and he tried to hide his condition in his kindness and
his attention to them. For a time this succeeded ; but at last
the truth was felt by her, his replies when he spoke to her
were so short, and his smiles were so slow in coming. At last
 id to him with a certain constrained abruptness —
 ow why you are so moody. You are afraid you have
 an injury, though you might perhaps have thought
 le sooner. But leave that matter to me. We
 ough each to do to bear our own responsibilities."
 bidly sensitive ear her voice seemed hard and
 hung his head, and walked on in silence.
 e said presently, "are you not going to speak to

 her, and was wounded afresh by a smile that
 mocking.
 said, "if what you tell me is true, I had
 my responsibility in solitude."
 she answered, "certainly."
 in his walk, and fixed a long look on her,
 s hand, and quietly said, "Good-bye."
 e repeated, and turning away moved on.
 he was, leaning listlessly against a tree.
 g thoughts at once sprang at him out of
 ng with hateful voices the woman from
 g himself.
 d to him, "are by no means her first lover.
 rst in fact, and you have not even the first
 y."
 suggestions came to his mind like truths it is
 ay ; but they irritated him like the stings of
 with a pain which he despised while it maddened
 ooked after her to see if she were out of sight.
 not. She was at some distance, but just as his eyes
 ned to her, she too, stopping, had turned a glance towards
him—a glance which, though still resentful, seemed to be full
of melancholy. He hurried towards her, as though she were
his life escaping him, which he must return to, though the
process were full of pain.

 "Irma," he said, "forgive me. My soul will kill itself if I
leave you."

 They walked on side by side, each of them s
At last she spoke.

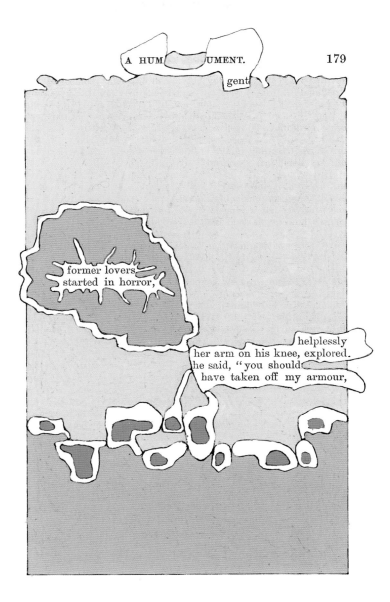

gent

former lovers
started in horror,

helplessly
her arm on his knee, explored.
he said, "you should
have taken off my armour,

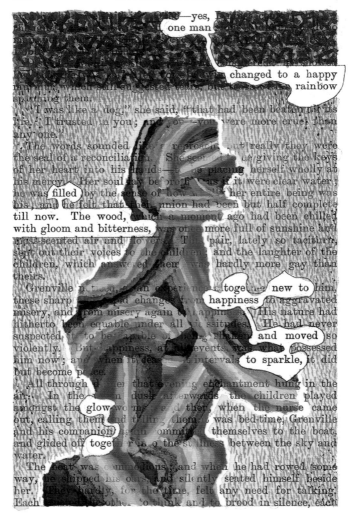

—yes,
one man

changed to a happy
rainbow

"I was like a dog," she said, "that had been beaten all its
life." "I trusted in you, and . . you were more cruel than
any one."

The words sounded like a reproach, but really they were
the seal of a reconciliation. She seemed to be giving the keys
of her heart into his hands—to be placing herself wholly at
his mercy. Her soul lay before him as if it were clear water;
he was filled by the sense of how . . . her entire being was
his, and he felt that their union had been but half complete
till now. The wood, which a moment ago had been chilled
with gloom and bitterness, was once more full of sunshine and
grass-scented air and flowers. This pair, lately so taciturn,
sent out their voices to the children, and the laughter of the
children, which answered their, was hardly more gay than
theirs.

Grenville an experience altogether new to him,
these sharp and changes from happiness to aggravated
misery, and from misery again to happiness. His nature had
hitherto been equable under all vicissitudes. He had never
suspected it to be capable of being shaken and moved so
violently. But happiness, at all events, was what possessed
him now; and when it ceased at intervals to sparkle, it did
but become peace.

All through that evening enchantment hung in the
air. In the . . . dusk afterwards the children played
amongst the glow-worms, and there, when the nurse came
out, calling them and telling them it was bed-time, Grenville
and his companion . . . in committing themselves to the boat,
and glided off together the stillness between the sky and
water.

The boat was commodious, and when he had rowed some
way, he shipped his oars, and silently seated himself beside
her. They hardly, for the time, felt any need for talking.
Each trusted the other, to think and to brood in silence, each

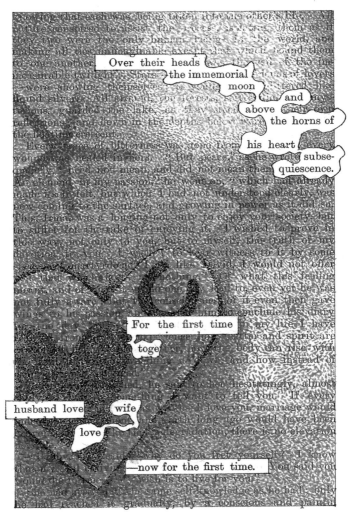

Over their heads the immemorial moon and above the horns of his heart subse-quiescence.

For the first time together husband love wife love —now for the first time.

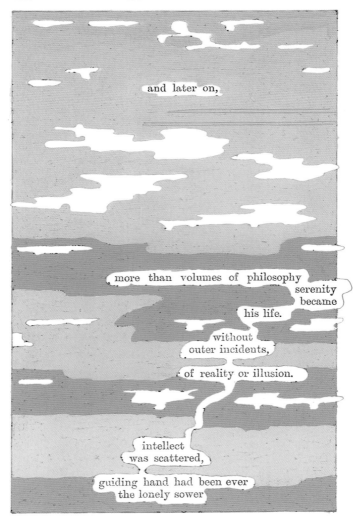

and later on,

more than volumes of philosophy

serenity
became

his life.

without
outer incidents,

of reality or illusion.

intellect
was scattered,

guiding hand had been ever
the lonely sower

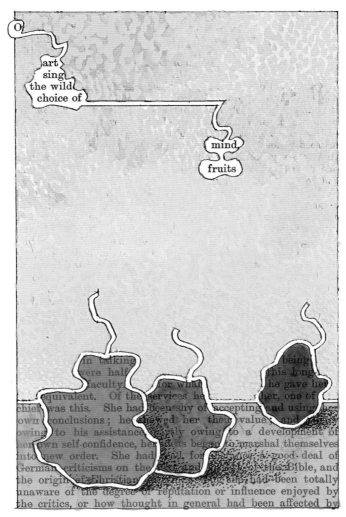

O

art
sing
the wild
choice of

mind

fruits

in talking
were half
faculty for what
equivalent. Of the services he her, one of
chief was this. She had been shy of accepting and using her
own conclusions; he showed her their value; and
owing to his assistance, partly owing to a development of
her own self-confidence, her ideas began to marshal themselves
into new order. She had read, for a good deal of
German criticisms on the and of the Bible, and
the origin of Christian she had been totally
unaware of the degree of reputation or influence enjoyed by
the critics, or how thought in general had been affected by

embroidered on hours
to the music of
pages,

children's
philosophy

silent,

leaves,
silent

laughing amongst
colours

" Every day of my life is like a page

only

connect

toge[ther]

like two lonely voyagers

discussing

passion,

Grenville, it ... upon her was naturally yet more direct.
At the same ... their singular isolation from the world
made many ... considerations so dim as to be hardly
imaginable; at l... the conventional judgments which had
remote world ... ht pass upon them, some seemed based on
beliefs no longer ... nable, and others on a necessary ignorance
of their own ch... acters and circumstances. They read their
situation only ... its own internal light; and the only trans-
gression they c... see in it, was one not of depravity, but of
daring. They ... 'e ... like two lonely voyagers striking out a
course for the... lves, who indeed had lost their landmarks,
but had for th... guide a star.
They had n... ness in ... discussing ... his conclusion, whenever
they were ... at interval... misgivings as to its
soundness. ... their passion, ... justifying itself by its own
intensity feel that small misgivings must be in
themselves But they... er neglected them, or
... contemptuously. As eated itself,
they examined it and
cried in the dark, ...

only

connect

to-morrow,

the world

answers

everything

clairvoyance in

her diary

acramen

acramen

acramen
to confess

words
work

nature

women

needs
kill

conditions

support

friends

successes
close

fit nothing

experience

knows

happens

sometimes
walks

faculties

exercise
kills

star

function

shuts

life
stands alone

no remedy is allowed

all of us suffer
suffering

seven times

seventy times seven—

the

stability
principle

speech
gave way

At last
she felt
toge

even

night
gave
in

still as
an inverted heaven.

silence,
and stars,

Look up; look up.
Come, be near me.

See the depth above us, and

endless

a ball of
milky light
—the book of

new universes forming

stars
vibrating

to-night

"Can it be ... dreaming ? Is the rose ... in my ... thought fabulous ! Barren garden of life ... can ... that you ... blossomed for me into this one wonderful flower ?"

CHAPTER XIX.

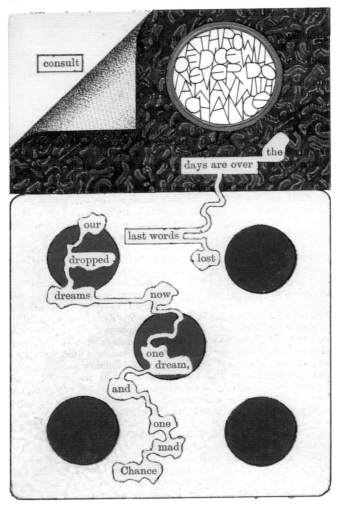

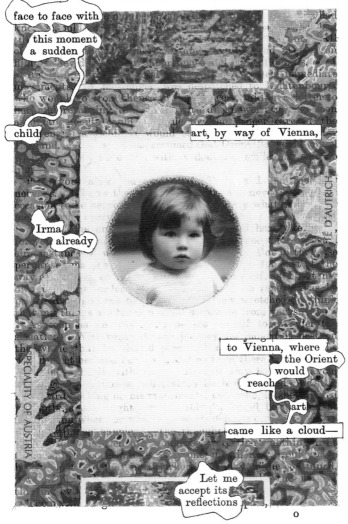

face to face with
this moment
a sudden

children

art, by way of Vienna,

Irma
already

to Vienna, where
the Orient
would
reach
art

came like a cloud—

Let me
accept its
reflections

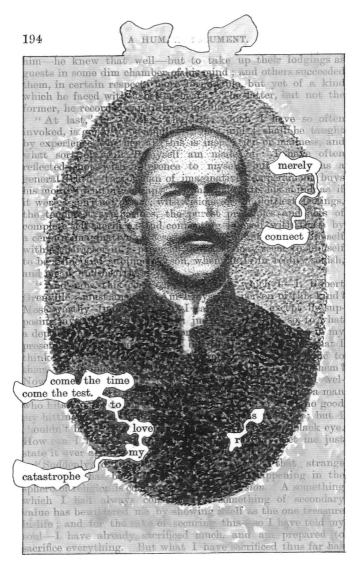

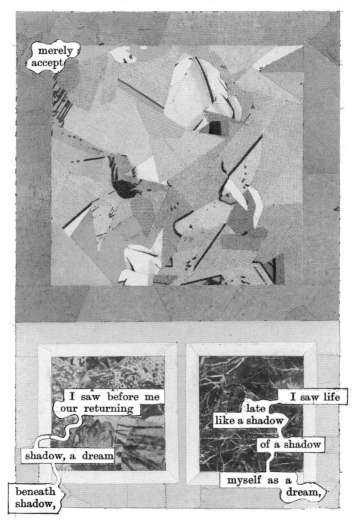

merely accept

I saw before me our returning

shadow, a dream

beneath shadow,

I saw life late like a shadow

of a shadow

myself as a dream,

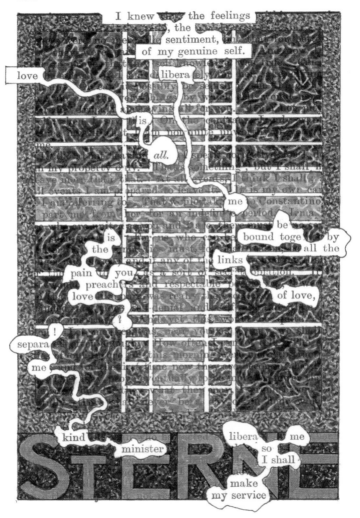

I knew the feelings

the sentiment,

of my genuine self.

love

libera

is

all.

me

bound toge by

the links

pain in you

preachers and respectable

love of love,

?

!

separa

me

kind liber me

minister so

I shall

make

my service

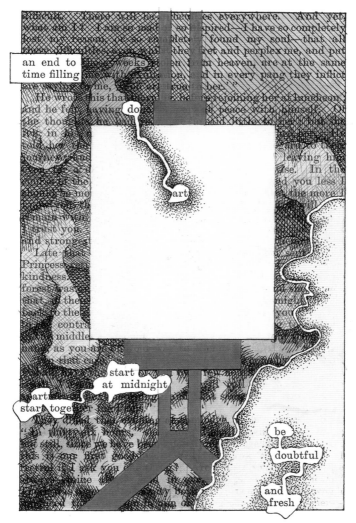

an end to
time filling

do

art

start
at midnight
start
start together

be
doubtful
and
fresh

The starlight
gleamed like dew
on his sleeve,

by four o'clock
he dressed himself
amongst the eastern clouds.

though
their perfect union were done with
forests at
the wan dawn

meant
Eden forgotten
gardens,

The
shuttered
dress,

fluttered with cherry-blossom
muttered to
horses were put to, the bells
and the wheels drowned it.

CHAPTER XX.

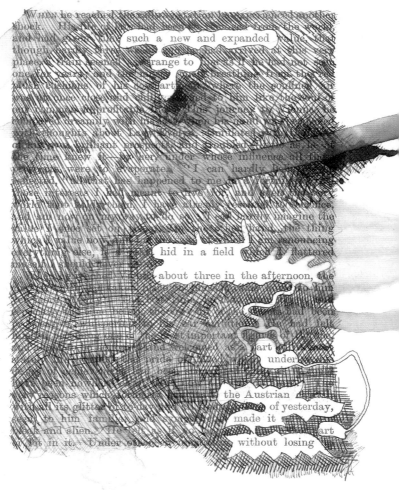

When he reached ... shock. His ... and had ... such a new and expanded value, ... though ... place ... strange to ... one ... breathing ... high column ... once ... led to him like ...

... unprofitable ... This journey to ... compared ... other his mind ... thoughts about ... of his own ... prospects and aroused ... as he ... the same knew ... their under whose influence all the ... were to evaporate ... "I can hardly believe ... that has happened to me ...

... interests ... meant to have ... and twenty ... I have had ... Would ... sacrifice, ... I am now on my way to ... hardly imagine the ... have ... set out ... than the thing which I value now ... renouncing everything else, ... hid in a field ... I flattered ... build any ...

about three in the afternoon, the ...

... had been ... he had felt important things of ... part ... pride ... as part ... under ...

... now ... tions which ... with all its glitter to ... to him fami ... and ... the Austrian ... of yesterday, ... bleak and alien. He ... made it it in it. Under ... art ... without losing

his wife;

he took

her

extra ticket

to the Ring

huge carving

splendid

the sound of

he emerged from

the opera,

that

huge engine of torture

ennui *ennui*

ennui

under the trees,

this and that personage,

whom he ought to know,

the Countess

with silver

and crimson

bearded,

the King of

two faces under parasols.

refined

velvety

The Baroness X—

pretty

as

pain and

the

vulgar crowd

mundane

murmur of dust

At last
a letter.

night
acceptance,

and
a
prospect ; a
prospect

of

a pleasure to

merge
with
pleasure
after pleasure

night
 saw her hasten towards a man—a corpulent man,

The calm ... part of the electric ... drawing ... a private photograph of the arranged objects

of the shelves and tables were some ormolu trays for cigar-ash, some inlaid cabinets for cigars, and several sets of bottles and glasses for liqueurs, coloured and gilt as gaudily as artists in glass could make them. One thing more he discovered, and one thing only. It was a photograph lying under one of the ormolu ash-trays, faded and ragged, and representing a half-clothed Viennese actress.

Anything more depressing, anything more hopelessly *bourgeois*, it would hardly have been possible to imagine. And this was the home, or at least one of the homes, of the woman to whom he was devoting everything! He thought of the drawing-rooms at the Embassy, and compared them with it. They seemed to belong to two wholly different universes—designed for the lives of people who had not a thought in common. A surprise which he could not analyze at first occupied his mind, and made him forget how the time was passing; but at last it gave place to wonder as to when Mrs. Schilizzi would present herself; and wonder by and by gave place to impatience and resentment.

Of all the troubles of life, the suspense of protracted waiting, with every nerve of doubt, of hope, and of expectant hearing stretched upon the rack, is in proportion to its real importance, the hardest for sober temper to endure. He now discovered his own temperament to be of this sort; it is no exaggeration to say that he soon was enduring tortures. Hitherto, though like most men he knew what pain was, he had rarely if ever found himself robbed of it of his self-control. Now he found himself at its mercy. Angry, savage thoughts came leaping into his consciousness—creatures all now hidden in the unexplored jungle of his mind, leaping to lacerate the woman whose conduct appeared so heartless, and lacerating him meanwhile in their wild fantastic fury. As he stood amongst them, he felt like a man almost a pack of wolves, trying to beat them down, to kill them, to lash them into silence, and yet strong with a temptation to let them have their way, on the woman, and on himself. Once, once one memorable day, he had indeed quarrelled with her before, and thought bitter things of her; but that passed quickly—that he had quite forgotten. And then, only last night, he had experienced pain on her account, of a new kind. But that was pain merely; this was humiliation mixed with pain. He hardly recognized himself.

[Highlighted fragments: Grenville — Now he — savage came leaping into his — unexplored jungle — woman who — stood amongst — wolves, — with her — only last night, — a new kind. — mixed with pain.]

explain its history

a
queur
photograph.

Ah!

"how
I thought of my
well-worn books,
—and our boxes of
laughing
bricks.

assembled, and hoping

more than

a couple

the

shining
selves reflect

inner
windows
repeat the

shared
morning,

in
the photograph,
both of them
banish

change

wagger
wang

wagger
wang

the wind

CHAPTER XXI.

Mrs. Schilizzi not at y her
mother-in-law—a lady instincts always Cross rusted
and strong in virtue that comes never
possessed it, felt herself bound, whenever circumstance
admitted . . . towards her daughter-in-law the part of
guardian angel. Her zeal, indeed, was much in excess of that
which . . . well-worn simile ascribes to the angels of tradition;
and contenting herself with keeping
under her she endeavoured to hold her fast
of her guardian clutches. Grenville
from hag . . . Mrs. Schilizzi told him accordingly . . .
from her Dove taking the train to Victoria
not to call on her till she wrote to him to give him no . . .

He saw her . . . turned after
the crowd with less puff of ny . . .
swept between them side and
packed. Having reached London at six, and ha sl . . .
tried . . . sleep for an hour or two, he found himself . . . tw . . .
washed and brushed and dressed . . . so far as . . . ter . . .
went ready to face the d . . . as new
around him turned blank than Sab

Everything bewildered him hardly
realize what . . . time of social
stages he m . . . expect . . . London season in full
swing, or how . . . by chance lit upon summer holidays
Or . . . it possibly East presented them-
sel not bec ed for g . . . ty, but for a reason
pre . . . op headed very sight or sound of th . . .
. . . had st it, he would wrongly have been no . . .
. he should again see Mrs. Schilizzi . . .
. . . . at all events would not be till . . . morr . . .
. . . . while itting of no delay—matters fran . . .
. ain only, but with embarrassment also with
. his whole life were calling on him for
. . . . action, and m rep all events he
. this over wandered wearily his

Everything had an air of being blighted—even the light . . .

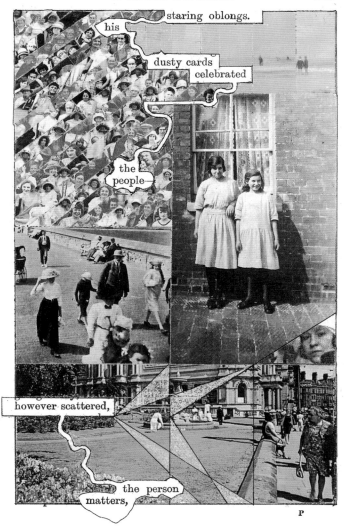

staring oblongs.

his

dusty cards
celebrated

the
people—

however scattered,

the person
matters,

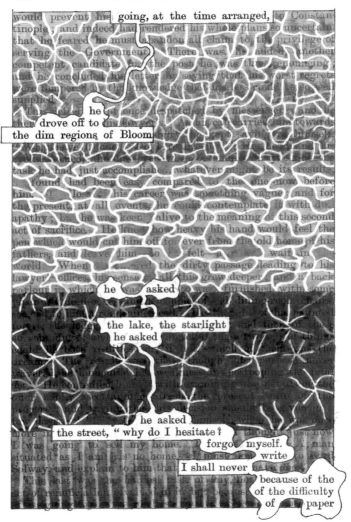

going, at the time arranged,

drove off to
the dim regions of Bloom

he was asked

the lake, the starlight
he asked

he asked
the street, " why do I hesitate?
forgot myself.
write
I shall never
because of the
of the difficulty
of paper

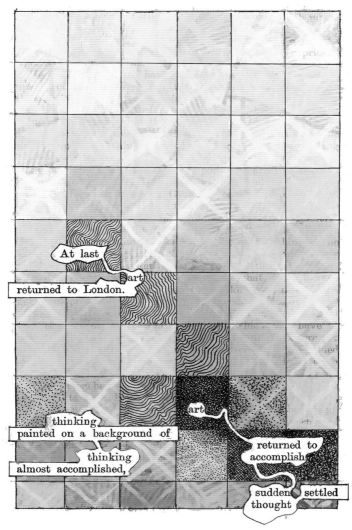

At last

art

returned to London.

thinking

painted on a background of

thinking

almost accomplished,

art

returned to accomplish

sudden settled thought

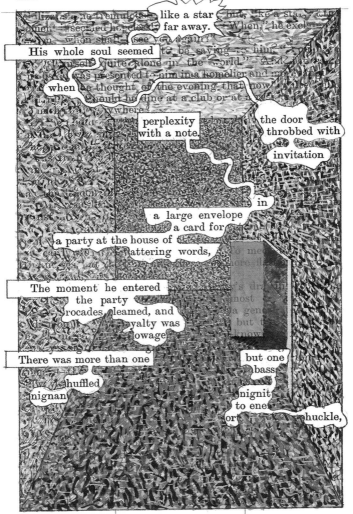

His whole soul seemed

when he thought of the evening that now

perplexity with a note.

the door throbbed with

invitation

in

a large envelope a card for

a party at the house of

flattering words,

The moment he entered the party

brocades gleamed, and

loyalty was

owage

There was more than one

shuffled

nignan

but one

bass

nignit

to ene

or huckle,

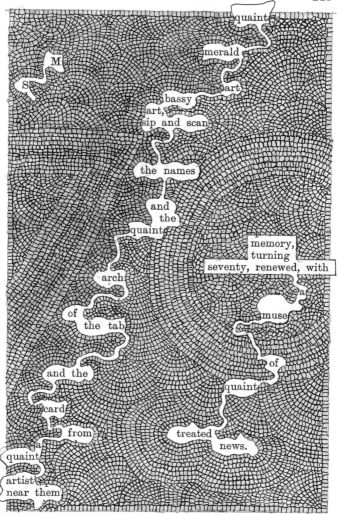

quaint

merald

art

M

S

bassy
art,
sip and scan

the names

and
the
quaint

memory,
turning
seventy, renewed, with

arch

a

muse

of
the tab

of

and the

quaint

card

from

treated

a

news.

quaint

artist
near them

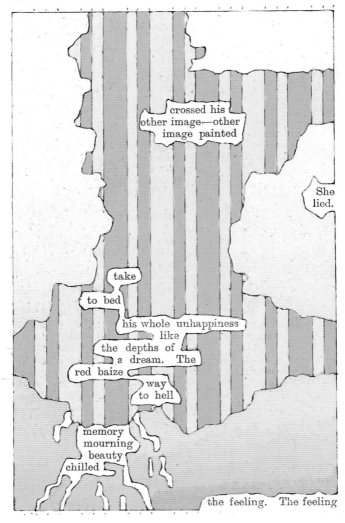

crossed his
other image—other
image painted

She
lied.

take

to bed

his whole unhappiness
like

the depths of

a dream. The

red baize

way
to hell

memory
mourning
beauty
chilled

the feeling. The feeling

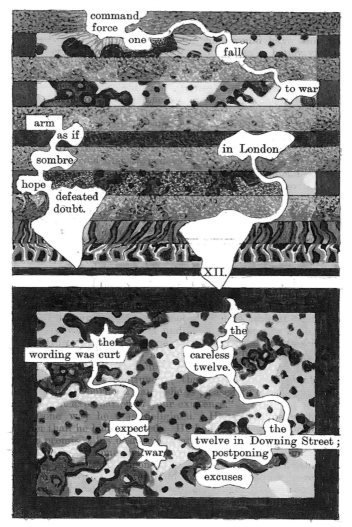

command
force
one
fall
to war

arm
as if
in London
sombre
hope
defeated
doubt.

XII.

the
the
wording was curt
careless
twelve.

expect
the
twelve in Downing Street;
war
postponing
excuses

fused sense

blew through his mind

turbe
he could hardly breathe.

bulated figures,
with feathers,

lying on his chest and smothering him.
about

to tear in pieces
and open
an intolerable anal

secret

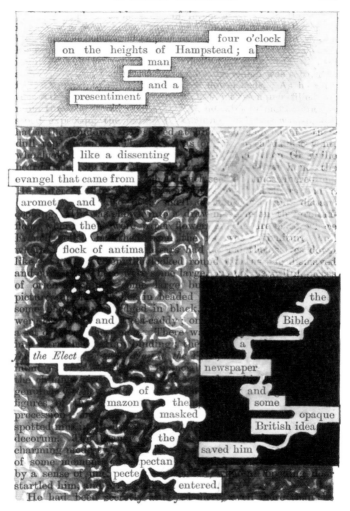

four o'clock
on the heights of Hampstead ; a
man
and a
presentiment

like a dissenting
evangel that came from
aromet and
the
flock of antima
the Elect

the
Bible
a
newspaper
and
some
opaque
British idea
saved him

of
mazon the
masked
the
pectan
pecte
entered.

"And who," he asked,

"Oh," she replied,

English

belong to

expensive

speak of him as

a souvenir of my dear

He brought

covered

lines

full of

broken
suggestions

to the British Museum,

to the Museum,

my dear

and as a sign of heartlessness. Here he was, half separated from her, seeing her only in this breathless interval, longing to breathe to her some words of devotion, and to receive from her the comfort of some answer; and her deliberately wasting this short golden opportunity in idle gossip about Greek vases and a mother-in-law, filled him with a bitter and growing sense that he was being trifled with. He made one or two further attempts to force her to speak more seriously; but he made the attempts in vain. She reverted each time to topics more or less trivial; and at last, stung by her treatment, and hardly reflecting on what he did, he rose abruptly and said to her,

"I have bored you enough. I am now going."

"Must you?" she said ... **art** ... and looking as if she understood nothing ... **What time is it?** It is ... later. Perhaps you ...

He had not ex... a word like this. He stared at her ... voice which sh... **"When shall I come again,** if you don't wish m... **"**

"Bobby!" ... talking of? How silly you ... **You had, indeed, better go now,** unless you wish to is... time, as she looked at him, ... in his expression. She came ... by both hands, with distress in her ... him, "What is it, dear?"

"I feel," he **said**, "that you have hardly let me speak to you, and now you turn me away as if I were some chance visitor, and you will not even trouble yourself to tell me when, if ever, I am to see you again."

"Don't," she said, "don't remain any longer so near me. I feel as if all these rosewood chairs had eyes. You can see me to-morrow, I think. I have to go to my lawyer's, and you might take me afterwards to some place where we can have luncheon. I will let you know to-night. Please don't be angry with me, but go."

Half soothed by her parting words and manner, and yet still embittered by the unnatural constraint of the interview, he went out ... **into the maze of suburban roads,** and **heavy with** sense of desolation, began to walk towards **London.** But a week ago—only a week ago—they were in that enchanted

and now,
the
promised letter arrived,

There was
toge
under the circumstances,

the
tender
circumstances,

personal

with regard to
and with regard to

mind

affairs

give
no particulars eve

this
night
wounds
time,

an intellectual
silenced

and so
my intellectual
fool.

naked of everything

everything for
my hands.
I am
I am
what ? This
man of

her yesterday

I should have felt less

my old
troubles

Irma, Irma—

I can't my comfort

weapons

all

eyes with tears in them.

snatched

pain hours of anxiety

time torture

Irma, Irma,

time

wretched

days

strain

time

bush anger would spring out at him suddenly, he

clothes had fallen from her at the smooth banker's.

half a policeman came,

"Well—are you not going to ?" he asked.

pose ?" she answered.

CHAPTER XXIII.

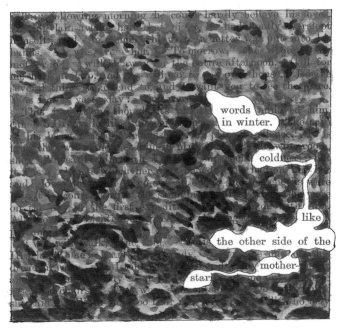

words in winter.

cold

like

the other side of the

mother-

star

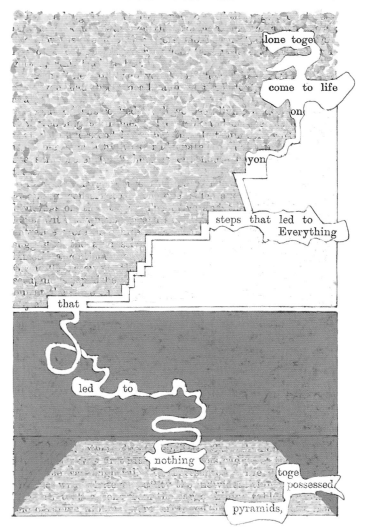

lone toge

come to life

on

yon

steps that led to
Everything

that

led to

nothing

toge
possessed

pyramids,

the carpet rich in pile, but monstrous in design and colour, whose crude vulgarity made a staring ground for everything.

Granville tried to keep his impression of the room to himself, and merely said, "What a fine collection you have here!"

"Paul," she replied, "says that there isn't a single thing wouldn't fetch now at Christie's more than the price he paid for it. Come—I will show you his room."

This was full of floridly carved walnut furniture, much resembling that he had seen amongst at Vienna; and the whole was somewhat *suggestive* of the interior of a first-class car. On the third hearth-rug was an *electroplated* inkstand; there were some showy designs for books, several boxes of *cigars*, and *art* was represented by some coloured prints of racehorses.

"You won't," said Mrs. Schilizzi, "mind the presence of any actress here. Paul is afraid of his mother, whose *eyes* are as quick as arrows. She tolerates these horses only under severe protest; and she takes him to church with her every Sunday twice. Oddly enough, in England he thinks she is quite right; and for this reason he prefers living abroad."

"What a home," thought Granville, "for such a woman as this!" It bore the same relation to her home with which he was familiar that a schoolboy's nonsense verses might

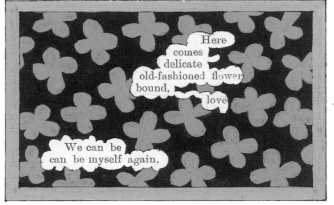

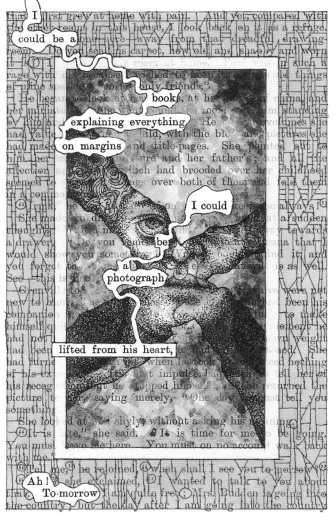

that first grew at home with pain. And yet, compared with the other rooms in this house, I look back on it as a refuge. Do you see this carpet, how old and shabby and worn... room at home. ...in such a rage with it... because I wished to keep it... these things of mine... only friends."

He began to look at the books, at her... china, and her miniatures. She went round the room with him, standing by him... the volumes she had valued as a child, with the blots and pictures she had made... and title-pages. She pointed out to him her own... and her father's; and all the... affection... which had brooded over her childhood seemed to... things over both of them and told them in a common...

"Irma," he... "I could keep you always..."

She made no... a sudden thought... towards a drawer. "Do you remember... Irma that I would show you something... find it, and you forgot to... photograph...

See—this is it."

Grenville too... features were not new to him... had been his companion... to make himself... moment he had not... weight had been lifted from his heart, ...ed. She had turned... when he took... need nothing of his ex... impulse had seized all her of his recog... but he stopped himself, and he returned the picture to her, saying merely, "One day you must tell you something...

She looked at him shyly, without asking his meaning.

"It is late," she said. "It is time for me to be going. You must leave me here. You must on no account walk back with me."

"Tell me," he rejoined, "when shall I see you to-morrow?"

"Ah!" she exclaimed, "I wanted to talk to you about that. To-morrow I am quite fretful. Mrs. Budden is going into the country, but the day after I am going into the country...

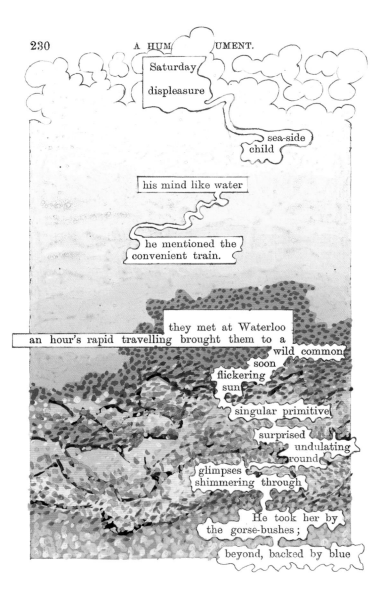

Saturday

displeasure

sea-side
child

his mind like water

he mentioned the
convenient train.

they met at Waterloo
an hour's rapid travelling brought them to a
wild common
soon
flickering
sun

singular primitive

surprised
undulating
round

glimpses
shimmering through

He took her by
the gorse-bushes;

beyond, backed by blue

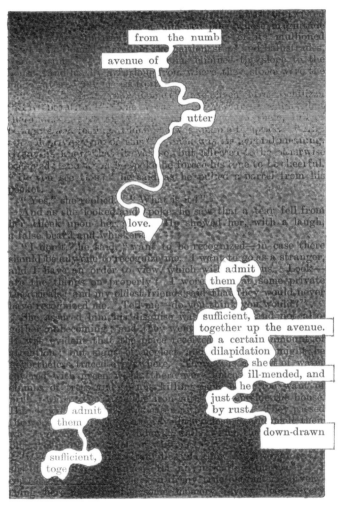

from the numb

avenue of

utter

love.

admit them

sufficient,

together up the avenue.

a certain

dilapidation

ill-mended, and

just

by rust

down-drawn

admit them

sufficient, toge

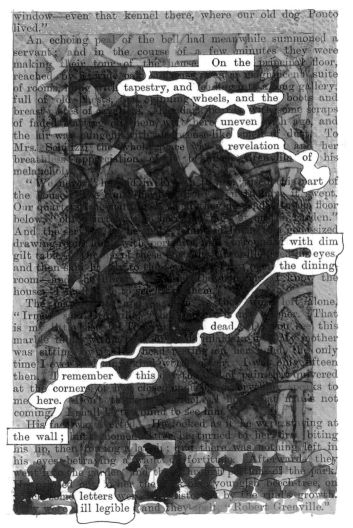

window—even that kennel there, where our old dog Ponto
lived."

An echoing peal of the bell had meanwhile summoned a
servant; and in the course of a few minutes they were
making their tour of the house. On the principal floor,
reached by a wide oak staircase, was a magnificent suite
of rooms, hung with tapestry, and leading into a long gallery,
full of old chests, and spinning wheels, and the boots and
breast-plates of cavaliers. The dark boards, with some scraps
of faded matting on them, were here uneven with age, and
the air was pungent with an incense-like smell of dust. To
Mrs. Schilizzi the whole place was a revelation, and her
breathless appreciation of it befitted the tenderness of his
melancholy.

"We never had dim. this part of
the house to keep it swept.
Our quarters . the floor
below . on the garden."
And the ser. good-sized
drawing-room, . . . with portraits, with dim
gilt tables. On of these his eyes,
and then said to the ser. the dining-
room—I should like to see them."

The . were left alone,
"Irma . That
is my sister You see this
marble dead My mother
was sitting head resting on her the only
time I ever . I was only fifteen
then. I remember this of pain that quivered
at the corners of the closed speaks to
me here. Don't . that man's not
coming. I shall be . . . bound to see him.

His face was averted. He looked as if he were staring at
the wall; and a moment after he turned to her, first biting
his lip, then forcing a laugh; and there was nothing left in
his eyes betraying a fortitude. Afterwards they
went into the garden, and pathways of the park.
. the youngish beech-tree, on
. letters were by the wind's growth.
. were ill legible, and they spelt, "Robert Grenville."

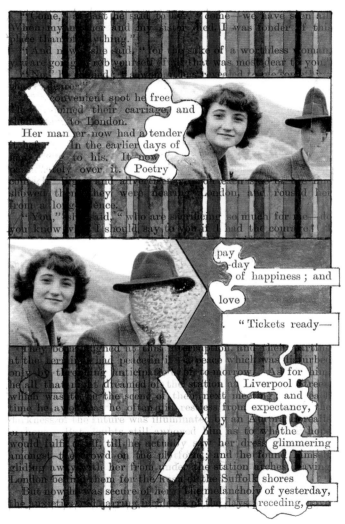

free

Her man ... now had a tender
... In the earlier days of
... to his. It now
... over it. Poetry

pay
-day
of happiness; and
love

"Tickets ready—

Liverpool Street
and
expectancy,
glimmering
shores
of yesterday,
receding,

of bondage

Two
at the station,
pleased

two well-dressed strangers

The two
on a
beach
arranged

far apart.

sea.
and
chance
noises

precarious

velvet
sounds heard

—the occasional
little yellow
traveller,

two playing,

waves
fell on the shingle

confidingly,

the sea

threw
their shapes on the
sunset.

"To-morrow," she said to

toge

meanwhile,

moonlight, and the
crazy benches.

toge

At last felt her
forest.

dearer to him now than
broken syllables which
are for lovers signs

world ;
world's
gerating
alchemist.
topsy-turvy
passionate
baldest and most
real,

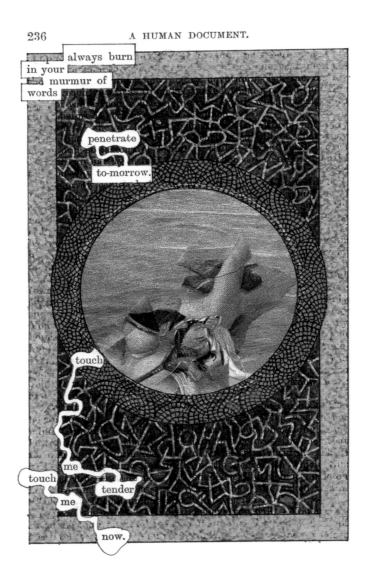

always burn
in your
murmur of
words

penetrate

to-morrow.

touch

me

touch tender

me

now.

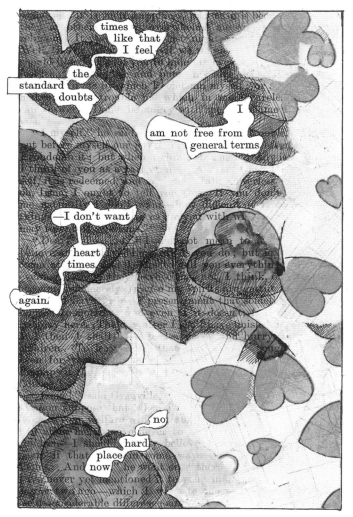

"Yes?" she gasped. "Is it anything very dreadful?"

"You remember," he answered, "that at your house the other day you showed me a certain photograph. Well—I recognized it. I have already met the original. I travelled with him from Paris to Vienna before my visit to the Princess. I talked to him. Listen, I will explain to you all about it."

"Are you sure it was he?" she interposed. "Was he alone? I believe he very rarely is."

"He was alone in the train; but somebody was with him on the platform. He told me who she was. He was very frank and communicative. You, I dare say, will know what I mean by that. I don't want to dwell on it, but I want to tell you that since I made this discovery, the chief uneasiness that lurked in my mind is gone. I only knew it was there by the relief it has given me by going. I am appropriating nothing that he either understands or values. I always felt that this was so; but only now has it been proved to me. Can't you see with me what a difference this must make?"

She looked him long in the face; and at last, turning away, "I am glad," she said, "of this. It makes me also happier. You now see what my position is, and how completely, except for you, I am alone. Please don't fret about me. My heart has been lightened as yours has been. I am happy. I am alone no longer."

Nor next day was the state of her mind changed. The thought that this peaceful interval would so soon come to an end did, indeed, sadden both of them; but it was a sadness brooding over peace, like clouds over a quiet sea. The mid-day post, however, brought her a letter from London, bearing many stamps on it, and darkened with re-directions. "It is something from Paul!" she exclaimed. Her cheeks flushed as she read it. "His work at Smyrna is nearly done," she said presently, "and what is this? There are some new waterworks at Bucharest, for which the firm has a contract. He will be going there in three weeks. He supposes that I and the children are at Vienna or with the Princess; and as soon as he is able to do so, he will come to us."

She dropped the letter on her lap, and looked at Grenville silently. "Of course," she said at last, "it must have happened sooner or later; but sometimes, Bobby, sometimes one forgets things."

sad

toge
watching the waves fall

beautiful
last
random fragments of poetry

repeating

Certain sorts of
verse

finding
syllables,

the waters fall

the waves fall

repeated

musical.

music of your mistake.

pencil
murmuring

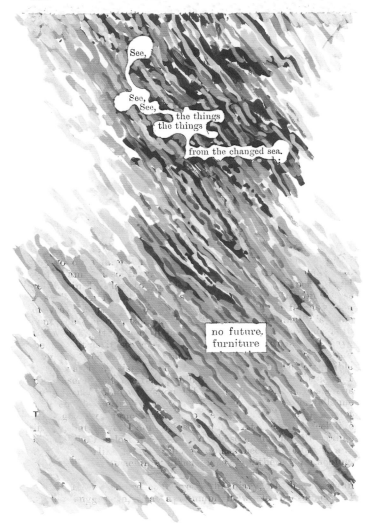

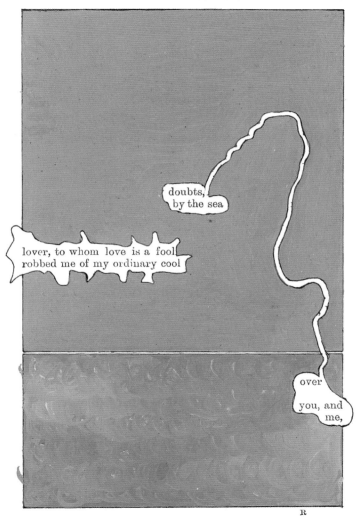

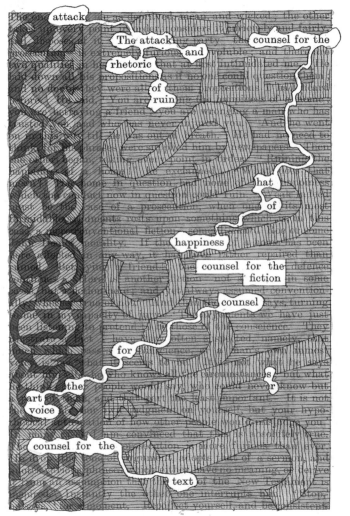

attack

The attacking party

and

rhetoric

counsel for the

of ruin

hat

of

happiness

counsel for the fiction

counsel

for

the

art voice

counsel for the

text

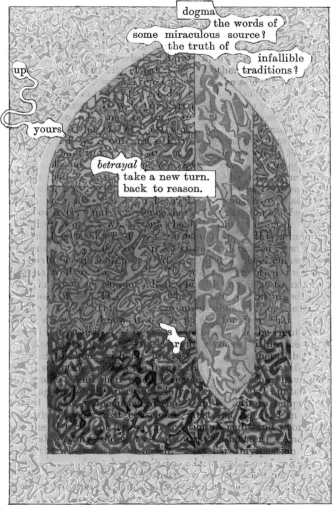

dogma

the words of some miraculous source? the truth of infallible traditions?

up

yours

betrayal

take a new turn. back to reason.

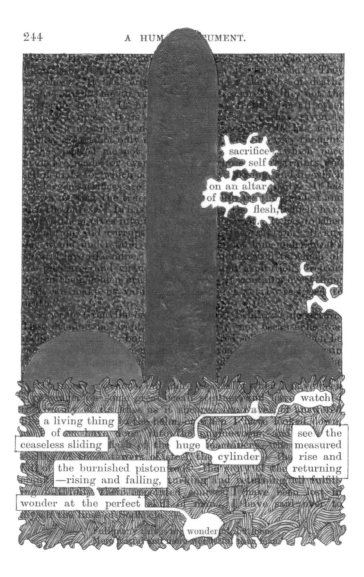

sacrifice which once self on an altar of the flesh, which have

watch

a living thing of ceaseless sliding

see the measured rise and returning

huge cylinder

the burnished piston —rising and falling,

wonder at the perfect

wonder

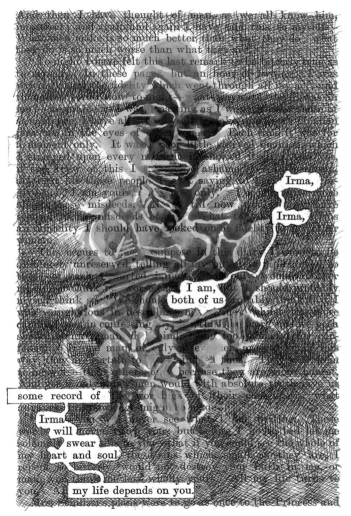

Irma,

Irma,

I am, both of us

some record of

Irma will swear art and soul

my life depends on you.

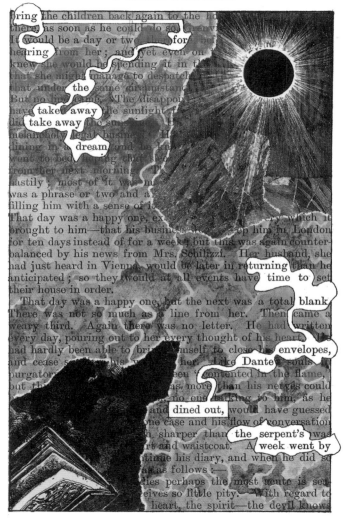

bring the children back again to the H
the as soon as he could do so
It would be a day or two therefore
hearing from her; and yet even on
knew she would be spending it in t
that she might manage to despatch
that under the same circumstance
But no li came. The disappoi
have taken away the sunlight
di take away the so
melancholy legal busine H
dling in good to kn
went to bed ng that he
from her next morning
astily, most of it wa m
was a phrase or two and a
filling him with a sense of it
That day was a happy one, ex y which it
brought to him—that his busine ep him in London
for ten days instead of for a week; but this was again counter-
balanced by his news from Mrs. Schilizzi. Her husband, she
had just heard in Vienna, would be later in returning than he
anticipated; so they would at all events have time to set
their house in order.

That day was a happy one, but the next was a total blank.
There was not so much as a line from her. Then came a
weary third. Again there was no letter. He had written
every day, pouring out to her every thought of his heart. He
had hardly been able to bri mself to close his envelopes,
and cease s his v her. Like Dante's souls
purgator een contented in the flame,
but th as more than his nerves could
no one talking to him; as he
dined out, would have guessed
ne case and his flow of conversation
sharper than the serpent's wa
t and waistcoat. A week went by
tinue his diary, and when he did so
as follows:—
les perhaps the most acute is se
eives so little pity. With regard to
heart, the spirit—the devil knows

what to call it—I am beginning to see that the same thing
holds good. Some of the most pitiable are those that would
be least pitied. I think this week I have been almost mad
sometimes, and even now my temper gets into my pen, and I
talk of the devil before I know what I am doing. I am a fool
—a fool—and yet I am not a coward, for to all the world I
have shown an unruffled front. But—fool I must be; for
what is the cause of my wretchedness? Merely that a woman
in ten days has written only three times to me, and one of
these times only three careless lines. What a trifling calamity
that sounds to one who reads of it—but to me, who feel it—
what has it meant to me? Here is a woman for whose sake I
am renouncing everything. I am remaining in London for no
other reason than to complete the death of my ambition, and
the act that will make me homeless. And though every
hour of the day her image has haunted me. Every thought I
have thought I have mentally brought to her, as some
Catholic votarist lays flowers upon an altar. The one occupa-
tion that has given me any real comfort has been to write to
her. All my hours of exertion have been like steps to the
hour which was dedicated to this writing. And each day all
my hopes naturally were to hear from her. I have been
accustomed to reason with myself from my own experience;
and knowing how to write to her is for me a daily necessity—
how every day I am straitened till this is accomplished, I
could not but conclude that unless her affection were de-
creasing, to write to me would be an equal necessity for
her.

"Two of her letters have been almost worse than none—
evidences of carelessness far more than of care. I was patient
at first, though disappointed; but at last the gathering pain
burst out in my mind like a fountain of bitter water. Much
as I long to be honest, I cannot for very shame's sake commit
to paper all the things I have said about her; and I cannot,
for another reason—because no words could express it—
commit to paper the misery in which I said them. But the
kind of judgment which, in these moods, I have passed upon
her, I can describe in general terms. Just as her connection
with myself has been ennobled and sanctified in my eyes by
my believing it, as I have done, to be the result of a serious
———, so at one moment I was tempted to consider that passion
caprice, was not even strong enough to have the semblance of,

unselfishness her whole conduct and character were entirely
changed the aspect. My devotion to her turned into a
contempt, to be equalled only by my own

It will be perhaps as well if I put actually
two specimens of my accusations against her.
record Here am I am giving up all regards to
and I will not say how much does the more than out
have **said** does she feel **even** I can live
feeling so shows the
be again I have denied myself
things you value in life, you value
your children, the **your clothes** then
after your comfort you have **fancied you**

And day by day, whilst she was forcing me to look like
this of her I was completing for her sake the surrender of
all my worldly prospects. Had I been forced to be solitary,
I think I should have gone mad. I have been constantly
mixing in society by way of a counter-irritant; and the
kindness I have met in the world has seemed such a strange
thing to me, when compared with her cruelty, for whom I
am giving the world up. A few nights ago at a concert,
whom should I meet but Lady Evelyn S——? Was she
different or was I different, from what she was at
Vicenza? It seemed to me that there was nothing but welcome
in her eyes. She took evident pleasure in talking with me.
She contrived to dismiss civilly every one who attempted to
interrupt us; and I remained at her side nearly all
the evening. And I thought, 'I am giving up all for that
hard, thankless woman!' And yet, all that evening, not for
a single moment did I let voice or look convey any thought
or feeling which was more than what a friend might have
conveyed, or by which that hard, thankless woman would
have been wronged.

"Were my whole character this the mood I have been just
describing, I should never have had the heart to make so
miserable a confession. But I have as yet told only half my
story. I have said that I—I myself—have been accusing
her. I was not I, but some pack of rebellious voices in me
—voices of the spirit, which in lacerating her, lacerated me
first, for me—as for my real self—I was ashamed that

merely
think
art

I am coming to
that judgment

I shall be
The fatal
signature;"

as

the dusty
evening shone through his mind
his doubts

connect

at last

he wrote in his diary,

only

oddly

connect

x

connect

The stranger knew all of them

large personages,
the ultra-fashionable stars of society.

the name

my own

label,

asking me if I were myself.

adding
the clouds,

all

posting
art
on

my luggage, a
small bag containing
my
moment

my pilgrimage.

down-pour
dismay

its time
to grow bewildered,

the clipped
clock
blinking

I entered
a great bowl
at first.
light broke from her.
for years; her voice
looked strange.

Have you
felt that this was
likely to reach
a noiseless moment,
no

put off
this moment

determined to reach

art

music

something will be repaid in a great to-morrow.

assurance

I shall

attend to

I can bear

Let us try toge

art

to-morrow
to-morrow

to-morrow, and to-morrow, uninterrupted

hid in the child a king

of light

time however

increased by a

in the gardens

lurked amongst leafage.

passion

remembered and

some gardens had tears in them.

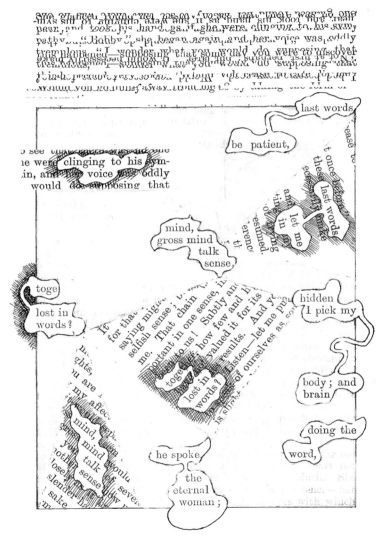

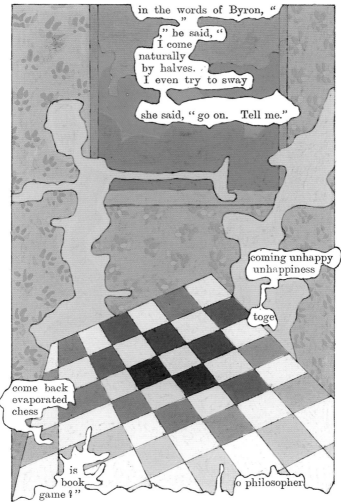

in the words of Byron, "

," he said, "
I come
naturally
by halves.
I even try to sway

she said, " go on. Tell me."

coming unhappy
unhappiness

toge

come back
evaporated
chess

is
book
game ?"

o philosopher

S

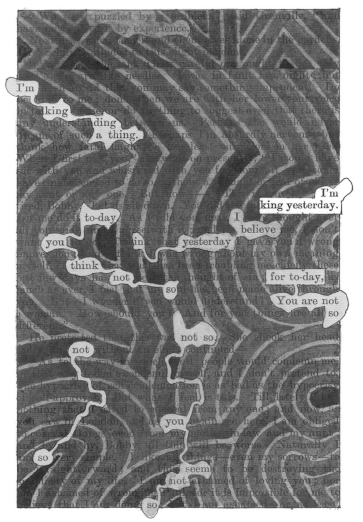

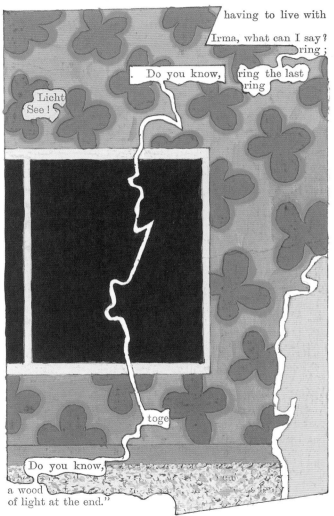

having to live with

Irma, what can I say?
ring ;

Do you know, ring the last
ring

Licht
See !

toge

Do you know,

a wood
of light at the end."

More philosophy!
Come—come. We ordered dinner

broken again
the lot he had chosen

studying the
sudden

the Princess under

in Styria hard and dirty

three legs

came

and

came

come

Princess

she

come to our room to be beaten again

came

long

and wild

and

came hard

selves in his ear against her he managed to drive away, by
quoting from his memory, as a saint might quote a text to the
devil, some former words of love, or some look of trust and
kindness. He tried to place himself in her exact position,
and see the requests she made him as he supposed she saw
them herself. He also—although on reflection he considered
them quite unnecessary—faithfully followed her instructions
with regard to his conduct towards the Princess. Without
committing himself to a statement as to when he was going to
leave, he let the Princess now—as he could do with perfect
truth, that he expected very shortly to be going to see the
Pasha; and more than this, with regard to Mrs. Schilizzi, he
put, out of deference to her wishes, a restraint on his manner
and movements, whenever they were in the Princess's presence,
which seemed as superfluous to his judgment as it was trying
to his feelings.

But though Grenville outwardly was perfectly calm and
good-tempered, and to Mrs. Schilizzi, whenever he was alone
with her, tender, his life for the next few days was one con-
stant effort of self-control. Apart from the Princess, for her
children he daily saw less and less of her. She did not deny
him the walks which had by this time become habitual; but
she professed a distaste for the lonelier parts of the gardens;
she kept as much as she could to the paths which were most
frequented; and she seemed by preference to take the children
with her. She did not find fault or quarrel with him; but
she did what was more estranging. She avoided, as far as
she could, all topics that were personal; and whenever he tried
to approach them, she adroitly turned to others. He had
sometimes thought her hard, he had sometimes thought her
cruel. He was now fretted with an even worse suspicion of
her—that so far as he was concerned she was gradually showing
herself frivolous.

Inward troubles like these, depending on such slight vicis-
situdes, seem to many people to be hardly troubles at all, and
to need on a man's part no firmness in bearing them. Let
such people consider how small and sudden an injury in the
vital part of the body may cause the most intolerable suffer-
ing; and they then may learn that a mind may be sometimes
as sensitive as a stomach; and that the finest minds, though
they may show suffering least, are those that feel it most, and
need most strength to bear it. Grenville's secret sufferings

were of two kinds. First was the sense, made the more
difficult to deal with, because it was doubtful, that the woman
who had been so near to him was now gradually withdrawing
herself; whilst a phantom was constantly facing him of his
own coming desolation. Secondly, was a sense of his own
unutterable folly, supposing the woman to be actually thus
treating him. All the thoughts which were in the service of
his own self-love began to plot together, and break out into
insurrections, threatening her, or clamouring to be revenged
on her; but never, by any sign, angry look or word, did he
allow a sign of this proud tumult to escape him. On the
contrary, whilst one part of his mind was stinging him with
distrust of her and resentment, he forced himself, by the aid
of another part, to act as if he completely trusted her. How-
ever unreasonable or capricious her conduct and words might
seem to him, he forced himself to interpret them in some way
to her advantage; nor did he relax his forbearance, though it
hourly grew more difficult, as he looked in vain for any sign
that she was touched by it, or was even aware of it.

As time went on, the situation became nearly intolerable.
Every day he hoped for some softening change in her; and
every day was the casket of some fresh and complete disap-
pointment. Not only did she avoid anything like personal
conversation, but she avoided even the literary and
subjects in which she had shown the
interest; or if by any chance she would
allude to them, it was of considering
ignored or sharply contradicted him. At last, indeed,
growing to dread rather than look forward to his
with her; when one morning, to his great surprise
received him with a voice and look in which there were their early
days—those days in the forest, and which now like some
lost existence.

"Bobby," she said softly, "I could on to see
you. I am going this morning for a long walk in the
country—you see—I am ready. Have you got your hat?
Then come—"

Hardly able to believe in such a turn of happiness,
Grenville walked by her side. It was out of the road they
were talking till she said, paway he to a place where she
took you once before. He realized that they were on
their way to the mill. On them on they went on presently

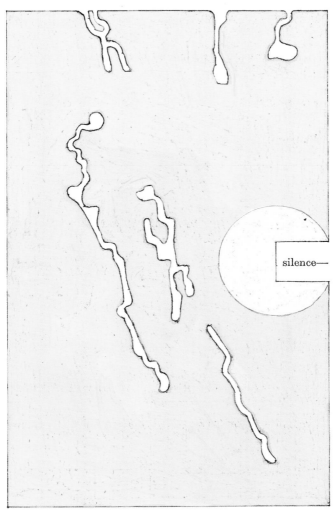

silence—

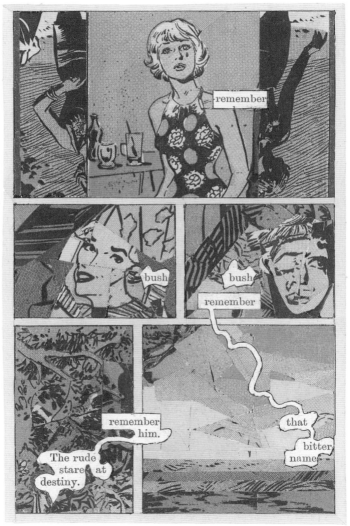

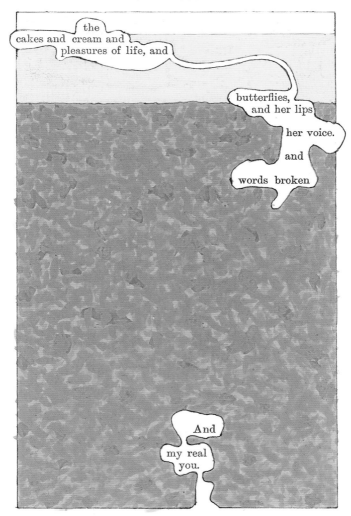

the
cakes and cream and
pleasures of life, and

butterflies,
and her lips

her voice.

and

words broken

And

my real
you.

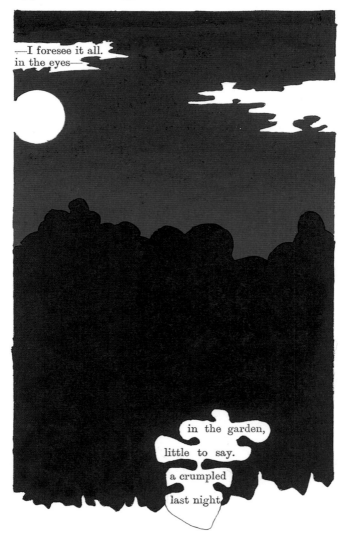

—I foresee it all.
in the eyes—

in the garden,

little to say.

a crumpled

last night

"Read it," ... read it; ... read it, ...

clouds
learn this secret:
turn the
clear lamp—
be faithful

CHAPTER XXVII.

"The event ... growing day by day distincter; but distincter only as ... more distinctly ... has at last become a reality ... I foresaw ... myself,

now that the time has come

like

he has come

written

like shadows,

daylight

painted

'He has come!'

come down to
to observe the
varnished

hands; and then

hasty

order

W

with silver ink

illuminate
his
mythology.

rose-bud

me,
ladies,
me.

in the vaulted hall,
A

figure of
rust

faded fifty; and

faultless

o
w

on their walls
smiled

natural

nothing odd about that;

insisted

toge

girl's eyes were trying to
talk,

The

smoking
man

I believe,

As for

everybody
told me

E
K

collected
ambiguous

to suspect

ask
the King.
and the
'Lady

eleven o'clock

a strange day ago :

ten o'clock ; and to kill the confronted morning

down

moving slowly along

water winding walk

like a wandering flower the whole world among he was there. walking slowly.

fifty people near her

judge, the grass ; he overtook his old fantastic hours

ha ha

And once again yesterday, in the restaurant,

yesterday

in the restaurant.

A figure clothed in a suit of light adorned

distinguished,

dark distinct,

must have been

the devil

But the
changed
moment
Ah,

Ah,
sidling
to me.
prosperity.

gorgeous
clairvoyance,

Smyrna!"

Grenville threw back his head, and half closed his memory.

"if you know where to look for them—God bless me, bill

I fancy, a good bit of the between you and me,— confidential,— out of school

Are you willing to join us?"

a lavender couple of Semitic dandies.

deep quiet

on the green floor

suddenly

influence of the past.

"We know little," he reflected, "when we enter on such a situation as mine, what problems it may in time reveal to us. It is like a plant whose thorns sleep in the sprouting stalk. It must root itself and grow in our lives till we really can know its nature. This man," he continued, "I can't be uncivil to him. Why should I be? On the contrary, I will, unknown to him, do him any good turn in my power. Only it must be unknown to him. I will never have him thanking me; and never from him will I take the smallest favour. And Irma what of her? Does the situation to her seem as hard as it does to me? She appeared this morning to be such a complete mistress of it! I ought to think of her far more than of myself. My moral anxiety was just now too selfish. And yet, in a way, things are simpler for her than for me. However civil and friendly she may be to her husband, she is merely paying him what he may justly claim. He will not put, and he will not want ... construction on her goodness which would

sometimes far more rapid ... any possible
sometimes far slower,

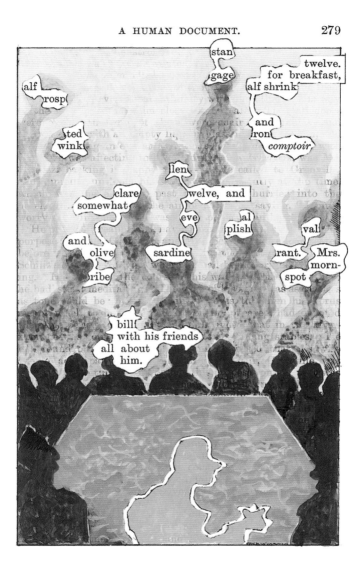

plete than this which would have baffled the eyes of the censorious.

chilizzi, when they all met again at dinn

holly forgo

sterio

ed

rits

quick with champagne

Perhaps, he said, as the banquet drew to an end, you will take my wife Mr. Grenville listen a little to the band have one or two matter with of friends which putting down

on the table, "Irma" he said,

Mr. Grenville must settle the bill toge Sticking in that wall of the side of his head and

together they together once more, silen ly listening to the music, and they parted hard

CHAP

VERA

bonhomie

val

Mr.

mome

norma fawn

occa

les the gay

bill and

tim and

daily

ed getting

she laid her hand on his arm, but as instantly she withdrew it, shrinking to a distance from him. Had any evidence that her insult had been betrayed to some latent loyalty, had she had not only shrunk from him but removed him, for in an **indignant** whisper. There seemed no alternative but like a **moon** still shining for her; but **moon** it was gradually eclipsing itself in the hazy gathering clouds. Apart, however, from the consciousness for which they themselves were responsible, none was the less an action of Mr. Schilizzi. As to what his wife did, he seemed **indifferent** except when some incalculable trifle evoked his resentful anger.

At last, however, a curious change came. The summer arrived, and though there were few English **visitor**, a stray English clergyman had organised a service in the reading-room. To this Mr. Schilizzi, for some reason or other, thought it incumbent on him to go; and having discovered that his wife had a new dress with her that pleased him, he insisted that she should array herself in this, and **come** with him to astonish the congregation. In the afternoon, when, having discarded his tall hat and his prayer-book, he descended from his bed-room, where he had been napping, to **sun** himself in front of the café, he saw his wife strolling across the *place* with Grenville. He had often, **with perfect** apathy, seen her do this before; but now **curve** of her **hurrying** dress at once showed **sun**

...ant for you. ... awayone till dinnerversation with Mr. Grenville. ... see myself that you have a walk as soon as it gets cooler."

"It *is* hot," said Grenville with ready tact. "Mrs. Schil... herself was saying so, just as you came up."

"It's not often," he replied, "that her judgment agrees with mine. Come **come** back ... your sitting-room. Mr. Grenville, will you ... **meet** ...continued."

At dinner the very stillness had come ... passed away and ... Grenville was again left afterwards ... with Mrs. Schil... **the music.**

... said, "has been in a dreadful temper. He... ... how ... making myself so conspicuous ... my arm ... know, at first I resolved that I wouldn't tell you—is ... the elbow black and blue from his pinching it...

"What," asked Grenville, after an expression of sympathy, "what is it that has put him out so suddenly?"

"I think I can tell," she said. "This dress I have on to-day—it's a great deal too smart for the place—but it struck him how pretty I look in it; and he heard, in the hall or somewhere, a Russian Grand Duke admiring me. I knew exactly what passed in his mind; I have noticed in him the same thing so often. I became at once, for the time, a valuable possession in his eyes, and he was determined to show me off as his own exclusive property. He doesn't want me himself; and as long as nobody else does, he never would care if I lived and died alone; but the moment he is reminded that other people may admire me, he likes to take me about in order that they all may stare at me, but is perfectly furious if I give even a smile to them. This afternoon," she went on, " he waited till the gardens were full, and then he walked me about wherever the crowd was greatest, as if he were a peacock, and as if I were his tail. I was so nervous, for whenever I turned my head, I felt his eyes were on me; and he said 'Who are you looking at?' However, as you see, he is perfectly quiet now. He was angry with me on your account for no reason personally to myself; and if you will not be out of reach to-morrow morning, before you hear from me, we may perhaps have better luck than those we have been passing lately. If this is so, you shall have a note by ten o'clock."

She was as good as her word. The note arrived punctually, and the news and the proposal conveyed in it were far beyond Grenville's hopes. Mr. Schilizzi and his boon companions would be absent the whole day, at a town some thirty miles distant, attending a sale of horses. They had, in fact, started already; and she proposed that Grenville should take her and the children to visit once again the hotel and the hunting lodge in the forest. They went. They picnic'd in the lodge,

like incense from some musical with memories;

suddenly
peace with the past.

the return of the

sad smile at

intervals

odd
times
and

always,

my
times
and
your
times
ink
the paper

read
my voice

the paper back
voices

the
moment

at
a word with
the moment

He stamped,
the moment

jeal

is the wrong word.

is

gure

is

dissipation, and the animal curves taken by the plausible

night
morning
yesterday, and
to-morrow.

One whole day,
sponged out of
hours.

Even
morning,
when it came was
glib and
distant,

the band, that music
that
her sofa,
B the night,
repeated
her voice tone her eyes

B
took an added sharp
and crystallized into c

at the end of one

fascinating figure

that she and Mr. S

followed
for five minutes
peeled
attention.

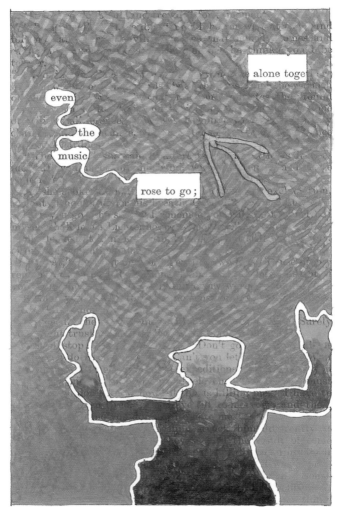

alone toge

even

the

music

rose to go;

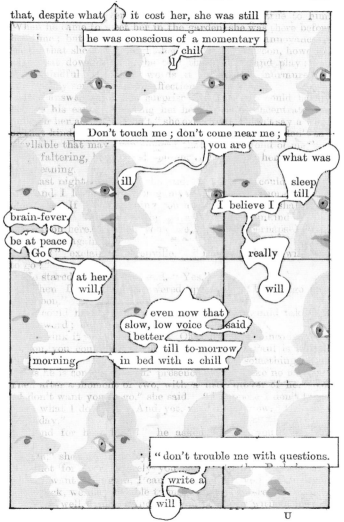

that, despite what it cost her, she was still

he was conscious of a momentary chill

Don't touch me ; don't come near me ; you are

what was

ill

sleep till

brain-fever

I believe I

be at peace

really

Go

will

at her will,

even now that slow, low voice said

better

till to-morrow

morning

in bed with a chill

" don't trouble me with questions.

write a

will

U

" I shall have you again by and by," she said more calmly.

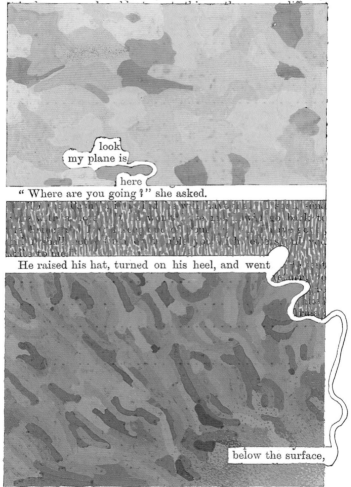

look
my plane is
here

" Where are you going ?" she asked.

He raised his hat, turned on his heel, and went

below the surface,

She had said it would be easy to her to alter the character
of their relations. the thought

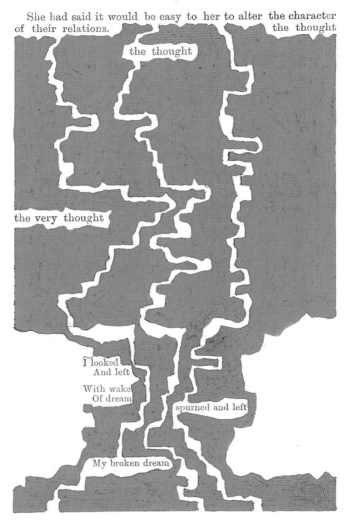

the thought

the very thought

I looked
And left

With wake
Of dream

spurned and left

My broken dream

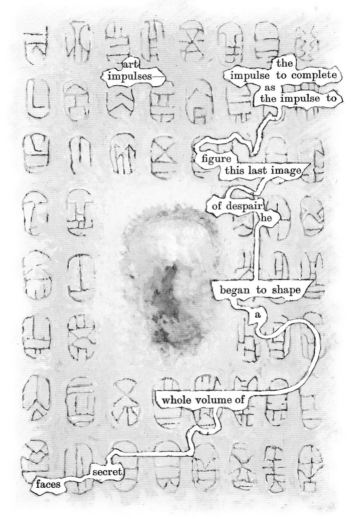

art
impulses—
the
impulse to complete
as
the impulse to
figure
this last image
of despair
he
began to shape
a
whole volume of
secret
faces

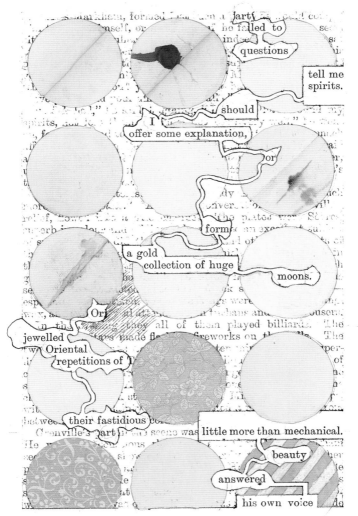

questions

tell me
spirits.

should

I

offer some explanation,

or

form

a gold
collection of huge

moons.

Or

jewelled

Oriental
repetitions of

their fastidious

little more than mechanical.

beauty

answered

his own voice

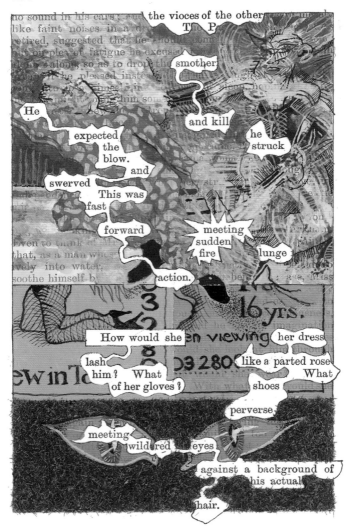

He
expected
the
blow.
and
swerved
This was
fast
forward
action.

smother

and kill

he
struck

meeting
sudden
fire

plunge

16 yrs.

How would she en viewing her dress

lash
him? What
of her gloves?

like a parted rose
What
shoes

perverse

meeting
wildered eyes

against a background of
his actual

hair.

a walking-
pocket-handkerchief

entered,

good-morning
handkerchief
Just smell
the world

ten guineas a bottle. Our
mischievous
bottle in bed-

I like it.

Grenville,

I
have so many buttons I may as well begin undoing them.
Help me. There's no one coming.

the artist's
usual sinister
truggling

forgotten
philosophy
forgotten

something
dawned on his mind

Ashton's hope that he might win Miss Markham's affections, be willing to seize on the throne which the monarch was prepared to vacate. No such thought occurred to him in any serious shape. But when Lord Stanford entertained it, to some degree the belief that it did so gave a fresh impulse to the baser recklessness of his mood. A sort of spurious good spirits now took hold of him, and drove back, and without hesitation he complied with his host's proposal that they should enjoy before dinner a private cigarette in the smoking-room.

Concerning this Grenville was doing a real work of charity. The Pasha's experiences and opinions were so wide and so comprehensive, that there were only a few of them which, with his happy audacity, he was able except in confidence to communicate except to ladies. There were therefore certain topics on which, when he might unbosom the exact condition of his nature, and Grenville presently found how keenly his presence was appreciated. The Pasha, unlike many meaner conversationalists, made no effort at anything. No prompting was needed. His conversation flowed easily like a shiny and babbling stream; nor had he any narrow contempt for jokes or anecdotes that were innocently. He was never bitter, never contemptuously impervious; and yet somehow, though he drew always from experience, he never lowered anything. Nothing seemed to degrade him. He touched pitch and was the cleanest that touched it. The generalization at which he arrived mainly were this—that no attachment was ever wrong if its beginning. "No, no, no," he laughed. "You moralists are purists, and if you only saw things as they are, you would be delighted with what I say. What can be better? Love is an upward progress—an ascent towards the divine, not a descent from it. Your Platonic affection—you can always have that afterwards. Consider, you now our esteemed friend the Baroness. We may speak of her history freely. All the world knows of her and her husband, one David, now dead. Now I, when younger, was once devoted to her. Endless phrases spent upon her—works of interest, of good! But then of course I was successful, without to begin with. You understand? You see my argument," said the Pasha, extending his forefinger, and screwing up his eyes in triumph, like a statesman confiding some astute consideration of policy.

chance words

merely

connect

After inner
yielding to
 the sea. She sang.

her voice
 , thrilled through
liquid
music

 music
to a fathomless

libretto. "Let me live my
life , no matter how
the mountains fall

he felt that
the piano
had finished
him

window

window

toge He felt he
came close to
cool,

a dagger
this

It was
bill

bill.

entered
violently

an avalanche

of the fallen angels.
from the window
winding
red. It reminded him of
ejaculation,

He seized his
eyes

saw him, and the light in them softly trembled under their
shadowy lashes. She was not a talker spoke of
the air, and of the flowers, of last really a
good deal, but which she seemed to for rather
than for their colour, except in so their might be
suitable to her own complexion. made
rose. "Pin it," she said, in my
eyes on him as she spoke and
very patiently dropped them. "I "we
not to go in to breakfast
the afternoon they rode together, Baroness
the arrangement severely conden propriety.
But the informed her that such done in
England. Isa Ashford confirmed the and so
there was to be said. In the again
music and there was no
the art of pro
several
her
narcotic,
aching with
nights;
slowly. He never watching
thought to her thoughts did ut
guests in his min most were no
Still she had her at
her side; about jectured,
were the They were for her no
part little more than its coverlet.
The these two she contrived a new stroke
generalship. Amongst her accomplishments she possessed
that of drawing; and, in alluring him to meet her
before breakfast told him a sitting-room
with she informed him
he was He acted on the hint
eyed to the room indicated; he
helped her with her paints and pencils but despite his assist
ance an hour passed away, a few outlines were all that

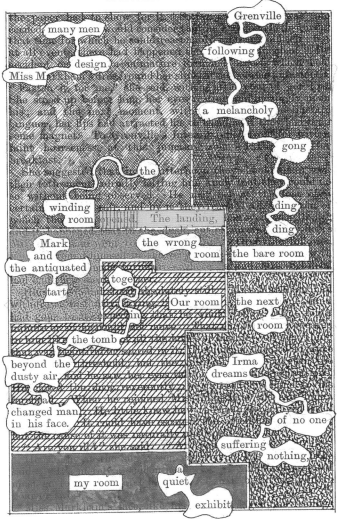

many men

design

Miss Ma...

the

winding room

Grenville

following

a melancholy

gong

ding ding

the bare room

Mark and the antiquated

the wrong room

The landing,

together

Our room

the next room

the tomb

beyond the dusty air

changed man in his face.

Irma dreams

of no one

suffering nothing,

my room

a quiet exhibit

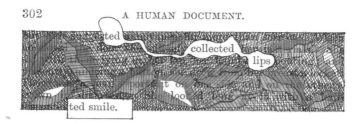

...ted

collected

lips

...n

t o
loo

ted smile.

CHAPTER XXX.

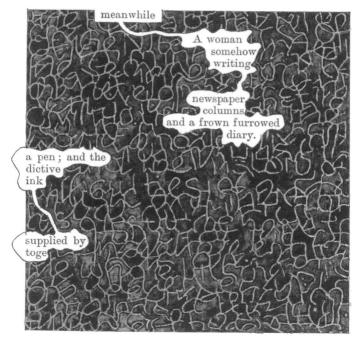

meanwhile

A woman
somehow
writing

newspaper
columns,
and a frown furrowed
diary.

a pen ; and the
dictive
ink

supplied by
toge

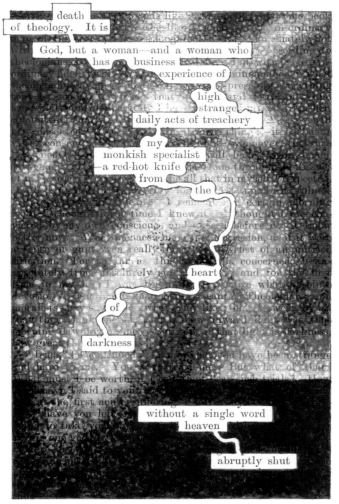

death
of theology. It is

God, but a woman—and a woman who
has business
experience of
that high
strange
daily acts of treachery

my
monkish specialist
—a red-hot knife
from the

heart

of

darkness

without a single word
heaven

abruptly shut

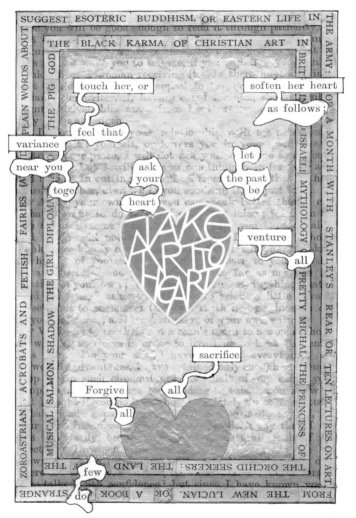

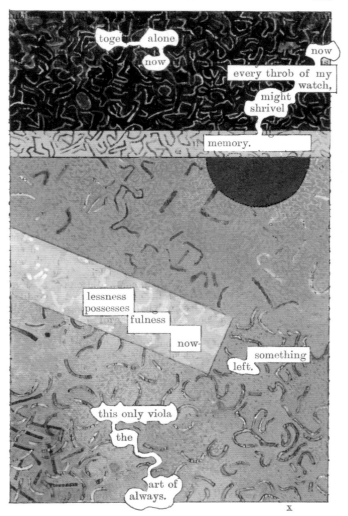

toge alone
now

now

every throb of my
watch,

might
shrivel

memory.

lessness
possesses

fulness

now-

something
left.

this only viola

the

art of
always.

x

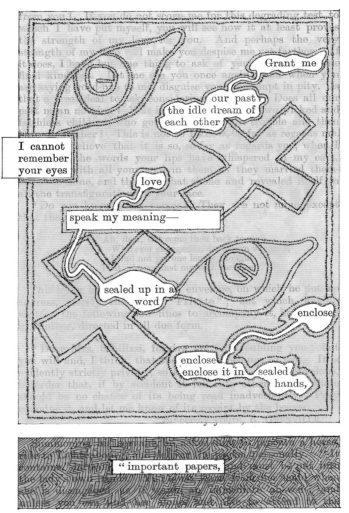

Grant me

our past

the idle dream of each other

I cannot remember your eyes

love

speak my meaning—

sealed up in a word

enclose

enclose

enclose it in

sealed hands,

" important papers,

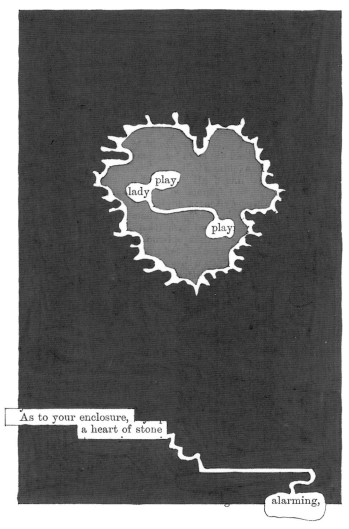

A last note
his spirit blew
see the
caprice of
rifled life,

He put
toge
he
tried to draw her
drawing her
art before self ;
strange
reality

ill

Irma,
ill.

Ill,

ill

in his room ;
take his orders.

ill.

ill

toge he has no strength
as he lies in bed, to drink champagne,

nurse

You
kill me."

she replied,

absorbed in

self-forgetfulness,

giving herself to the depth

of herself

she had everything in woman which kindled him. He made with her the way to delight in touch

some tea, and then
the matter,

the matter

talk
and chatter

had
the
same
attack
before,

—oh, Bobby, tell me, do I bore you?

She looked into his eyes searchingly. He tried to shape an answer, but his lips only trembled. She understood him. Her eyes told him so. She leaned towards him and continued. "All this," she said, "is only the preface to my troubles. The children, though they are supposed to be recovered, are still, according to the doctor, in a very delicate state; and the great thing for them soon—not to-morrow, perhaps, but next day—will be change of air. They will want most careful watching for weeks and weeks. The doctor has lent me a book. For the last ten minutes I've been reading it; so far as I can see, it may be two months before we can be sure that they are strong again. Tell me—what am I to do? Where am I to send them? And must I go with them too? It would kill me to leave them; but then—Bobby—can you tell what I am thinking of? If I don't leave my children, I shall have to desert Paul. Give me your advice. Help me. Think for me. I am bewildered."

"I should like," said Grenville, "to share all your troubles, except your bewilderment. It is lucky I don't share that. I think your course is clear. Your children require you far more than your husband does. At all costs you ought to remain with them."

She walked to the window, turning her face away from him. He watched her. He heard a slight sob, and a slight movement showed that she was gulping down some emotion. Returning to him with swimming eyes, "Ah," she said, "but I feel this." She came close to him. She laid her face on his shoulder. "I feel this," she went on with difficulty. "I have never wronged my children, but I have wronged Paul; so I want to repay him over and over again." She looked up at him with a sudden momentary smile. "I shall make myself in that way more worthy of you. Don't be shocked at what I say. I dare say you don't agree with me; and so far as my thoughts go, I can't think I have wronged him. But from habit, from the way one's been brought up, from the way even conventional opinion has somehow got into one's blood, I feel that I have wronged him, though I dare say the feeling is irrational; and I want to cauterize this feeling by suffering for him—by wearing myself out for him."

"Irma," he said, "whatever my thoughts may be, I too at times have a feeling resembling yours. Till now I have been shy of telling you of it; but I can never again have a secret

entirely practical.

the forest is an excellent doctor,

, and

chance

nurse

able

her

and,

of the nurses time is kindest

m r

"Will you really," she said, "do all this for me?"

Her wondering incredulity, which melted as she spoke into gratitude, profoundly touched him. "Do me one little kindness," he said. "Lend me the doctor's book. I should like to look at it during my journey."

She gave it him and he was gone. He found the Count at home, who received him with the greatest courtesy, and at once placed the lodge at the disposal of himself or of his friends. He then hurried on to the train which was to take him to the Princess. On the way he studied the book. He fancied that with more or less accuracy he could make out the general course which this disease, varying so in various cases, was taking with Paul Schilizzi. Whatever the mother had done and suffered for her children would not have surprised Grenville, though it might have moved him afresh to some new act of reverence for the beauty of her passionate maternity; but with regard to her husband, towards whom, as he knew well, patience was the highest feeling, and indifference the kindest, which his conduct and character made it possible for her to entertain or cultivate—with regard to her husband the case was quite different. That she should see him properly cared for and supplied with the best attendance, that whatever he wished her to do she should do and do willingly, this was natural enough. But what she had been doing, still more what she wished to do, went far beyond this. So far as his wishes went, his illness made few claims upon her. To him a nurse's care would have been just as welcome as hers; and the only thanks she received were either neglect or anger. And yet, in spite of this, she longed to do for him whatever was hardest—whatever to herself was naturally most repugnant; and what it was to which she was thus devoting herself, Grenville realized now, for the first time, as he read the account of the disease, and the attentions which were required by the patient. She had mentioned to him lightly that the symptoms were not agreeable. He now saw, from something else which had been told him by the doctor, and which fixed his attention on certain special paragraphs, that "these not agreeable symptoms" really comprised everything which could try and nauseate constitutions far stronger than hers. The infected air alone would for her be physical martyrdom; and there was nothing to sustain her, not even the sense that she was wanted—nothing but the passionate wish to be true to

an ideal of duty. And for the sake of this she had not only watched and suffered, but had done so, despite all provocation, with a tender and unfailing patience. These thoughts possessed him during the whole journey. "Quia multum amavit!" he several times exclaimed to himself; and then he said, "Let me only be worthy of her, let her only love me, till I die—and I shall not be afraid of death."

The Princess had been forewarned by telegraph both of his coming, and of the cause of it. Grenville were her idols. She was awaiting Grenville impatiently. He told her of the scheme he had proposed, reading them to the Count's hunting-lodge together, with all details as to the neighbouring doctor. She approved highly, praising his readiness of resource; and when he asked her if she herself were coming, she answered petulantly—

"Of course I am, as if she resented its being doubted. "My maid will see about packing my things to-night, and if the children can be moved to-morrow I shall be ready to go with them. But the lodge will that be ready."

"Yes, it will," said Grenville. "There is a train which passes your station at three o'clock in the morning. I return by that, I shall reach Lichtenberg by seven. I will ride over to the lodge. I can get there by half-past ten, and I'll engage that by to-morrow afternoon the whole place is fit for you."

"My poor friend," said the Princess with motherly pity, "you're almost dropping with sleep. You look yourself as if you'd been ill enough for all three of them." Grenville laughed and roused himself, for he was indeed nearly exhausted. "I tell you," said the Princess, "who causes me most anxiety. That is Irma herself. Of course in remaining with her husband she incurs the very gravest danger; and from what you tell me, her husband does not require her."

"I can't be sure," said Grenville, "how far she realizes the risk; indeed I myself till this afternoon knew very little about it; but I made her promise me that, at all events till I returned, she would stick to her children and leave him to the doctor and the nurse."

"I," said the Princess, "will write her a note for you to give her. Any scrap of paper will do. I have one here. Will you lend me a pencil? Read it," she went on when she had finished.

F

Every time you
get this letter—

you

have to

screw

the Princess,

on a sofa
the porter

found himself
damp

and it was not yet seven by

last night's
smell of

instantly

mistress
instant mess

the door of her bedroom opened ;
and a diaphanous
dressing-gown

softly came

eagerly

through. As she did so

she said to him. have
what you will
but suddenly

suddenly

night, and the room

, I did whatever there was to do.

; and it seems to me now like running away

pain; and yet, when you speak of them, you disarm me. I have not the resolution to leave them; though—don't you think this?—for a week or so they could do without me."

"You quite forget one thing," he urged. "You might by remaining here make yourself unable to go to them for many a week, or, Irma, perhaps for ever. Have you any right to run that risk? Have you the heart to do it? You wouldn't run the risk of leaving them alone in the street. Can you bear the thought of leaving them alone in the world? As for your husband, you may safely commit him to the Princess; and I will remain here also, to do whatever I can do."

"I yield," she said. "I see that you must be right. To be away from that sick-room costs me far more than to remain in it. Go, dear friend, and arrange things as you please for me."

A horse was ordered for Grenville, whilst he ate a hasty breakfast; and soon once more he was at the familiar hunting-lodge, making all necessary arrangements for Mrs. Schlizzi's arrival. Nothing escaped his forethought. Various provisions he ordered her from the hotel, and some articles of furniture which the manager kindly lent him. He had also a long interview with the doctor. Returning to Lichtenbourg, he found that the Princess had arrived, who was delighted—so far as the circumstances permitted of such an emotion—at finding her advice had been taken; not dreaming that it had needed seconding. Everything was ordered by the ever-useful Fritz; and almost before Mrs. Schlizzi knew what had been done, her boxes had been packed and sent off with a couple of servants; whilst a capacious landau, specially constructed for invalids, was waiting at the door in the warm afternoon sunshine, ready for herself, a nurse, and the two children. The briskness of the Princess's manner was of great service on the occasion. She told her niece she was "silly and wrong and selfish" for having any reluctance to do what so clearly was pointed out to her, not only by duty, but by ordinary common sense; and with a semblance of anger, which acted like a moral tonic, and was sweetened at the same time by an under-current of deep kindness, she almost drove the little party out of the house into the carriage, where she carefully packed the children, kissing them whilst she did so. As they all drove off she stood waving her wrinkled hand at them, and forcing a cheerful smile, till a turn in the road hid them; and

nobody without such a tube could perform it

"Never," said Grenville, and I only photograph afterwards."

Irma will be yours for ever. Ah, my

fancy

fool.

you

felt

deceiving dreamer—
wicked weakness,

love
noiselessly left him,

inquire

what

paper

person
next.

will

sprain
bed.

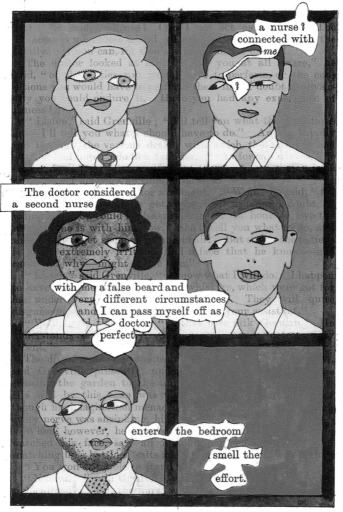

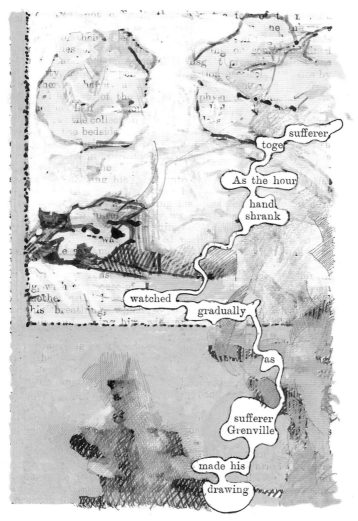

sufferer
toge
As the hour
hand
shrank
watched
gradually
as
sufferer
Grenville
made his
drawing

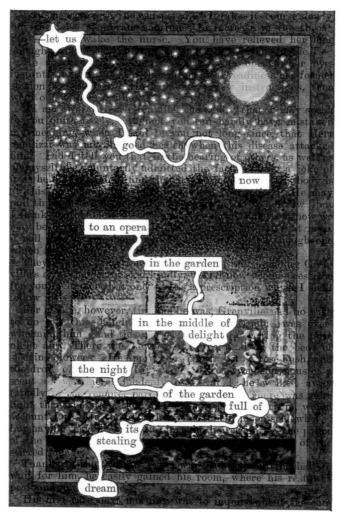

—let us wake the nurse. You have relieved her

now

to an opera

in the garden

in the middle of
delight

the night

of the garden
full of

its
stealing

dream

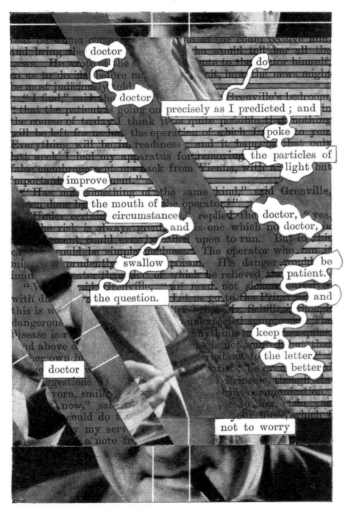

doctor

do

doctor

precisely as I predicted ; and

poke

the particles of

light

improve

the mouth of the operator

circumstance the doctor, " yes,

swallow

patient.

the question.

and

keep

the letter

better

doctor

not to worry

chance lies in my opera

to him again and again but he had resolutely refused to dwell on it, or on the prospects which lay beyond it, and absorbed as he had been in practical and painful effort, he had repelled it easily.

But now it presented itself to him more importunately and vividly, and he felt he had earned a right to speculate on the consequences of a death which he had risked and perhaps suffered, his own life to avert. This mood, however, did but last for a moment or two. He had hardly yielded to it before it shocked and disgusted him, and he presently exorcised it by sending his thoughts forward to the relief, if not to the pleasure, which he would be bringing to Mrs. Schilizzi by news pointing to the recovery, not the death, of her husband. He soon forgot everything else in this. The pleasure to himself even of being once more in her presence, and of reading the secret in her eyes which swam in them through all her trouble, was a prospect which gave place in his mind to the pleasure of the relief which, unconnected with himself, would come to her from the news he brought her.

As he approached the lake, the first thing that caught his eye was her red dress and parasol, motionless by the border of the lake. At the sound of hoofs she suddenly turned round, staring at him, doubtful as to who he was or what was his errand. As he drew near, however, and as she recognized his face and his expression, she eagerly came forward with a smile of hope and of inquiry.

"I have come," he said, "to relieve you of the anxiety which I know must have been wearing you out here. You got the note which I sent over this morning?"

"Yes," she said. "How good of you! It arrived two hours ago."

"Well," he continued, "I have a later bulletin for you. He was far easier when I left him than he has been for the last twelve hours. You need not fret yourself because of your being here. There is nothing you could do for him that is not done by his attendants; and your presence might excite him them quite quiet.

"And has he," she said, "not asked for me?"

"He has asked for no one," said Grenville. "He has not mentioned your name."

He wondered as he told her this whether she would be hurt

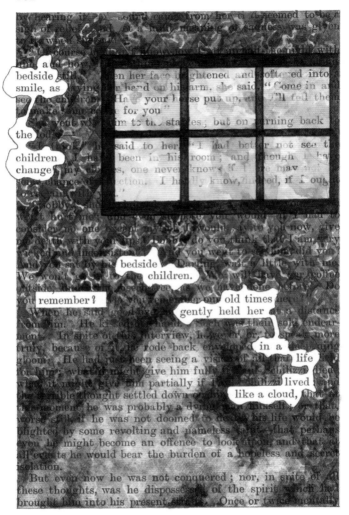

bedside smile, as

the children change

bedside children. remember? old times gently held her in a life like a cloud,

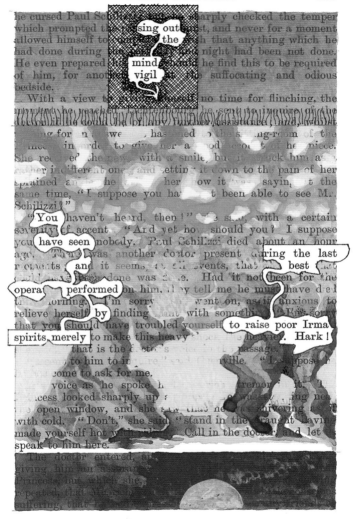

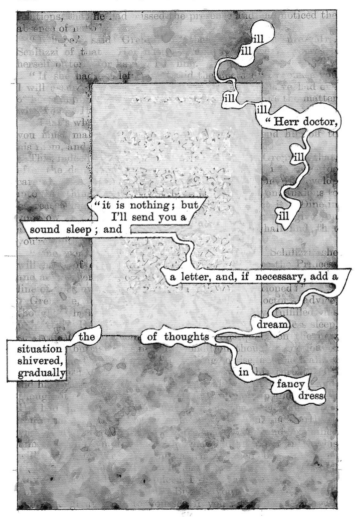

ill

ill

ill

ill

" Herr doctor,

ill

ill

" it is nothing; but I'll send you a

sound sleep; and

a letter, and, if necessary, add a

dream

the situation shivered, gradually

of thoughts

in

fancy dress

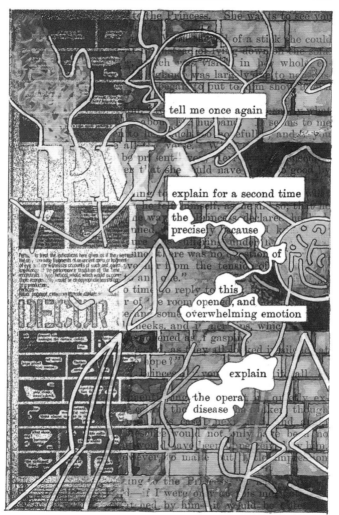

tell me once again

explain for a second time

the

precisely because

of

overwhelming emotion

explain it all

the opera

disease

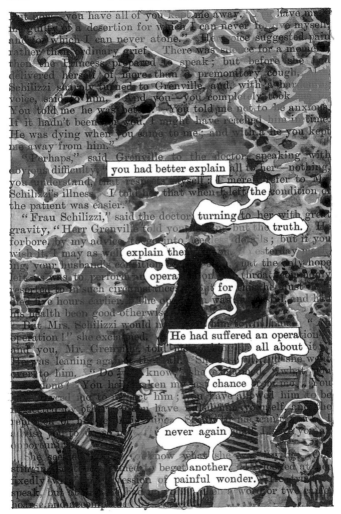

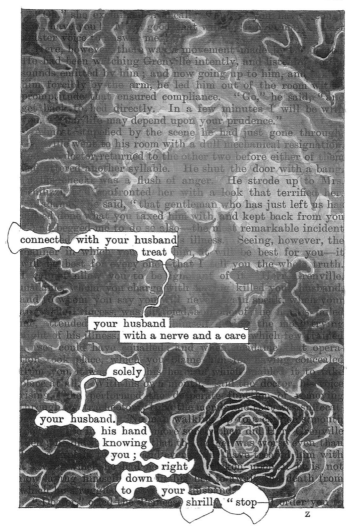

connected with your husband treat

your husband with a nerve and a care

solely

your husband. his hand knowing you; right down to your husband shrill "stop"

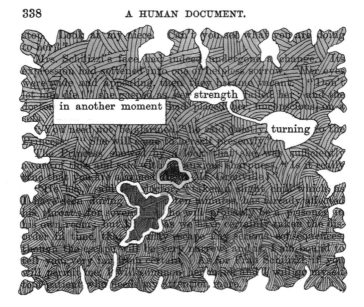

CHAPTER XXXII.

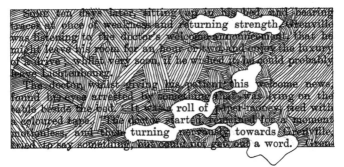

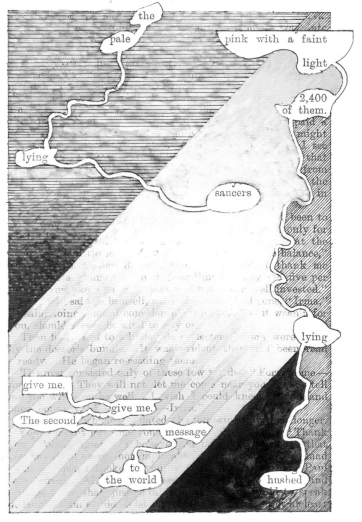

the

pale

pink with a faint

light

2,400
of them.

lying

saucers

lying

give me.

give me.

The second

message

to
the world

hushed

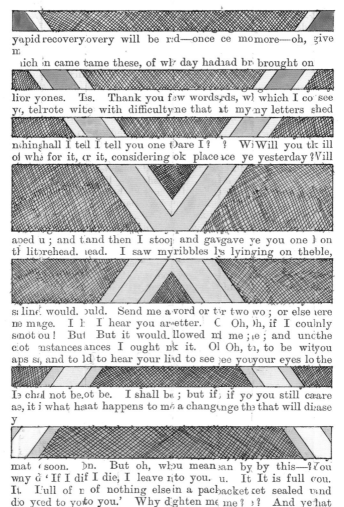

yapid recovery overy will be r;d—once ce mo more—oh, give
m

iich n came came these, of wl day had ad br brought on

lior yones. Ls. Thank you few words rds, wl which I co see
yc, tel rote wite with difficulty ne that it my ny letters shed

nuhing hall I tell I tell you one Dare I? ? Wi Will you tk ill
of wh. for it, cr it, considering ok place ace ye yesterday? Will

aped u ; and t and then I stoo] and gav gave ye you one l on
tl litorehead. ead. I saw my ribbles l's lyinging on the ble,

s: lind would. ould. Send me a vord or t'r two wo ; or else ere
ne mage. I l I hear you ar etter. C Oh,)h, if I coulnly
smot ou! But But it would. llowed nl me ; ie ; and und the
c:ot nstances ances I ought nk it. Ol Oh, ta, to be wit you
aps s, and to ld to hear your lind to see see you your eyes lo the

I. chal not be ot be. I shall be ; but if; if yo you still caare
a., it i what ha at happens to me a chang ange th that will di ase
y

mat (soon.)n. But oh, whou mean an by by this—? You
wny d 'If I dif I die, I leave nto you. u. It It is full rou.
It. Full of n of nothing else in a pac backet ret sealed und
d:o yced to yo to you.' Why d ghten me me ? > ? And ye hat

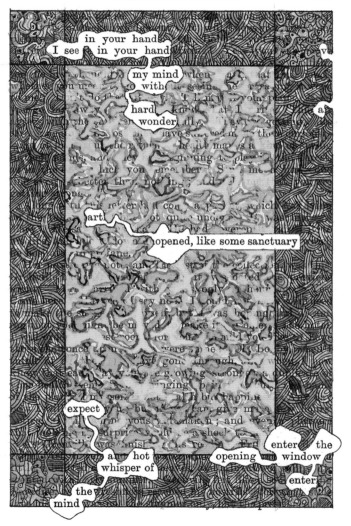

in your hand

I see in your hand

my mind

hard

wonder

art

opened, like some sanctuary

expect

enter the
opening window
and hot
whisper of enter

the
mind

of an unbelievable to which his own life was
expanding. breakfasting in the sitting
room lately vacated by the Princess. Then followed his drive.
His first excursion in the environs of Lichtenbourg had been
that way on the morning when Mrs. Schilizzi had
............ him that she wished rid her of his
company, and himself castle. That
............ he had known to wander every road
held happy memory of her which would then have haunted
him in misery. But now he was again
............ return memories were
............ it beneath was
............ and he lingered
............ he found himself in
the the whole with blossoms.
High bosom
Thorn broke out into masses of white and pink,
their penetrating
houses memories blossoms
everywhere like the

The evening the informa-
tion that, those and proper
cautious, and if he would not travel too far he
might leave Lichtenbourg next day. And where, he asked
presently, would you think of going?

The question caused in Grenville a certain amount of
embarrassment, but without any actual untruth he managed
to get out of it creditably. The Princess, he said, will
have me whenever I wish to go to her, but before doing that,
I must see Mrs. Schilizzi; so I thought of going first for a day
or two, to the hotel in the forest.

The doctor declared that nothing could be better than this,
as the air there was healthy and bracing to an extraordinary
degree. In fact, he said, I should advise you to remain
there till you are quite strong again.

And now, said Grenville, I must ask you an important
question, and I trust you to answer candidly. Do you think
that my health in any way has suffered, or is likely to suffer,
from what I have gone through? I say in any way, and you
will not misunderstand my meaning.

Herr Grenville, said the doctor, had your health been
less sound than it was some ten days ago, my answer might

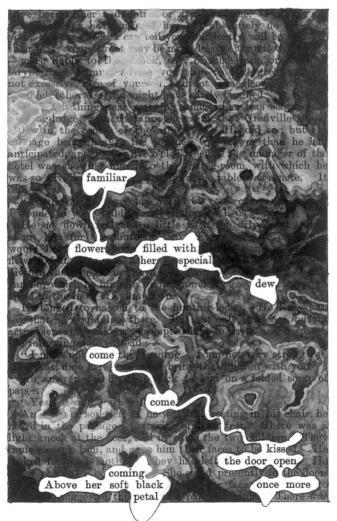

familiar

flower filled with her special dew

come come

the door open

coming

Above her soft black petal

once more

gentle

shining children

stand-beside you

toge

One child bone; the other gravy;

I will watch them from the

fairy

balcony

two small forms flitting about below

clump of bog-myrtle rose a large pale-winged moth, to which the
children instantly gave chase, jumping into the air, and reach-
ing their hands towards it. As she watched this incident, Mrs.
Schilizzi laughed. The sound was that unconscious ripple
which Grenville knew so well. He turned to her. Her face
was bright with a happy smile. It was a smile like the year's
first snowdrop.

"Bobby," she said, "you mustn't stay out too long. You
look so worn and tired. You had better come in now. Take
my arm; you are not too proud to lean on me."

She closed the window, to as to keep the draught from him.
She seated herself beside him on a sofa, and looked at him
gravely and in silence. He lost his head, and a slight move-
ment towards him, in an instant gently and closely, like
the tendrils of noiseless plants. He was soon about her
neck, and his lips were whispering in her ear; Emma, from
this day will never—with never leave you.

"Hush, oh, hush!" she murmured softly, disengaging
herself. "I will not—to leave you a little longer will let me
remain with you. But for a little while you must let me
watch over you. It is because you are very weak still, and
because—" Her voice was a little plaintive. "You are not strong
even—

There had arranged, before separating, if the weather
. . . though bringing them again
into the forest, and of a certain beech-
tree, whose smooth stem still spoke to their memories. The
morning brought with it all that could have wished
for. The scented air touched them like cool water, and they
drove with the children along the remembered tracks above
which the squirrels still leapt in the branches. They found the
glade they sought; they found the very beech tree. They
themselves under its shade, which now was a darker green.

the peace of the present

almost a dream

passing
we still have some

settle

settle our conscience

our conscience

something to

pay

pay
pay

the

payment due,

turn the dark
lamp

toge

fret now

about thin
thin

settle
our past,

future.

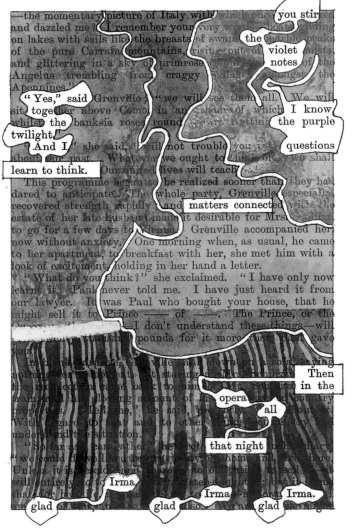

—the momentary picture of Italy with which once you stir and dazzled me? I remember your very words ... boat ... on lakes with sails like the breasts of swan ... the marble peaks of the pure Carrara mountains rising out of ... mists, and glittering in a sky of primrose of the Angelus trembling from craggy village ... amongst the Apennines."

"Yes," said Grenville; "we will see them all. We will sit together above Como in an ... of which I know whilst the banksia roses round ... are setting the purple twilight."

"And I," she said, "will not trouble you ... questions about the past. Whatever we ought to think of ... we shall learn to think. Our united lives will teach ...

This programme began to be realized sooner than they had dared to anticipate. The whole party, Grenville especially, recovered strength rapidly; and matters connected with the estate of her late husband made it desirable for Mrs. ... to go for a few days to Vienna. Grenville accompanied her, now without anxiety. One morning when, as usual, he came to her apartment, to breakfast with her, she met him with a look of excitement, holding in her hand a letter.

"What do you think?" she exclaimed. "I have only now learnt it. Paul never told me. I have just heard it from our lawyer. It was Paul who bought your house, that he might sell it to Prince —— of ——. The Prince, or the ... —I don't understand these things—will thousand pounds for it more than ... gave ...

In ... case, ... ville ... down on ... sofa, saying nothing for ... but staring at Mrs. ... She back to him ... Schizzo ... him a glowing account of his ... opera ... country properties ... "Then," he said, ... With regard to ... and to other understand the situation.

"So far as ... can gather," he wrote ... that night ... Irma, "we should ... like ... to ... you ... home ... have here. Unless it is resolved ... these ... no one ... himself will entirely ... to Irma ... glad ... to Irma ... glad ... Irma. ... glad ...

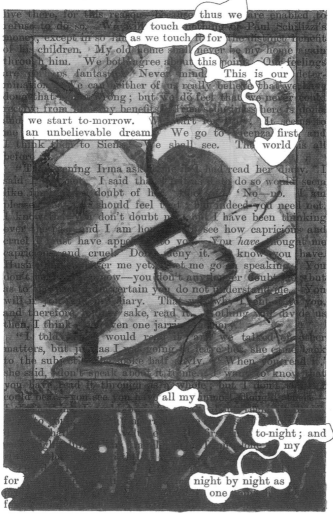

live there, for this reason ... thus we are enabled ... refuse to do so. ... touch ... Paul Schlizzi's money, except in so far as we touch it for ... benefit of his children. My old home shall never be my home again through him. We both agree about this point. Our feelings are ... fantastic. Never mind. This is our ... determination. We can neither of us really believe that we have done that ... wrong; but we do feel that we never could receive from ... any benefits ... darkness here is ... and we start to-morrow. We start ... It seems to me an unbelievable dream. We go to ... Vicenza first, and I think then to Siena. We shall see. The ... world is all before ...

"This evening Irma asked me if I had read her diary. I said ... I said that ... to do so would seem like ... doubt of her ... 'No—no. I am pleased ... should feel that ... but indeed you need not. I know ... don't doubt me, but I have been thinking over ... and I am ... to see how capricious and cruel I must have appeared to you. You *have* thought me capricious and cruel. Don't deny it. I know you have. Hush ... over me yet; let me go on speaking. You don't ... now—you don't any longer doubt ... but as to ... certain you do not understand me. You will ... diary. That ... why I want you, and therefore ... sake, read it ... nothing ... divide us then. I think ... even one jarring ...

"I told ... would ... as we talked of other matters, but just as I was going to leave her she came back to the subject ... spoke half shyly. When you read it, she said, don't speak about it to me. I want to know that you have read it through as a whole, but I don't ... could bear ... you see you have ... all my ...

to-night; and my

night by night as one

for
f

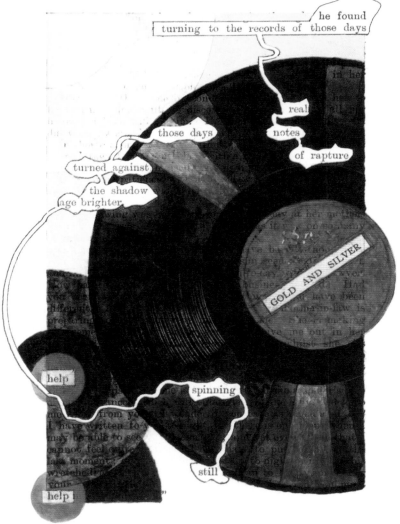

he found

turning to the records of those days

real

those days notes

of rapture

turned against

the shadow

age brighter.

GOLD AND SILVER

help

spinning

still

help

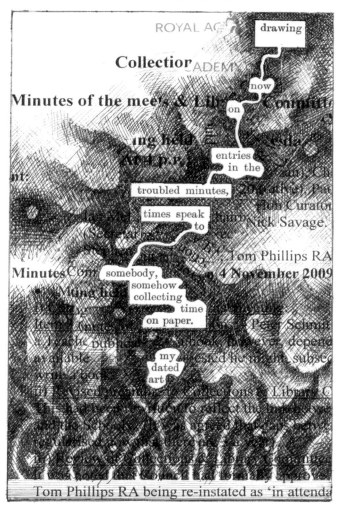

drawing now on entries in the troubled minutes, times speak to somebody, somehow collecting time on paper. my dated art

not

to be good

to be

never

to

the sea, troubled

Hamlet's father, from another quite different book

never realized

conscience

heard before

man

appreciate reasoning as well as a man can; but it is not by
reasoning that she sees her own way in perplexity. I can
reason, and say that I am breaking some ties which, if
everybody broke, all society would be ruined. But then
again, comes an answer—an answer I learnt from you—that
what we do depends upon what we are; and that if all society
were as true as you and I are, and if all couples loved as we,
society would not be ruined, but would be saved. Again, I
can say that I am making Paul miserable by giving to you
what is due to him alone. But again comes the answer, that
this misery is merely imaginary—merely the creation of some
conventional formula; for I am merely giving to you what to
him is wholly valueless. So too I can apply to myself—and I
have applied them as if I were in getting myself—all those
names such as "impure," "degraded," "faithless," shameless,
and so on, which are always the first stones cast at women
like me. But against names like these I hardly care to defend
myself. I know them to be so inapplicable that they hardly
cause me uneasiness. All they can do is to turn me away
from argument, and drive me back to my own consciousness of
myself, and in spite of every argument they still remain the
same, like a flame inside a lantern which no wind can agitate.
And then I know with a woman's absolute certainty—with a
certainty which I would die on—that my heart is not impure,
that I am not shameless or degraded, that my one aspiration is
not to be faithless, but to be faithful; and that in spite of
the many selfishnesses which sully one's daily life, I long to
consecrate my whole being to you. I feel, as I write this, as
if I were being lifted off my feet by some wind of the spirit;
and as if the voice of the spirit were inspiring me. What
nonsense that would sound if I were saying it; but I
am it is full of meaning. Words—words! Where are you?
Come and help me. Make me intelligible. I don't know
what to say. If a rose has blossomed, can I help it? If an aloe
has blossomed, can we help it? Well, here is something I can
see. I can see that under your influence, Bobby, I myself
have blossomed. It's a fact. I know it to be one. Why
should I vex myself by insisting on it any farther? As for
arguments, they may play at see-saw if they will. They will
sometimes make me feel that there is nothing to be said for
us, sometimes that there is nothing to be said against us.
But whatever is true, I know I have chosen my part.

you;

loving you was the first right thing

a mystery

written on the night

Oh, come, come quickly!
I long for your coming
Yes—come!

My

together

now

mine only;

I want

I want the most

! I want your whole sole love—your complete

all within me—

all

all

troubled by echoes of my childhood hammering my mind,

I see what they do not know. I have deeper kind.

that I long to

say

(eye)

in my affection,

I long to

fetch and carry for you devoted

verse.

 say much to you; and I feel angry for that very reason, and vent my anger on you.

"Last night you were cold and distant. I was, I know; but I didn't want you to be. If you could only have a little more penetration, you would see that when in speaking to you I have seemed most hard and odious, I have really been longing to cling to you, and tell you I was your own."

Presently came this passage, which, as Grenville read it, sent the blood to his cheeks.

"I have driven you away? I have told you to go. I couldn't help it. I should have gone mad if you had stayed—at least I thought so. And now you are gone. Till I see you again I can write no more diary. Already I want you back."

Then followed this, written during his visit to the Pasha.

"I said I would write no more till I saw you, till I had you with me again. But I must write. I must ease my mind somehow. When are you coming back? Everything is blank without you. Paul is rather poorly. I have been nursing him as much as he would let me. That at all events was a duty. But he would let me do little. He preferred the company of—what shall I call her?—my rival—one of my twenty rivals: and most of my time I am alone. Oh, Bobby—what can I do without you? You will come back soon, won't you? I don't know how to write to you."

Next day she wrote, "The children are both ill, as well as Paul; so I could hardly see you now, dear, even if you were here. All day I have been by their little beds; but all through my care my heart is aching for want of you. I believe you will come soon; for cruel as you seem to have treated you, I believe in you so entirely. I am weary in body, and sick in mind. Come to me."

Having studied these passages and others relating to the same period, Grenville felt that his principal right to the secrets of the volume was gone. All of her conduct that had pained and troubled him was explained. He had felt, whilst reading her account even of this, as if he were treading on sacred ground; and he shrank from perusing these earlier parts which referred to the period before his perplexities had begun. Her whole life lay here undisfigured upon the pages, which she had put into his hands unreservedly. But still, that he might not seem to be abusing her confidence, or missing anything which she might really wish him to know, there was

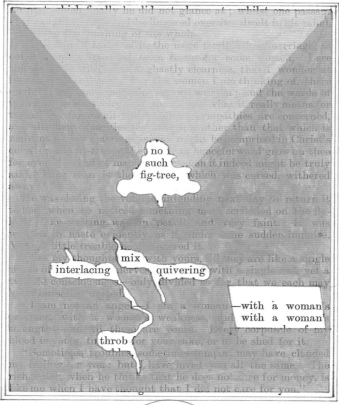

... did ... lly he did not glance at; whilst one passag...
... over... dwelt in his mind
... meaning of the whole.

... the more terrible ... marriage ...
... seen ... for some women. I see
... ghastly clearness, that I wonder ...
... women I am thinking of, there ...
... w ... y ... the words of ...
... via ... really means for
... sympathies are concerned,
... than that which is
... be comprised in Christ's
... no ... henceforward grow on thee
such ... en it indeed might be truly
fig-tree, which was cursed, withered
... away

... was ... ing the vel... intending next ... to return it ...
when he noticed ... nothing more scribbled on the fly ...
... the writing was in pencil, and very faint. It was ...
... n haste exactly as if under some sudden impulse.
... little trouble ... red it.

... may thoughts mix with yours. They are like a single ...
interlacing ... in each ... quivering with a single ... yet a ...
... consciousness only divided so far that we each may ...
... tears ...

I am not an angel I am a woman—with a woman's
... you, with a woman's weakness, ... with a woman's
... ength ... all those are yours. Every corpuscle of my ...
... od is yours, to throb for your sake, or to be shed for it.
"Sometimes troubles, sometimes temper, may have clouded ...
... belief in you; but I have loved you all the same. The
rich ..., when he thinks that he does not care for money, is ...
... me when I have thought that I did not care for you."

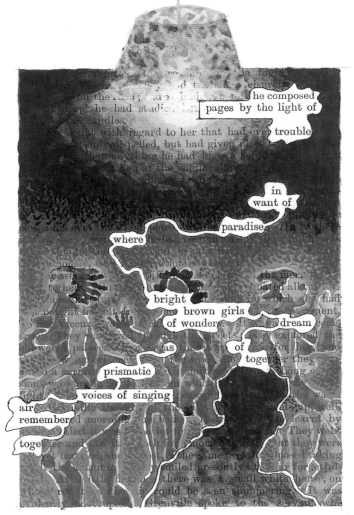

he composed
pages by the light of

trouble

in
want of

paradise,

where

bright

brown girls
of wonder dream

of
together

prismatic

voices of singing

air
remembered

together

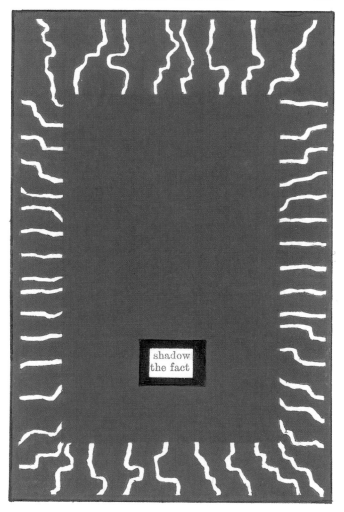

shadow
the fact

All the same I maintain
his longing for what
have this longing an
by love alone, but
when the documents
Downing Street,

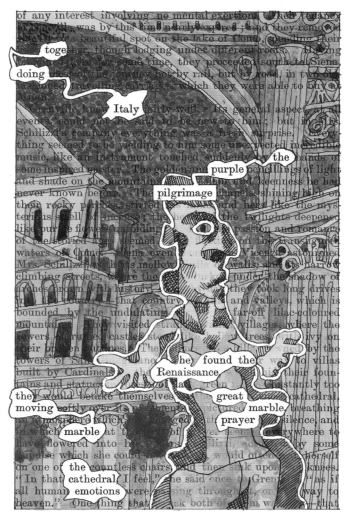

of any interest involving no mental exertion. Their journey, indeed, was by this time nearly expired; and they removed shortly to a beautiful spot on the lake of Como, spending their together, though lodging under different roofs. Having for some time, they proceeded south to Siena, doing the journey not by rail, but by road, in two

Grenville knew Italy but well. Its general aspect, at all events, could not be said to be new to him; but in Schilizzi's company everything was a fresh surprise. Everything seemed to be yielding to him some unexpected inexhaustible music, like an instrument touched suddenly by the hands of some inspired master. The golden purple of light and shade on the mountains and keenness he had never known before. The pilgrimage chapels, shining high on their rocky perches, stirred and held like the mysterious smell of incense; the twilights deepened like purple flowers, holding passion and romance of the storied age, seemed on the waters of Como. Siena even Vicenza astonished Mrs. Schilizzi, with its mellow walls and its narrow climbing streets, where the market under the shadow of arches brown with history, they took long drives that country and valleys, which is bounded by the undulating far-off lilac-coloured mountain. They visited villages, where the towers of ruined castles trees of ivy on their broken bushes. The villages owned by the towers of San they found their way to villas built by Cardinals fountains and statues green. Constantly too they would betake themselves great cathedral, moving softly over its marble, breathing an atmosphere which silence, and in which at the seen everywhere to have flowered into Schilizzi, by some impulse which she could world often herself on one of the countless chairs and they sink upon knees. "In that cathedral I feel," she said once to Grenville, "as if all human emotions were rising through, on way to heaven." One thing that both of them was that

Autumn
arrived

and
they bought
the Mediterranean,

and

by the square yard,

summer

paintings
the rooms were well-
ready to receive

even

the

children

recognized

demoiselles

"Allo me" said Grenville with ready presence of mind,
"allow me to introduce you to my wife. But I beg you have

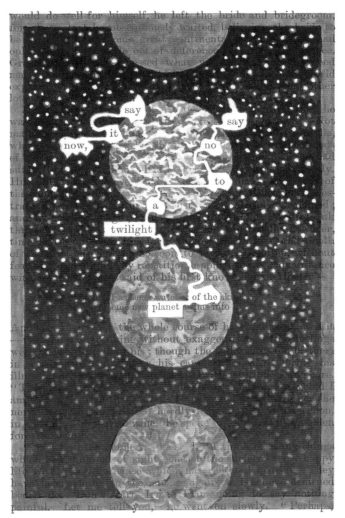

say
say
now,
it
no
to
a
twilight
of the sky
planet swims into

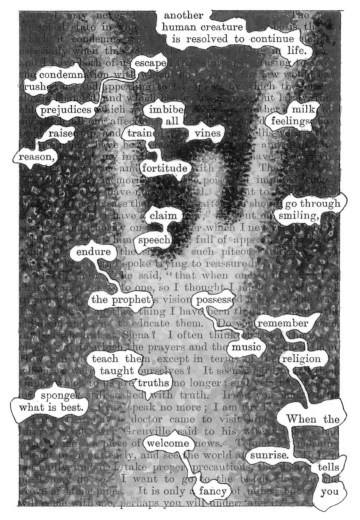

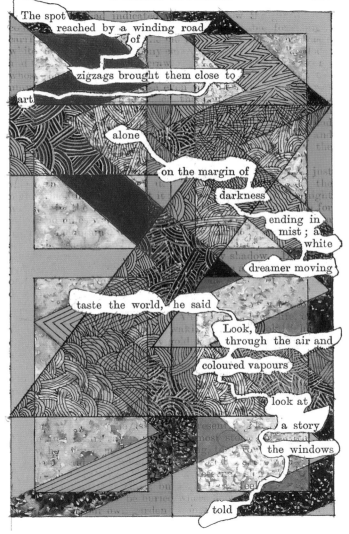

The spot
reached by a winding road
of
zigzags brought them close to

alone

on the margin of

darkness

ending in
mist ; a
white

dreamer moving

taste the world, he said

Look,
through the air and

coloured vapours

look at

a story

the windows

told

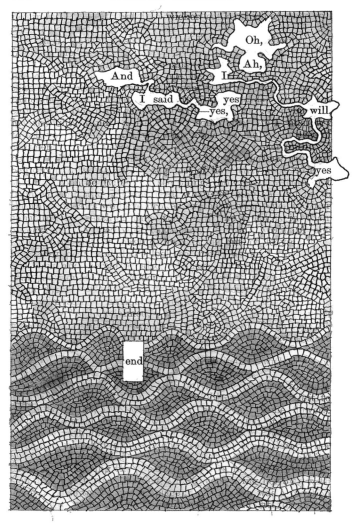

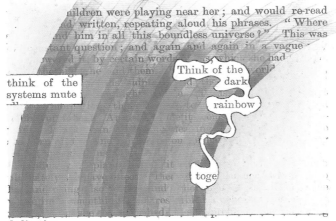

hildren were playing near her; and would re-read
written, repeating aloud his phrases. "Where
him in all this boundless universe?" This was
question; and again and again in a vague
by certain word

think of the
systems mute

Think of the
dark

rainbow

toge

dedication—

"TO THE SOLE AND ONLY BEGETTER OF THIS VOLUME.

"You by whose side I shall lie, in a wicker coffin like yours,
with whose bones my bones shall mingle; and whose flesh
shall meet my own in the cup of the violets above our grave,
have done my best, whilst waiting to come back to you in
death, to perpetuate in this book neither your life nor mine,
but that one single life in which both our lives were fused.
Were my power as a writer equal to my love as a woman,
that life should live in these pages, as it lived and breathed
once in our now lonely bodies. I would make it live—all of
it; I would keep back nothing; for perfect love casts out
shame. But if any one should think that I ought to blush
for what I have written, I should be proud if, in witness
of my love for you, every page of it were as crimson as a
rose."

THE END.

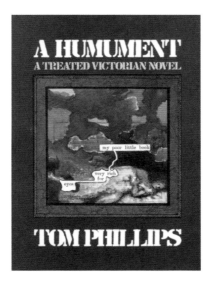

A Humument started life around noon on the 5th of November 1966; at a propitious place. Austin's Furniture Repository stood on Peckham Rye, where William Blake saw his first angels and which Van Gogh must have passed once or twice on his way to Lewisham.

As usual on a Saturday morning Ron Kitaj and I were prowling the huge warehouse in search of bargains. When we arrived at the racks of cheap and dusty books left over from house clearances I boasted to Ron that if I took the first one that cost threepence I could make it serve a serious long-term project. My eye quickly chanced on a yellow book with the tempting title *A Human Document*. Looking inside we found it had the fateful price. 'If it's a dime,' said Ron 'then that's your book: and I'm your witness.'

A Human Document, 1892

W. H. Mallock in 1907

It turned out to be a novel by someone that neither I nor my even more bookish companion had heard of, W. H. Mallock. The words 'ninth printing' above the date 1892 suggested, however, a certain popularity when it had been published by Chapman/Hall. Fortunately for me, as it turned out, Mallock's stock had depreciated from three shillings and sixpence at the rate of a halfpenny a year to reach the requisite level.

Mallock was born in 1849 and after leaving Oxford started what promised to be a brilliant career with a rapturously received political satire *The New Republic*, followed by a stream of anti-socialist polemic and writings on religion as well as many novels. By his death in 1923 he had faded into somewhat embittered obscurity, his views and attitudes all but obsolete. His class prejudice and imperialist hauteur are well on view in *A Human Document* and his attitude toward Jews (though not untypical of the time) supplies the crux of its love story. For Mallock the adultery of its heroine Irma with Grenville somehow did not really count since her wealthy husband was Jewish.

These aspects of his literary persona assisted rather than impeded my scheme, as did his intelligence, immaculate prose, luxuriant vocabulary and wide range

of allusion. In a way his complete lack of humour helped, for it is a pleasure to tease the odd joke out of a novel that contains almost none.

Like most projects that end up lasting a lifetime this had its germ in idle play at what then seemed to be the fringe of my activities. A liking for words plus the related influences of William Burroughs and John Cage with their use of chance had led me into casual experiments with partly obliterated texts, mostly in the columns of *The Spectator*. By the date of the encounter with Mallock I had already begun to toy with the idea of treating a book in the same fashion. Now the die was cast, the dice thrown: chance had become choice and a notion grown into an idea.

Once I had got my prize home I was excited to find that page after randomly opened page revealed that I had indeed stumbled upon a treasure. In my eagerness of darting here and there I somehow omitted to read the novel as an ordered story and, though in some sense I almost know the whole of it by heart, I have to this day never read it properly from beginning to end. Nonetheless, from that time on, whenever I have had a problem of providing a text for some artistic purpose, be it grave or trivial, I turn to Mallock first.

It was while I was experimenting with ways of combining pages that the book's christening took place, again by a chance discovery. By folding one page in half and turning it back to reveal half of the following page, the running title at the top abridged itself to A HUMUMENT, an earthy word with echoes of humanity and monument as well as a sense of something hewn; or exhumed to end up in the muniment rooms of the archived world. I like even the effortful sound of it, pronounced as I prefer, HEW-MEW-MENT.

In the early days I merely scored out unwanted words with ink leaving some (often too much) text to stand and the rest more or less readable beneath neat rapidograph hatching.

The first page I finished in 1966 was p33, whose revised version makes its appearance in this new edition. Reworking it I have incorporated part of the original as a memorial to the start of things, burned and pasted on to its successor. I discovered in the process some new words above: '... as years went on you began to fail better.' This hoped-for truth incorporated a phrase of Beckett I have used elsewhere, but which did not exist until seventeen years after my initial treatment. Serendipity is my best collaborator.

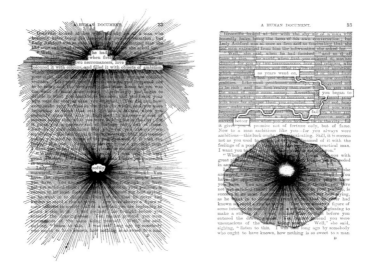

A Humument p33 from 1966 and 2010

Soon a hidden hero emerged from behind the columns of text to interact with the novel's actual protagonists, and to make a contrast to them in class and style. Since the W in W. H. Mallock stands for William, its commonplace short form, Bill, would provide a good matey name for his more humdrum alter ego. When I chanced on 'bill' it appeared next to the word 'together' and thus the distinctly downcast and blokeish name Bill Toge was born.

It became a rule that Toge should appear on every page that included the words 'together' or 'altogether' (as indeed befits a doppelgänger). The intended pronunciation is 'toe' (as part of a foot) and 'dge' (as in 'drudge' or 'fudge', two words redolent of the artistic enterprise). I have heard it variously pronounced, but Bill Toge seems about as unfancy a name as you can get; as are those of the anti-hero's friends who make guest appearances (Eve Sardine, Ted Wink, Stan Gage, Mrs Mornspot et al.). Toge's story, a little less glum now than in the first edition, is the non-linear narrative of one who has a somewhat bumpy ride on the roundabouts of art and love.

In a work such as this it is necessary to have some rules, and as far as I know the condemned presence of Toge on the relevant pages, after he takes the stage on p9, is a rule never broken. Nor, more importantly (for otherwise the whole task would become too casual and easy) are there any but the smallest divergences from a general imperative that Mallock's words should not be shunted around opportunistically: they must stay where they are on the page. Where they are joined to make some poetic sense or meaningful continuity, they are linked by the often meandering rivers in the typography as they run, with no short cuts.

By 1973 I had worked every page. The finished book was shown within weeks of its completion at the Institute of Contemporary Arts in London (in whose bulletin it had first been mentioned, by Jasia Reichardt, and a page from it illustrated, in 1967). It was shown the next year in an exhibition that travelled from London's Serpentine Gallery to the Gemeente Museum in the Hague and ended up in Basel. There, at the Kunsthalle, it was seen by Ruth and Marvin Sackner, who were to become the owners of the whole manuscript as well as keen supporters of the continuation of the project.

Seeing the book shown as a whole (and in this state being issued in the loose sheets of Ian Tyson's Tetrad Press edition) gave me some satisfaction, but the feeling that I could fail better than that began to nag. The first bound trade edition (1980), prepared by Hansjörg Mayer in Stuttgart and distributed by Thames & Hudson, marked the end of a dormant period. The book had become a book again and in its turn a suitable case for treatment.

I had originally avoided introducing outside material, thinking to keep the work 'pure'. Since, however, *Humument* fragments crept in to almost everything I did, I felt the urge for reciprocal action and began to incorporate motifs and collaged imagery from other aspects of my work. In the original introduction I spoke of 'mining and undermining' Mallock's text but I was now aware I had not dug as deeply as it might permit. Thus the first version could be regarded as preliminary opencast mining leaving more hidden seams to be investigated.

So I set about doing the whole book again, showing bit by bit, as edition followed optimistically imagined edition, what I could come up with. A few of the original pages however resisted reworking: I had grown fond of their words and designs. Occasionally I am content in such cases merely to redraw them with only slight variations. As I revisit and revise I begin also to imagine some eccentric scholarly recidivist one day making a Variorum Edition, bringing together all the multifarious word clusters I have contrived.

As early as 1969 the novel provided not only the libretto for the opera *Irma* (of which I have yet to make the definitive score) but its stage directions and design brief. In the seventies it also served to accompany many series of watercolours, largely based on postcard sources, such as *Ein Deutsches Requiem*, *The Quest for Irma* and *Ma Vlast*. The most elaborate of these excursions was the long suite of illustrations to Dante's *Inferno* in which Mallock provided an excellent foil to the all-knowing Virgil. Here at the opening of the volume some blank verse echoes the metre of my translation.

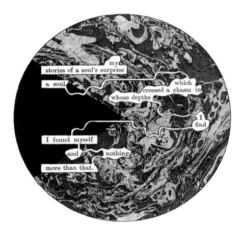

This process has continued over the years, with *Humument* fragments providing gores for fictitious globes (now in the Victoria & Albert Museum) or decorating both the inside and outside of a skull. Most recently excerpts have decorated the covers of an ongoing set of books prepared for the Bodleian Library from my archive of vintage photo postcards, and in 2011 (once more on commentary duty), accompanied an illustrated edition of Cicero's *Orations* made for the Folio Society.

Terrestrial and celestial *Humument* Globes, 1989 (Victoria & Albert Museum)

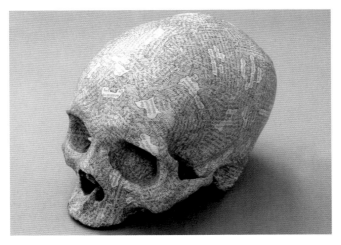

Humument skull, 1996 (collection the artist)

However diligent the compilers any such an omnium gatherum might turn out to be, there will always be scraps and shards that elude them; a trivial greetings card here, a record sleeve or CD cover there or even a faded T-shirt at the bottom of a drawer.

It is, after all, my resource of greatest use – and all thanks to a man who, from photographs and contemporary accounts of his personality, would seem to be someone I would not at all have enjoyed meeting.

I have so far extracted from his book well over a thousand segments of poetry and prose and have yet to find a situation, sentiment or thought which his words cannot be adapted to cover. That Mallock and I were destined to collaborate across a century became quite clear when I tested other fictions and discovered nothing to equal him in the provocation of fresh conflations and conjunctions of word and phrase.

How this serendipity has worked is well illustrated by the result of a recent urge to react in some way to the catastrophe of the twin towers in New York. Many years ago I had a concordance made (largely by Andy Gizauskas) of the whole novel in a little notebook now frayed and stained to the point of unusability. This has recently been replaced by an electronically created version masterminded by John Pull and smartly bound, which I duly searched for the unlikely occurrence of 'nine' and 'eleven' on the same page and in the right order. To my amazement I found them, on p4.

As has always been my practice I look for a text first and let its disposition condition any imagery that is at the back of my mind. In this case I scanned the page on the lookout for apposite commentary. I recalled the event's uncanny prefiguration in the *Inferno* where Dante compares the giant Anteus to the skyscrapers of his day, the bristling skyline of 13th-century Florence with its many tall and narrow towers. A postcard of King Kong was already featured clutching at the World Trade Center in *A Postcard Century*, as was a version of Goya's *Saturn Devouring his Children*. These pictures were thus 'pasted on to the present' as the text suggests. The accompanying Roman numerals make a twinning palindrome and their non-arabic presence suggests the 'time singular' also mentioned. Thus classical mythology joins medieval poetry together with an early 19th-century Spanish painting, a Victorian novel and a 20th-century American film, combining to link late modern architecture to a 21st-century disaster.

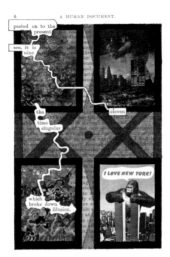

Few pages are as complex in their devising as this one, yet, even though a lot of the book is intended as a diversion, there is a current of reference to literature and music throughout. I was specially thrilled, right at the other end of the book, to extract from the penultimate page the closing mood and actual words of Joyce's *Ulysses* with the famously repeated 'Yes'.

To a great extent this amenability in providing text after text comes from the typography and layout of the one-volume edition that I have been using. As was the normal practice of the time *A Human Document* made its first appearance as a luxury three-decker. When eventually I found a copy of this the whole story, spread over three volumes, looked very aerated, with highways rather than rivers through the type.

A particular curiosity (that has led some transatlantic commentators to accuse me of serial cheating) is the single volume American edition, also of 1892; in this, tricky foreign phrases are suppressed, so that words become quickly out of step with the British edition, setting up quite a different field of possibilities for a whole new work (given a whole new lifetime to do it in).

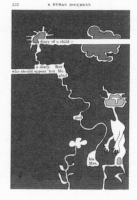

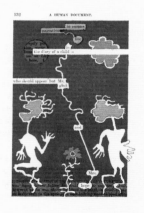

p132. The original page of *A Human Document* (top left) plus 1973 version (top right), revisions in progress (bottom left), and version for this 2012 edition (bottom right).

Occasionally the rivers in the type are not only used to link words and phrases (to avoid a staccato effect except where wanted) but are brought into play to make drawings, usually a face or a figure. Other gaps, as can be seen in the preliminary artwork to p132, can be similarly exploited.

Inasmuch as *A Humument* tells a story it could be described as a dispersed narrative with more than one possible order; more like a pack of cards than a continuous tale. Even in the revision, I still do not tackle the pages in numerical order. A narrator, unreliable as is fashionable in contemporary literature, has most of the text. Sometimes he might be identified with the artist and sometimes not: and sometimes in any case it could be a 'she'.

As well as words with meaning I have enjoyed the discovery of nonce or nonsense terms which provide a fantasy obbligato to the measure of the text. These are extracted from longer words. The less self-evident their source the more autonomously real they can seem, as on p46 where 'derstan ansfig' are 'the last words on earth'.

This is only an extension of the more frequent practice of extracting sense from sense as on p1 where 'sing' is detached from 'singular' in order to provide the necessary formula for the launching of heroic, or in this case mock-heroic, tales. Here the words echo the beginning of Virgil's Aeneid, 'Arms and the man, I sing…' (*Arma virumque cano…*)

In the years since Mallock wrote his novel the English language has itself sent out new shoots. He could not have imagined the future use of 'plane' for example. Similarly at the beginning of my own endeavour I could not have predicted the dark resonance that 'bush' has come to have or how a simple word like 'net' would grow immeasurably in significance. Suddenly in 2011 I can find on p9 both 'app' and 'facebook', which would have had no meaning at all even ten years ago, not to speak of that grim conjunction already mentioned of 'nine' and 'eleven', once inert but brought to sad life by so much death.

The original copy of *A Human Document* that I started out with in 1966 was worked on without destroying any of its pages and is now, intact in its original binding, housed in the Sackner Archive in Miami. Unlike this integral and somewhat fragile version the revised pages have been worked on using one side only, mounted on acid-free paper to make them not only more durable but easily frameable. These originals have also largely found their way to Florida.

Another copy has stayed with me in which are noted the dates of completion of each revised page and any variant fragments of it that have been used. Yet another whole copy went into the making of *The Heart of A Humument* (1985), a miniature book extracted from the middle of selected pages.

This accounts already for five copies and, in the production of various fragments, I have made substantial inroads into at least four others of the one-volume edition. Many have been sent to me by well-wishers, notably that *miglior trovatore* Patrick Wildgust. Others were bought by me at a time when the book could be more easily found and had not attained the price it now fetches (which can be anything up to £80). Although that original book was unmarked except for its pencilled price and the signature of its former owner the pooterishly named Mr Leaning, others feature a little more bibliographical information. One was purchased at the Beresford Library, Jersey, in 1898 by Colonel J. K. Clubley and passed into the hands of someone who merely signs himself 'Hitchcock'. Another came from the library of a past president of the Royal Academy Sir Gerald Kelly (whom I once met when a schoolboy in Dulwich) though how he got it from 'Nell' to whom it was presented by 'Michael' in 1901 is not recorded.

Lest I should think myself the first to doctor this work I happened upon a copy (coincidentally from that same furniture repository in Peckham, this time for one shilling and sixpence) that had belonged to Lottie Yates who had herself treated it with much heavy underlining and word encircling that seemed to reflect her own Togeian romantic plight, sighing into the margin from time to time 'How true!' It seems also that she had used it as a means of saying to her beloved the things she lacked words for, passing the marked copy to him as a surrogate love letter. Thus in 1902 someone had already started working the mine. Most intriguing is a copy not in my possession but among the books belonging to Oscar Wilde in the library of Magdalen College, Oxford, whose librarian notes a perhaps significant stain, possibly made with jam, on one of the pages.

The publication history of *A Humument* is not without bibliographical byways after the first of those ill-fitting boxes in fugitive colours appeared in 1973 from the Tetrad Press. That publishing venture, heroically undertaken by Ian Tyson, was beset by economic crises as the subscribers dwindled in number, and pages destined to explore various printing media were hurriedly finished photolithographically. A full account of initial publications (including variations I made of p85 in an effort to demonstrate the inexhaustible nature of Mallock's text) will appear in due course on the appropriate website.

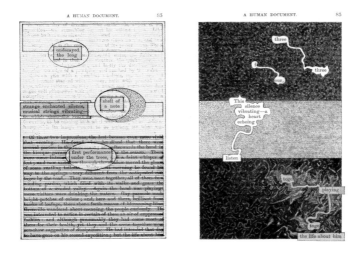

A Humument p85 from 1967 and 2010

A Humument has always been a kitchen table task, initially in Camberwell, then in Peckham, and occasionally in recent years in my apartment at the Institute for Advanced Study in Princeton where I am writing this. It has also been almost entirely an evening employment at the end of a studio day.

In an earlier rendering of this introduction I grandiosely described *A Humument* as 'a *Gesamtkunstwerk* in small format'. Perhaps now with its various by-products, recyclings and revisions it really does aspire to that lofty Wagnerian formula of the comprehensive work of art. The App version for iPad and iPhone can also be employed as an oracle with appropriately random access and suitably cryptic advice. A full Variorum Edition may remain a dream (or a posthumous project) since the wheel is still turning and the odd spark still flies off.

For the time being I must try to get to the end of the revisions and deal with those pages which have so far evaded change, especially the ones whose original solutions have stood up to almost fifty passing years. I retain the option of leaving them as they are, thereby forestalling the absolute end of my venture, even if hanging on to the book in such a way may be thought a suspect strategy synonymous with hanging on to life itself.

I once combed the churchyard in the town of Wincanton where he died for the grave of William Hurrell Mallock, thinking to put some flowers of gratitude upon it. I failed to find it however and must keep unredeemed some apprehension of guilt at having ransacked and upturned his writings like a wrecked room, subverting them to say things that would have dismayed and disturbed him. It may happen though that one particular page might stand unchanged to do service, not without a degree of irony, as a curiously mutual epitaph. He might desist from turning in his undiscovered grave at the thought that he has been in some way perpetuated through me as I through him.

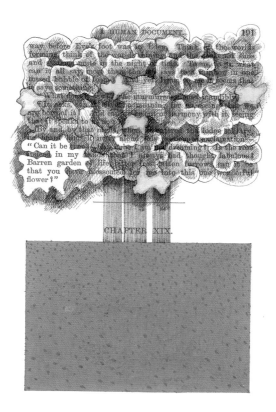